Folk Art

TIME-LIFE BOOKS

Alexandria, Virginia

Folk Art

*imaginative works
from American
hands*

A REBUS BOOK

CONTENTS

Expressions of the People

Decorated Boxes · Scrimshaw Pie Jaggers · Ornamental Canes
Sculptures and Whirligigs · Folk Sculptor John Scholl · Homemade Dolls
Pictorial Quilts · Adam and Eve in Folk Art
Table Rugs · Floor Rugs

Living with Folk Art

A Taste for Collecting · An Eclectic Eye
A Love of Americana

CREDITS

INDEX

ACKNOWLEDGMENTS

The American folk art presented in this volume encompasses a broad and lively range of paintings, carvings, embroideries, pottery, and household furnishings and utensils produced primarily before the 20th century. As folk art, this is not the work of formally trained artists, but of common folk: artisans and itinerant painters, farmers, housewives, and even schoolchildren who were taught needlework and painting as part of a proper education. Some of these individuals were well-known in their own time, and remain so today, while many more are anonymous; all, however, have left a legacy of work so original and varied in character that America's folk art is now considered unique in the world.

Indeed, in other countries, the term "folk art" refers to the specific craft traditions of particular ethnic or regional groups; American immigrants, however, not only continued the traditions they knew, such as the decorative carving and painting brought to Pennsylvania by German-speaking settlers, but went further, exploring and developing new areas. Only in America, for example, is there such a broad and well-defined body of folk portraiture. And, while some familiar folk-art forms, such as weather vanes, originated abroad, it was in the hands of their American makers that they were transformed from mere utilitarian objects into "sculptures" of true artistry.

The flowering of folk art in this country was due in large part to America's newness. Settlement was still going on in the late

1800s, and large segments of the population lived in rural areas. Those people who lacked access to ready-made products had to craft many household goods themselves, and the natural desire to own or give someone else something beautiful could turn the challenge of making such goods into a creative process.

Another notable characteristic of this fledgling democracy was an ever-growing middle class. Along with newly filled pockets came the desire for "better" things that were previously reserved for the wealthy. For modest fees, itinerant artists met part of the demand; their paintings, depicting individuals and families in their Sunday best, were proudly hung in parlors and passed from one generation to the next. Along with portraits came other fashionable artworks, including the samplers stitched at young ladies' seminaries, the stenciled paintings known as theorems, and memorial pictures, which became popular after George Washington's death in 1799.

In fact, death, a familiar visitor in the days before medical advancements, was just one of the many recurring themes in folk art—themes that logically reflected immediate, everyday concerns centered on family and religion, as well as the impact of historical events. Weddings and births were commemorated in embroideries and paintings, "portraits" of family pets were hooked into rugs, biblical characters stitched into quilts, eagles and flags painted onto tavern signs. These expressions of love, piety, and patriotism are the essence of a remarkable body of work aptly called "the art of the people."

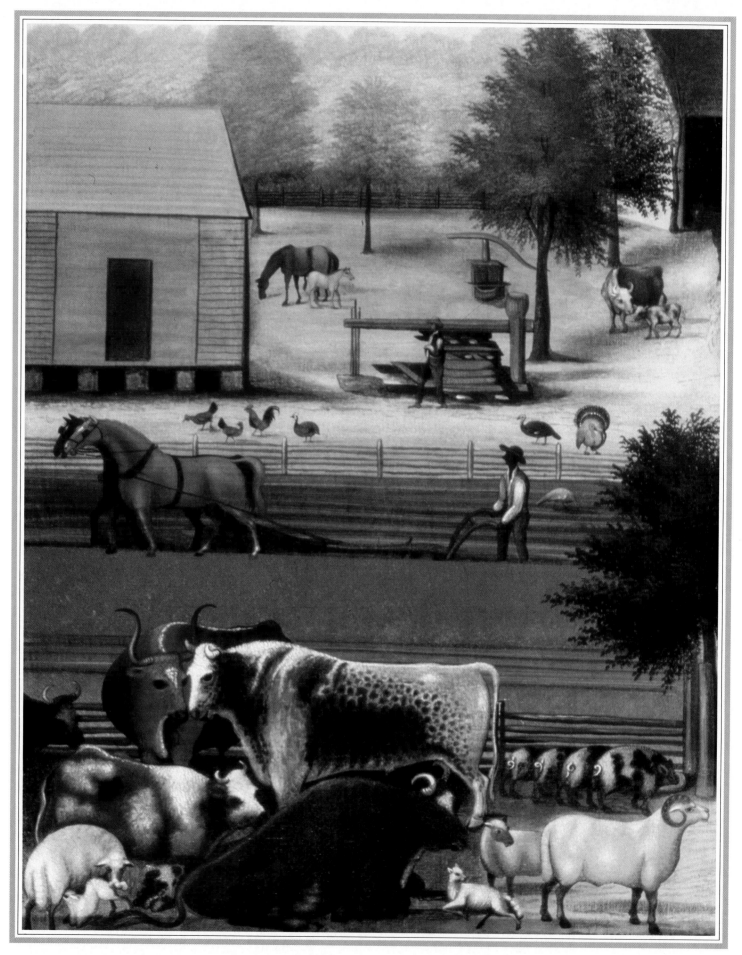

An American Portrait

*the detailed pictorial record
left by early folk artists*

Before photography became widespread in the 1850s, the work of American folk artists provided an important visual document of the people and events of the time. Much of it—including paintings, miniatures, and silhouettes—comprises human likenesses. Numerous landscapes, farm and village scenes, and interior views, however, suggest that the artists were also interested in recording a broader portrait of life's everyday circumstances.

While the work of the thirteen individuals presented in this chapter is only a small sampling of that produced in past centuries, it helps tell the larger story of all early American folk painters—including the many whose names are forgotten. They were an intrepid lot. Despite the hardships of travel, a number of them covered great distances in search of commissions, and were still compelled to take additional jobs to get by. Most were also self-taught. Yet the technical limitations of these artists have proved, over time, secondary to their ability to convey the character of a sitter or to offer a glimpse into small-town life.

A detail of The Residence of David Twining *(page 18), painted around 1845 by*
Edward Hicks, shows life on the farm where the artist grew up.

Rufus Hathaway

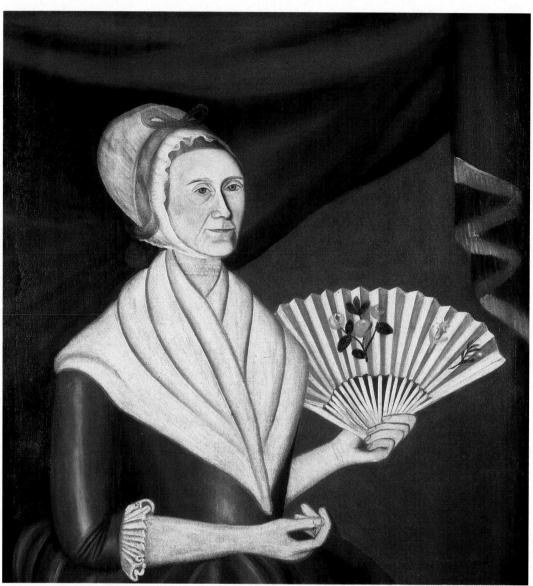

Mrs. Caleb Turner (Phebe King), 1791 (oil on canvas, 35½" x 34"). Rufus Hathaway was twenty-one when he painted Mrs. Turner and a companion portrait of her husband, the Reverend Caleb Turner. Despite evident problems with perspective and anatomical drawing, Hathaway successfully depicted the clothing of this sitter and managed to convey a sense of her personality with a hint of a smile.

Rufus Hathaway, born in 1770 in Free-town, Massachusetts, was in his early twenties when he arrived in Duxbury, Massachusetts. Hathaway, believed to have been a self-taught artist, had come seeking commissions for portraits.

By 1795, one of Duxbury's wealthiest merchants, Joshua Winsor, had asked Hathaway to paint likenesses of his two daughters. While working on the portrait of the younger girl, Judith, Hathaway reportedly fell in love with his subject. Winsor agreed to a proposed marriage but suggested that his future son-in-law adopt a more secure career. As a result, the artist studied with a doctor in a nearby town, and practiced medicine in Duxbury until his death in 1822. Despite this new profession, however, Hathaway continued to produce portraits. Because his technical skill was limited at best, his paintings often have a stiff appearance, yet they are appealing for their remarkable ability to capture the prideful character of his sitters.

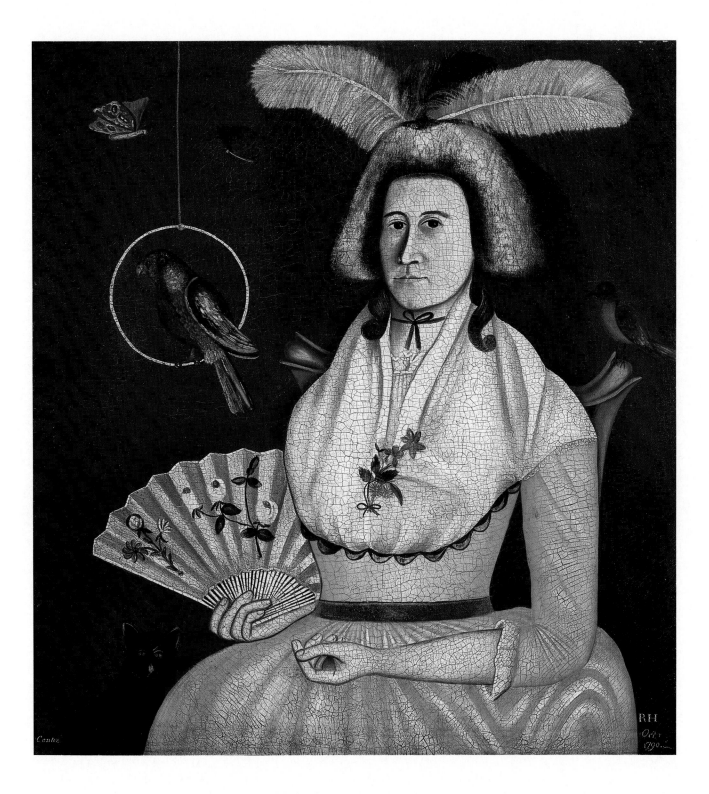

Lady with Her Pets, 1790 (oil on canvas, 34½″ x 32″). The name of the lady in this earliest known portrait by Hathaway has been forgotten; that of her cat, however, is marked in the lower left corner.

John Brewster, Jr.

Above left, One Shoe Off, *1807 (oil on canvas, 34⅞″ x 24⅞″). Above right,* Francis O. Watts with Bird, *1805 (oil on canvas, 35⅜″ x 26⅜″). The pale, gentle faces in these two likenesses are typical of John Brewster's paintings of children.*

The gentle faces in John Brewster, Jr.'s, paintings, especially those of children, place his canvases among the best-loved American folk portraits. Brewster, who had considerable success obtaining commissions, supported himself throughout his life solely by painting. This is quite remarkable since he was born deaf and never learned to speak. Because the work of an itinerant painter required introductions to and discussions with prospective sitters, Brewster's existence cannot have been easy.

The son of Dr. John and Mary Brewster of Hampton, Connecticut, the artist was born in 1766, and grew up in a cultured and comfortable household where he was taught to read, write, and communicate with sign language. He studied painting with the Reverend Joseph Steward, who was both the local minister and a successful portrait artist. Brewster also may have had opportunities to examine portraits of the day in the homes of Hampton's well-to-do citizens. But precise brushstrokes and a sensitive rendering of his subjects' eyes make Brewster's work unlike any by his contemporaries.

Among the few paintings known from the artist's early career are the likenesses of Lucy

Continued

Comfort Starr Mygatt and His Daughter Lucy, 1799 *(oil on canvas, 54″ x 39¼″). Mygatt is shown seated with his legs crossed, a pose Brewster often chose for his male subjects.*

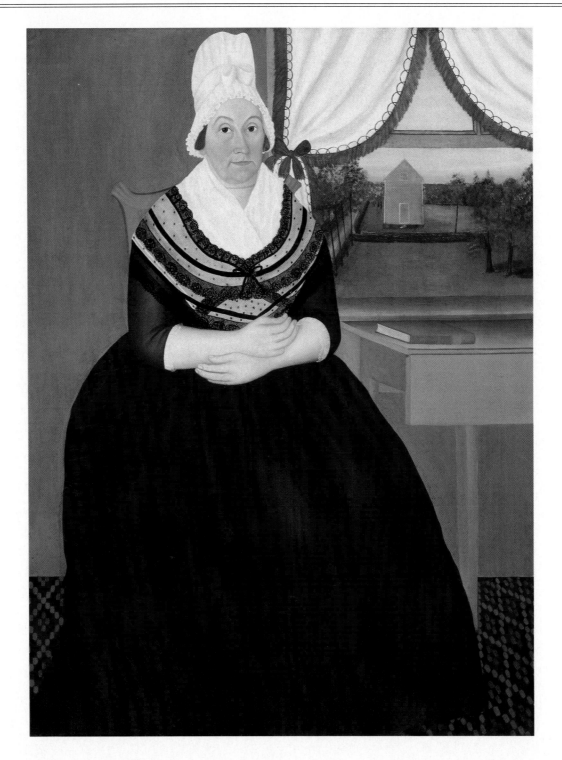

Lucy Eldredge, 1795 (oil on canvas, 54″ x 40½″). Eldredge and her husband lived in Brooklyn, Connecticut, near Brewster's family.

and James Eldredge, above and opposite. Although he produced only portraits, Brewster often included landscape scenes as backgrounds in his compositions. The barn and marshland seen through the windows in the Eldredges' portraits were probably views of their property.

Brewster's work also frequently details interior furnishings of the period.

In 1795, one of Brewster's brothers married and moved to Buxton, Maine. The artist joined the couple there and subsequently made Buxton his home. Most of his work during the next two

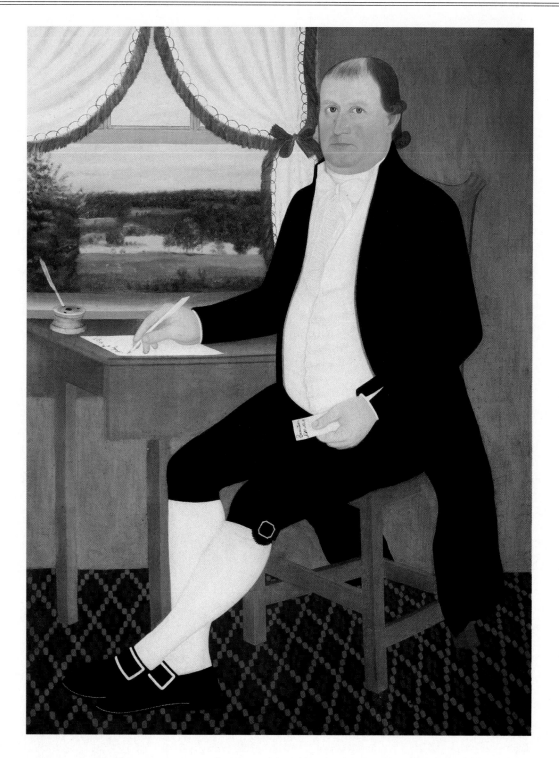

decades was done as he traveled through Maine, Massachusetts, and Connecticut. He apparently stopped painting briefly in 1817 when, at fifty-one, he moved to Hartford to enroll in America's first school for the deaf and mute. He resumed his career upon his return to Maine in 1820.

In his later years, Brewster painted portraits that were increasingly strong character studies: the faces more somber and deeply shadowed than in his earlier paintings. The last known examples of his work date to the 1830s. Brewster died in Buxton in 1854 at the age of eighty-eight.

James Eldredge, 1795 (oil on canvas, 54″ x 40½″). Brewster dated the letter, perhaps to indicate when he finished the painting.

MEMENTOS IN MINIATURE

The child in this c. 1825 painting wore a miniature for the portrait.

Miniature pin, watercolor on ivory, c. 1830-1840

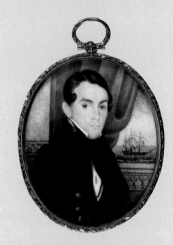

Elisha Buchanan, watercolor on ivory, by Isaac Sheffield, 1840

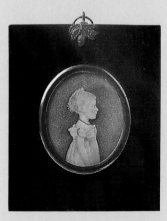

Framed portrait miniature, watercolor on ivory, c. 1840

Generally small enough to fit into the palm of a hand, the diminutive paintings known as miniatures were often the work of the same artists who painted full-size pictures. The delicately rendered works, done in watercolor, gouache, or oil paint on paper or ivory—then set in a locket or pin, perhaps with a lock of hair—originated abroad in the 1500s and were fashionable in America from about 1750 to the mid-1800s.

In Europe, the use of miniatures had been restricted to court and aristocratic circles. In this country, however, their popularity corresponded directly to the social prestige they represented for a burgeoning middle class that could now afford such niceties. Beyond status, the painted images, which were commonly portraits, also had important personal meaning. Mothers commissioned them of their children, betrothed couples exchanged them as tokens of esteem, and the bereaved wore them as memorials.

The popularity of miniatures began to fade in the 1840s as the daguerreotype became available and competed with the paintings. The images grew larger in size and, framed for display on tables and walls, were treated as household accessories rather than personal mementos; eventually they fell from favor altogether.

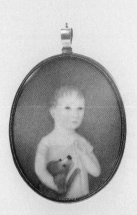

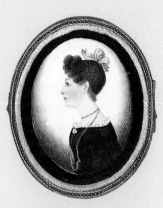

Portrait of a boy, c. 1840, with a later daguerreotype of him on the reverse

Locket by J. H. Gillespie, water-color on paper, c. 1835

Portrait locket by J. Bradley, oil on ivory, c. 1840

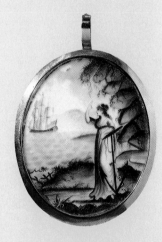

Miniature pin, watercolor on paper, c. 1840

Inscribed friendship pin, water-color on ivory, c. 1830

Mourning locket, attributed to Samuel Folwell, c. 1825

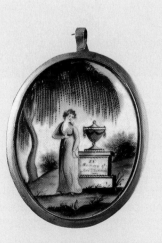

New England portrait locket, oil on ivory, c. 1830

Mourning locket, attributed to Samuel Folwell, c. 1825

Portrait locket with a lock of hair on the reverse, c. 1830

Edward Hicks

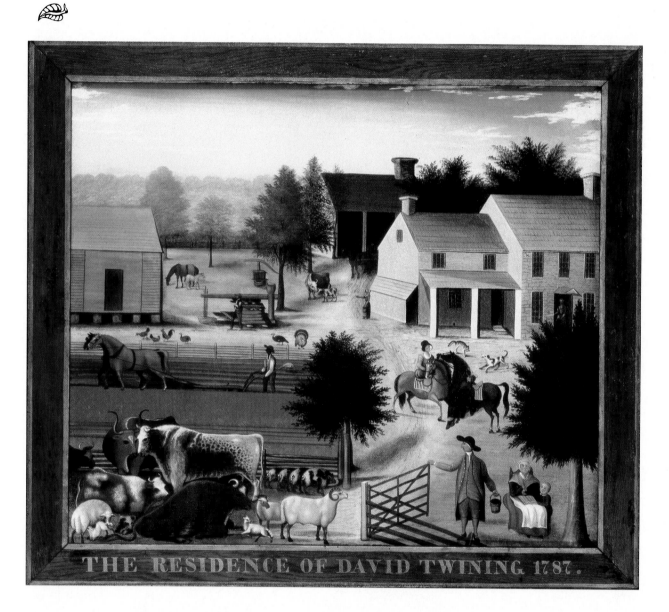

THE RESIDENCE OF DAVID TWINING. 1787.

The Residence of David Twining 1787, c. 1845-1848 (oil on canvas, 26½″ x 31½″). The woman on horseback is Mary Twining, the favorite of Edward Hicks's four adopted sisters.

Famous for his familiar images of *The Peaceable Kingdom,* Edward Hicks is one of America's best-known folk artists. That his work is highly regarded today would have surprised the artist, since Hicks considered himself "a worthless, insignificant painter." Yet, even in Hicks's own time, his career as an artist was remarkable, since he was also a Quaker minister. Because the Quakers rejected painted

embellishment, Hicks had to reconcile his art with his religion, and he frequently turned to themes from the Bible and nature in an effort to resolve his struggle with what he called his "poor zig-zag nature."

Virtually from the start, Hicks's life was fraught with difficulties. By the time of his birth in Bucks County, Pennsylvania, in 1780, the Revolutionary War had already devastated

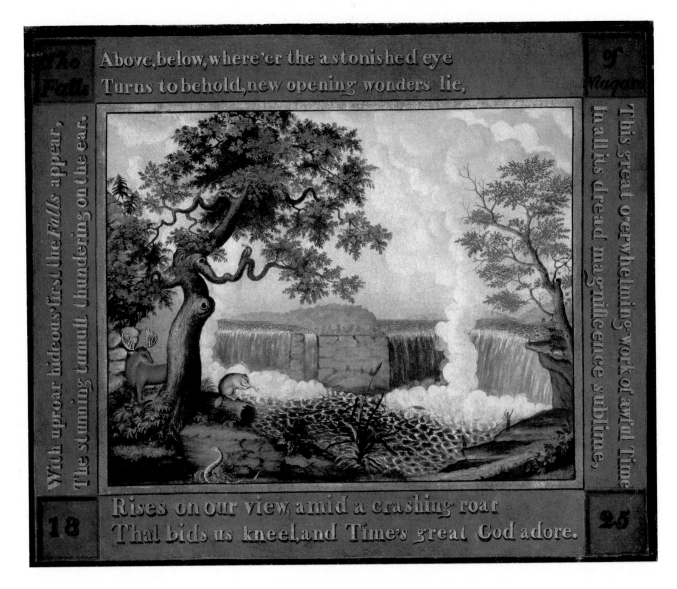

The Falls of Niagara,
1825 (oil on canvas, 31½″ x
38″). Hicks used a vignette
from a map as the model
for this painting.

his family's fortune. When Hicks was eighteen months old, his mother died, and his father placed him in the care of the Twinings, a Quaker couple. The love, warmth, and religious training that he enjoyed in the home of his adoptive family remained important to Hicks all his life; later, in his sixties, he painted at least four versions of the Twining farm as it would have appeared in 1787. Within the neat farmyard scene, Hicks always portrayed his foster parents dressed in plain Quaker garb.

Like many other boys, Hicks began his vocational training when he was thirteen. Living away from home, he worked under a seven-year apprenticeship in a coachmaker's shop, where, it is thought, he learned the art of decorative painting. During his tenure, Hicks evidently became overly fond of "frolics" and visits to Philadelphia

Continued

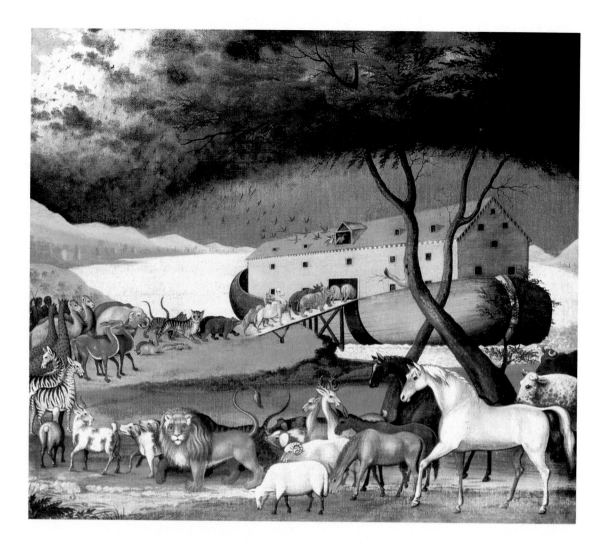

Noah's Ark, 1846 (oil on canvas, 26½″ x 30½″). An 1844 lithograph by Nathaniel Currier was the source for this composition, but Hicks's adaptation is distinctive. He added the crossed trees, placed the white horse in the foreground, and turned the lion to face the viewer.

taverns while on weekend outings. But by the time he reached his early twenties, he had grown tired of his wayward lifestyle and repented of his ways. In 1803, he joined the quiet-living Quakers, married, and began to work as a coachmaker in Bucks County.

By 1812, Hicks was named a Quaker minister—an unpaid position, but one that he took very seriously. From the time of his appointment until the end of his life, he would make periodic trips on horseback, sometimes traveling thousands of miles, to meet with other Quakers in towns throughout the Northeast.

By 1813, Hicks and his wife, Sarah, had four children. To supplement his income from coach-

making, and to help pay off the debts he incurred by taking the trips for the ministry, Hicks used his skills as a decorative artist to paint household objects, such as chairs and fire buckets. But his fellow Quakers, devoted to a plain way of life, looked on his fancywork with disapproval. Consequently, Hicks made a brief attempt at farming, which proved to be unsuccessful. By 1817, he had turned to coach and sign painting instead, and had begun experimenting with painting on canvas at the easel.

Hicks's knowledge of sign painting techniques, such as lettering, is often evident in his canvas work. He sometimes surrounded scenes with a painted border that was inscribed with

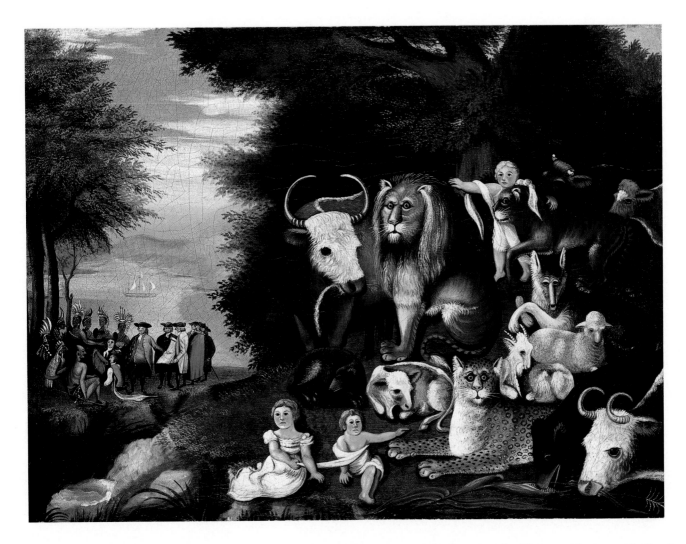

poetry or a biblical quotation, or hand-lettered the titles of his works directly on the veneered frames that he made in his workshop.

Apparently, Hicks collected American and English prints and frequently used them as sources for his compositions. But while he painted certain scenes many times over, the elements in them were often varied. Around 1820, Hicks painted the first of his numerous versions of *The Peaceable Kingdom*, a biblical scene depicting fierce and meek members of the animal kingdom peacefully coexisting with small children. The initial inspiration probably came from an engraving by English artist Richard Westall that appeared in a number of 19th-century Bibles as an illustra-

tion of world peace recorded in Isaiah 11:6: "The wolf also shall dwell with the lamb, and the leopard shall lie down with the kid; and the calf and the young lion and the fatling together; and a little child shall lead them."

Hicks's *Kingdoms* are posed in a variety of American landscape settings and often include a vignette of William Penn, the Quaker founder of Pennsylvania, peaceably signing a treaty with the Indians on the banks of the Delaware River. (Penn's fair dealings with the Indians were evidently linked in Hicks's mind with the concept of global harmony.) Hicks continued to paint his kingdom theme until the very eve of his death in 1849.

The Peaceable Kingdom, c. 1832-1834 (oil on canvas, 17¼" x 23¼"). Using several print sources, Hicks completed at least sixty paintings on this theme. The background scene of William Penn purchasing land from the Indians was adapted from a popular 1775 English engraving.

Joshua Johnson

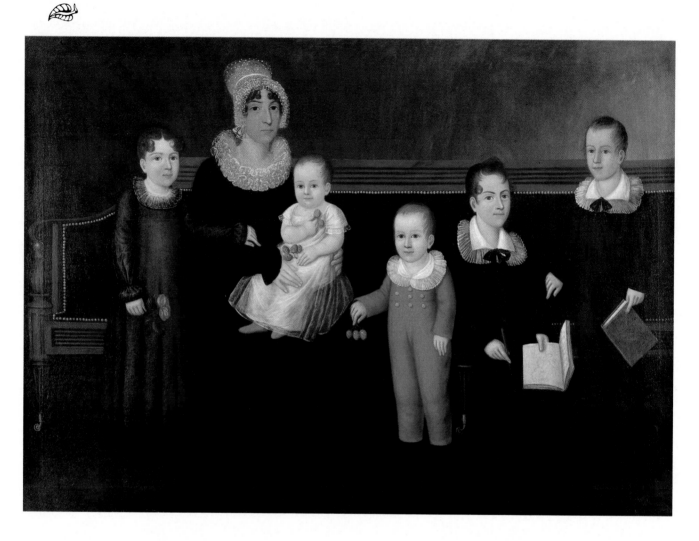

Mrs. Thomas Everette and Her Children Mary, Rebecca, John, Thomas, and Joseph, 1818 (oil on canvas, 38⁷/₈″ x 55³/₁₆″). Thomas Everette was a successful hardware merchant in Baltimore who died shortly before Joshua Johnson painted this family portrait.

In December, 1798, the painter Joshua Johnson placed his first advertisement in the *Baltimore Intelligencer*. He informed readers that "having experienced insuperable obstacles in pursuit of his studies," it was "highly gratifying to him to make assurances of his ability to execute all commands with an effect, and in a style, which must give satisfaction."

Very little regarding Johnson's life is known for certain, but chances are he did experience obstacles in establishing his painting career. Johnson was black and had obtained his freedom from slavery possibly only two or three years before the appearance of his advertisement. Although there were many black freemen working in various crafts and trades at that time, portrait painting—which often required introductions to well-to-do families—was an unusual career choice. Johnson, in fact, is the first known black portrait artist in America. Working exclusively in Baltimore, a center of abolitionist activity, he had an active career for a period of about thirty years, during which time he also married and raised a family.

While the dates of his birth and death are unknown, it is believed that the French-speaking

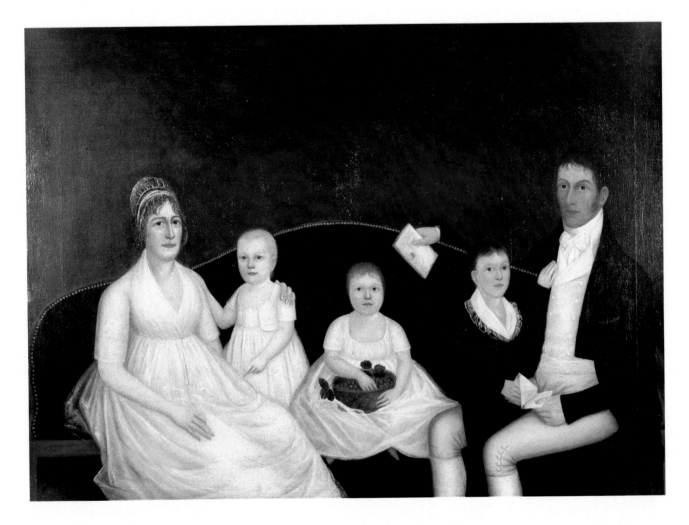

Johnson was a native of the West Indies brought to this country as a boy. It is also thought that he worked as a valet in the Philadelphia household of Charles Willson Peale, who was America's best-known portrait artist of the time. An association with a painter like Peale (whose son and nephew were also working artists) is perhaps the only way a young black man would have had access to studying portraiture firsthand.

The poses and backdrops in many of Johnson's portraits are very similar to those in Peale family paintings. But, after Johnson gained freedom—and particularly during the height of his career, from 1803 to 1814—he also devised many ambitious compositions of his own. Among them are several large canvases that portray families of four to six members—difficult works because they require arranging large and small figures gracefully within a single picture.

Over half of Johnson's subjects are children, often shown with unusual and beautifully rendered details such as strawberries or fluttering moths. Many of these portraits also reveal his mastery at depicting translucent fabrics. The artist's eye for such elements gives his paintings much of their delicate charm.

Mr. and Mrs. James McCormick and Their Children William, Sophia, and John, c. 1804-1805 (oil on canvas, 50¹³/₁₆" x 69⁷/₁₆").

This painting is typical of Johnson's family portraits, in which he often posed a young child standing on a sofa to balance the heights of the figures.

Jacob Maentel

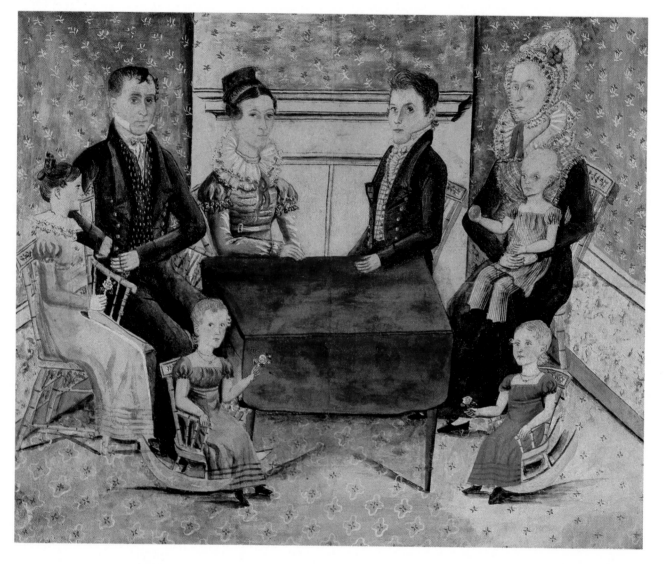

Portrait of a Family, c. 1825 (watercolor on paper, 17½″ x 23″). As is typical of Maentel's paintings, the girls in this work hold flowers, and the details of their clothing are carefully rendered.

Born in Kassel, Germany, around 1763, Jacob Maentel trained as a physician, and served as a soldier and secretary under Napoleon before emigrating to America at an unknown date. By 1810, he had taken up farming in Lancaster, Pennsylvania, and had begun developing a reputation for what he referred to as a "fondness for painting."

Maentel specialized in watercolor portraits, and some two hundred of his works are now known. These were done both in Pennsylvania and, later, in Posey County, Indiana, where the artist moved with his family around 1838. Most of his earliest likenesses showed people in profile; for a self-taught artist this was an easy way to portray difficult areas of the anatomy, such as faces and feet. By the 1820s, however, Maentel apparently felt sure enough of his talents to paint his subjects head-on. His most sophisticated pictures show his friends and

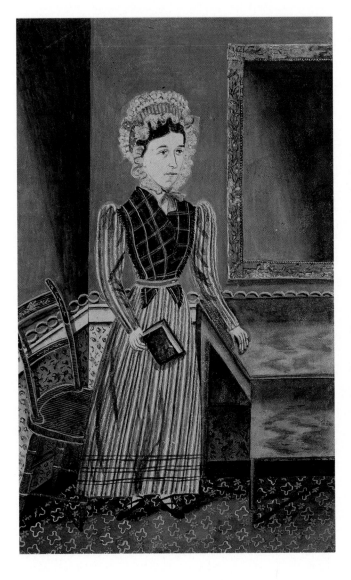

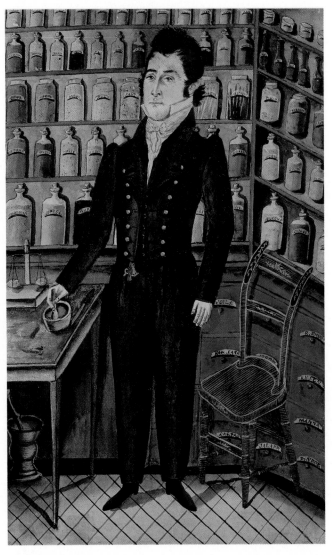

neighbors in their homes and places of business.

Although the poses were stiff and the perspective awkward at best, the careful studies Maentel made of faces, and the personal effects that he added to each painting, make his portraits highly original. The artist took meticulous care with each article of clothing, detailing the printed fabric of a gentleman's vest, the ribbons and lace on ladies' bonnets, and even the tucked trim on children's dresses.

Maentel also left an important record of the interiors of his day. He depicted patterned carpets and wallpapers, and even the grain-painted woodwork. His props often included such furnishings as drop-leaf tables and Windsor and painted Hitchcock-type chairs, as well as elaborate mirrors. The painter also showed gentlemen at their workplaces with the tools of their trade. Thought to have painted into his eighties, Maentel died in 1863.

Mr. and Mrs. Christian Bucher, c. 1830 (gouache and watercolor on paper, 17¼" x 11" and 17" x 10⁷⁄₁₆"). Maentel posed Mrs. Bucher at home, while her husband, an apothecary, is shown at work.

PICTURES IN THE HOME

NATHAN HAWLEY, and FAMILY, Nov.ᵣ 3.ᵈ 1801.

The unframed landscapes in the Albany, New York, parlor shown in William Wilkie's 1801 painting were hung with screw eyes and nails; portraits are visible in the next room.

Although displaying pictures in the American home was once a luxury limited to the wealthy, the practice became more widespread in the 1800s, when the members of a growing middle class could afford to choose their furnishings according to fashion rather than necessity. During the century, portraits of family members predominated, but there were also landscapes and exterior views that might feature the family dwelling, business, or farm. Popular too were "fancy" pieces such as theorems and samplers, as well as memorials, silhouettes, prints, and maps.

Often, inexpensive works were left unframed and were just tacked to the wall. Household directories of the period explained how to back prints and maps with linen and suggested varnishing their front sides, thus providing protection without an investment in glass. Paintings too might be displayed without frames; two screw eyes were simply attached to the top stretchers, then hung from nails or decorative pins. This was a common method for hanging framed pieces as well, although these might also be suspended from colorful ribbons or cords, or blind-hung from behind.

Popular taste throughout most of the century called for pictures to be hung high on the wall so that the bottom portion was at eye level or even a little higher. Symmetrical arrangements were favored, and oval frames, popular for portraits, were used with rectangular frames in groupings. Mixing picture types, however, was not advised, according to *Hints on Household Taste,* an 1868 book by Charles Eastlake. "If it is desirable, as I have said, to hang oil pictures by themselves, it is doubly advisable to separate water colour drawings...," wrote Eastlake, who also observed that the "art of picture-hanging requires much nicety and no little patience."

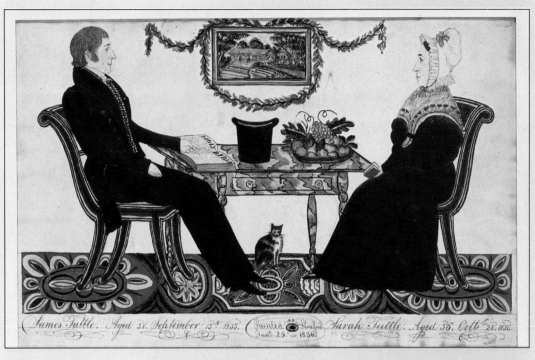

In this 1836 portrait by the itinerant painter Joseph H. Davis, Mr. and Mrs. Tuttle are featured with a picture of Tuttle's sawmill; the garland is a Davis trademark.

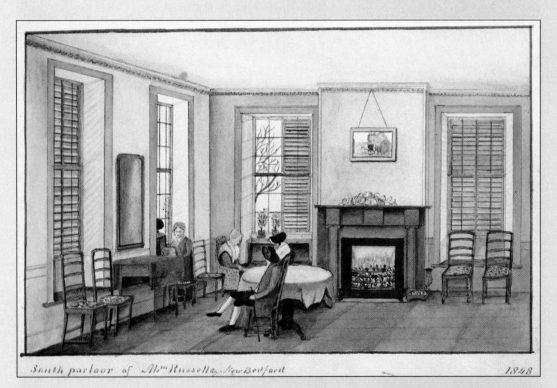

Joseph Shoemaker Russell's 1848 watercolor of his father's parlor shows a painting hung high over the mantel on a twisted cord; the frame is gilded.

Ammi
Phillips

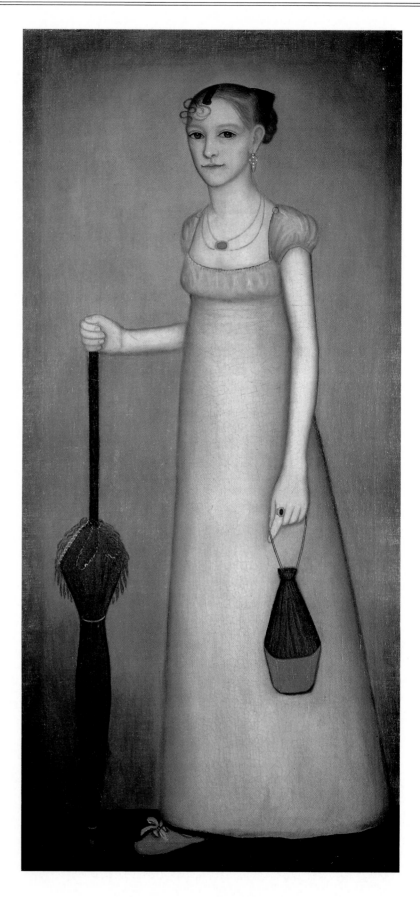

Painting from 1811 to 1862, Ammi Phillips was one of the most prolific of American folk artists; over five hundred of his portraits are known, and there may well be many others. Phillips was also one of the most inventive painters of his day. The artist's style changed so dramatically at certain points in his career as he gained technical experience, that his work was at times attributed to several different painters.

Phillips's unusual first name, which comes from the Bible (Hosea 2:1) and means "my people," curiously suits his life's work. The artist's subjects were mostly friends, relatives, and their extended families—residents of the region where he spent his life. Born in the village of Colebrook, Connecticut, in 1788, Phillips was painting portraits in nearby Stockbridge, Massachusetts, at the age of twenty-three. Two years later, in 1813, he married, and he and his wife settled in Rhinebeck, New York.

Throughout his life, Phillips would add few props to his paintings, and he always used plain backgrounds that called attention to his sitters' faces and clothing. The paintings that Phillips produced early in his career, from about 1813 to 1820, are often referred to as dreamlike. As the portraits of Harriet Leavens, right, and Polsapianna Dorr, opposite top, show, he fa-

Harriet Leavens, c. 1815 (oil on canvas,
57" x 28"). This was one of seven full-length
portraits of children that Phillips painted
in a two-year period.

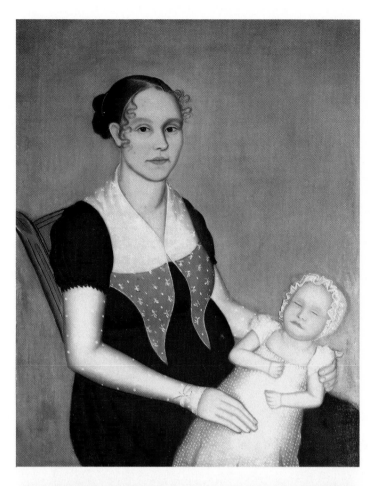

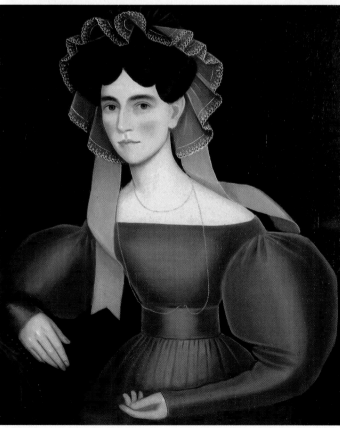

vored a pastel palette, used very little shading in faces, and posed his subjects against pale gray or beige backgrounds. In these early works, the difficulties that Phillips had in drawing the human figure are especially evident.

Beginning around 1820, Phillips's palette grew darker. Cranberry and black backgrounds replaced the pearly grays, giving his sitters a dramatic silhouette. The paintings lost their dreamy quality; formally posed, the figures were also more closely observed, with realistic light and shadow modeling the faces and clothing.

In 1830, Phillips's wife died, leaving five children. Soon remarried, the artist fathered four more children. Although he had traveled throughout New England in his early career, he now painted nearer to home. As he grew surer of his skills at composition, Phillips changed his style yet again. During this period, from about 1829 to 1838, his paintings became less subtly shaded: the subjects, such as the woman in a green dress, bottom left, appeared brightly lit against their dark backgrounds. He also painted clothing with flat color, as shown by the children's portraits on the following two pages. As he approached old age, Phillips began to produce paintings that seem quickly executed, without much detail. His last known works were completed in 1862, three years before his death.

Above, **Portrait of Mrs. Russell Dorr,**
c. 1814 (oil on canvas, 38″ x 29⅞″).
Left, **Portrait of a Woman in a Green Dress,**
c. 1830 (oil on canvas, 32″ x 27½″).

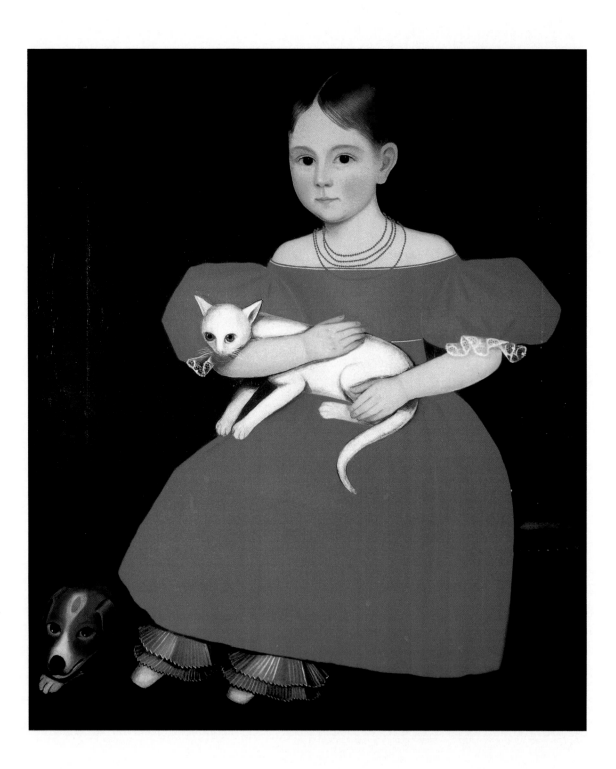

Girl in Red with Her Cat and Dog, c. 1834-1836 (oil on canvas, 31½″ x 27½″). Ammi Phillips's best-known
work, this painting shows the crisp composition that characterized his mature style.

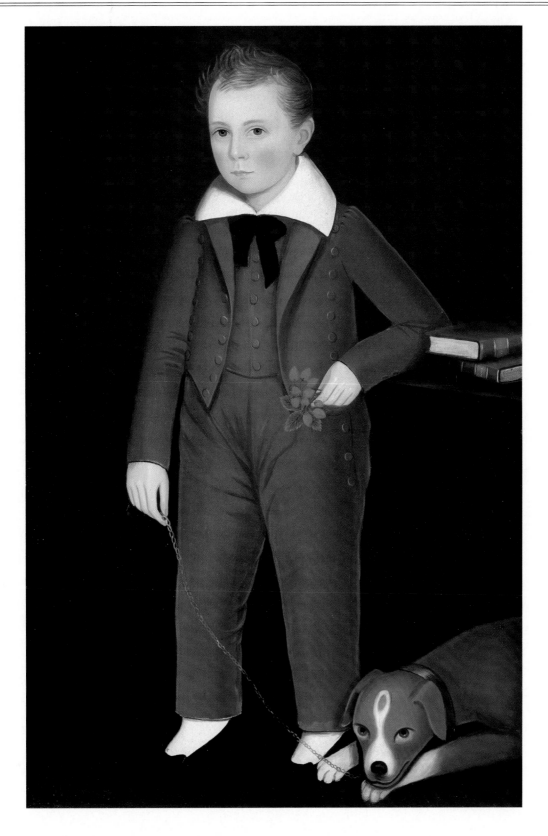

John Yonnie Luyster, 1838 (oil on canvas, 46½″ x 30½″). As is typical of Phillips's portraits of children done in the 1830s, this work includes a small brown dog with a white muzzle.

Rufus Porter

The Flagg Family of Massachusetts, c. 1830-1835 (watercolor and ink on paper, 4½″ x 3⅛″). In the early 1800s, Rufus Porter advertised side views like these for two dollars each.

Born in Massachusetts in 1792, Rufus Porter spent his youth in Maine, married twice and fathered sixteen children, and died in Connecticut in 1884. In his ninety-two years, Porter lived a multifaceted life. As a young man, he was a fiddler, a shoemaker's apprentice, and a teacher. He also built gristmills, ran a dancing school, and crewed on a ship.

In 1810, Porter learned to paint houses and signs, and by 1815, he had taken to the road as an itinerant painter. He is known today for the vibrant murals, like those opposite, that he painted on the walls of New England dwellings and inns, as well as for the small portraits, like those above, and silhouettes that he created of the residents of towns from Maine to Virginia.

Porter found many ways to speed his production. He was the first artist, for instance, known to use decorative techniques such as sponge-painting in landscapes. He also built a camera obscura, with which he could cut silhouettes in minutes. When Porter tired of painting, he moved to New York City, where in 1845 he founded *Scientific American* magazine.

Opposite top, Landscape (72″ x 96″). Opposite bottom, Steamship Victory (75″ x 96″). Porter painted these 1838 murals on plaster for a house in Westwood, Massachusetts.

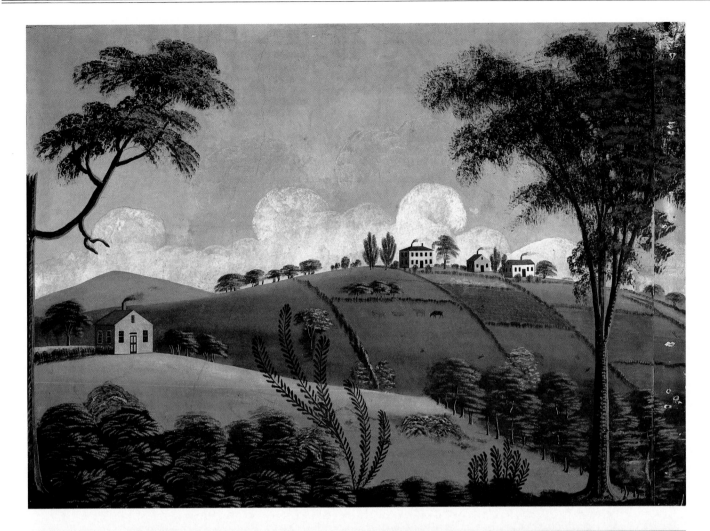

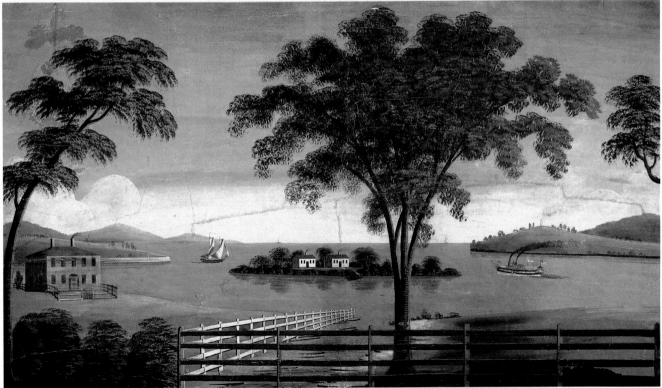

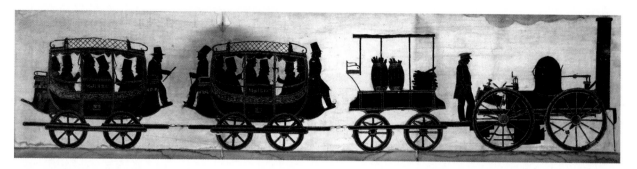

William Henry Brown's 1831 cut-and-paste silhouette of the *DeWitt Clinton*

A hollow-cut portrait by William Bache of Elizabeth Ropes Hodges, detailed with paint

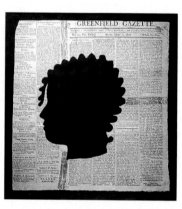

An 1808 hollow-cut silhouette of Hannah Fellows, made from a piece of newspaper

A 19th-century cut-and-paste silhouette of Daniel "Monitor" Andrews

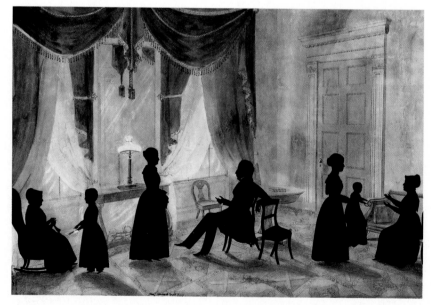

An 1842 group silhouette by Auguste Edouart with an elegant drawing room painted in as background

SHADES OF OUR ANCESTORS

Among the itinerant artists who knocked on the doors of rural households were silhouette makers. The solid-color profiles they produced with paint or scissors first appeared in this country in the late 1700s, and remained popular until the middle of the next century. During most of this period, silhouettes were known as shades, profiles, or shadow portraits, and the artists who made them were called shade cutters. (Since many of these itinerants often plied their trade at carnivals and apparently earned unsavory reputations, this term yielded the expression "shady character.")

The name "silhouette," which also had uncomplimentary undertones, came from Etienne de Silhouette, who, as an 18th-century finance minister to Louis XV, lobbied for a reduction of the pensions granted to the nobility. The nobility, in turn, responded by using the name of this infamous penny pincher as a pejorative, and the phrase *à la silhouette* became synonymous with anything cheap. The term caught on in America when the well-known French shade cutter Auguste Edouart arrived in the United States in 1839.

Indeed inexpensive, silhouettes, which sold for as little as two for twenty-five cents in America, were the most affordable form of portraiture available here; the low price allowed almost anyone not only to commission a portrait, but also to have multiple images made.

The two most common types involved cutting. In the "cut-and-paste" technique, images were cut from black paper (or sometimes black silk) and pasted onto a white

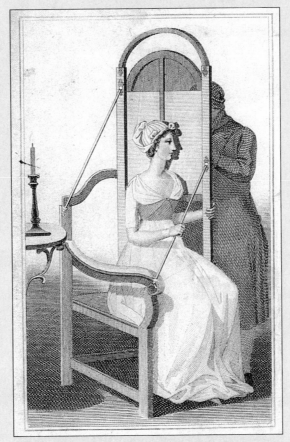

The portable silhouette chair, devised around 1800 by the Swiss inventor Johann Kaspar Lavater

card, perhaps in a group composition; background details might then be painted in. In the "hollow-cut" method, an image was cut from paper and discarded; the paper from which it was cut was then mounted over a dark background of silk, satin, velvet, or paper. Some rare hollow-cuts, such as those by the noted maker William Bache, were taken a step further; after cutting a portrait, Bache would add details, such as the lace on a bonnet, in ink or watercolor. Bache and other artists also specialized in a third kind of silhouette, in which a dark-colored profile was worked in paint on a plain background; no cutting was involved.

Many silhouette cutters worked using only hand, eye, and scissors (or foot, eye, and scissors in the case of armless "performers," who exhibited paper cutting and other talents at country fairs and town halls). One famous freehand hollow-cut artist was William Henry Brown. When the artist arrived in a town, he would ask someone to point out the mayor and other important locals. He would then cut their profiles from memory, using the works as advertising to attract clients. Brown also earned fame for impressive works such as his six-foot-nine silhouette of the *DeWitt Clinton,* an early railroad train.

Other artists might employ the portable silhouette chair, on which the subject was seated next to a glass plate. A candle placed near the sitter cast a shadow of his or her profile, which the artist would trace through the glass plate onto a sheet of tissue paper. The resulting life-size image was then reduced to scale using a special draftsmen's instrument known as a pantograph.

Sheldon Peck

Anna Gould Crane and Granddaughter Jennette, c. 1845 (oil on canvas, 35½″ x 45½″). Peck is said to have received a cow in payment for this painting. The canvas was cut from a linen sheet that belonged to the Crane household.

The opening of the Erie Canal in 1825 hastened settlement of the frontier, and by the 1830s, many New Englanders had established farms west of the Appalachian Mountains. Among them was Sheldon Peck, an abolitionist and the father of twelve, who, along with being a successful farmer, painted the likenesses of many of his fellow small-town settlers.

Peck was born in Cornwall, Vermont, in 1797 and started painting when he was about twenty-three. Married in 1824, Peck and his wife moved from Vermont to New York State, where they had a farm. Throughout the 1820s, the artist invariably produced somber, straightforward portraits that depicted sitters from the waist up. But these likenesses were nevertheless distinctive, featuring almost waxen faces with penetrating stares, as well as elaborate details of clothing and coiffure. During this period, Peck began to add props—a detailed sitter's chair, or a table topped by a Bible—to his works.

It was not until the 1840s, however, when

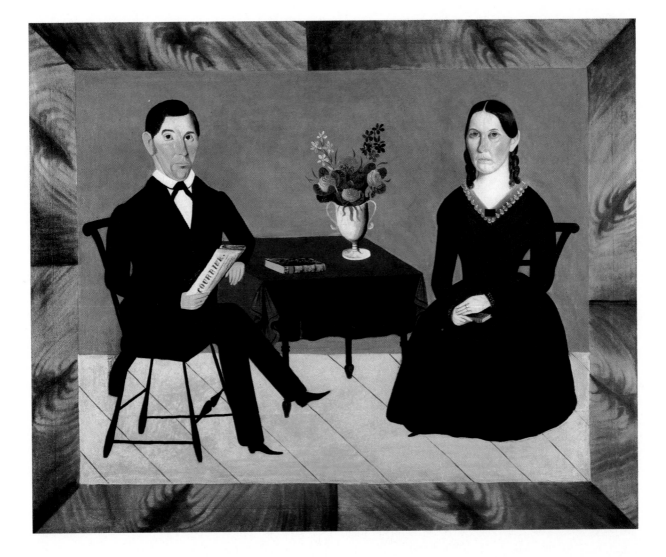

the artist and his wife were well settled in what is now Lombard, Illinois, that he began to paint full-length group portraits in room settings like those shown here. This change of style was prompted by the increasing popularity of daguerreotypes, which were introduced in America in 1839. The early photography made for quick and inexpensive portraiture, and gave many painters stiff competition. Attempting to compete with the realistic perspective of this new art, Peck added diagonal lines on floors to create the illusion of three-dimensional space. But because he usually neglected to paint in shadows, the furniture appears to hover over the floorboards. Peck also made his pictures large and brightly colored, which photographers could not do, and added trompe l'oeil frames around the edges of his canvases. Despite these innovations, the daguerreotype eventually took over Peck's trade; in the 1850s, he opened a shop, and specialized in decorative painting until his death in 1868.

David Crane and Catharine Stolp Crane, c. 1845 (oil on canvas, 35¾" x 43¾"). Tables topped with books and vases of flowers were favorite props for family portraits like this, which Peck painted throughout Illinois in the 1840s.

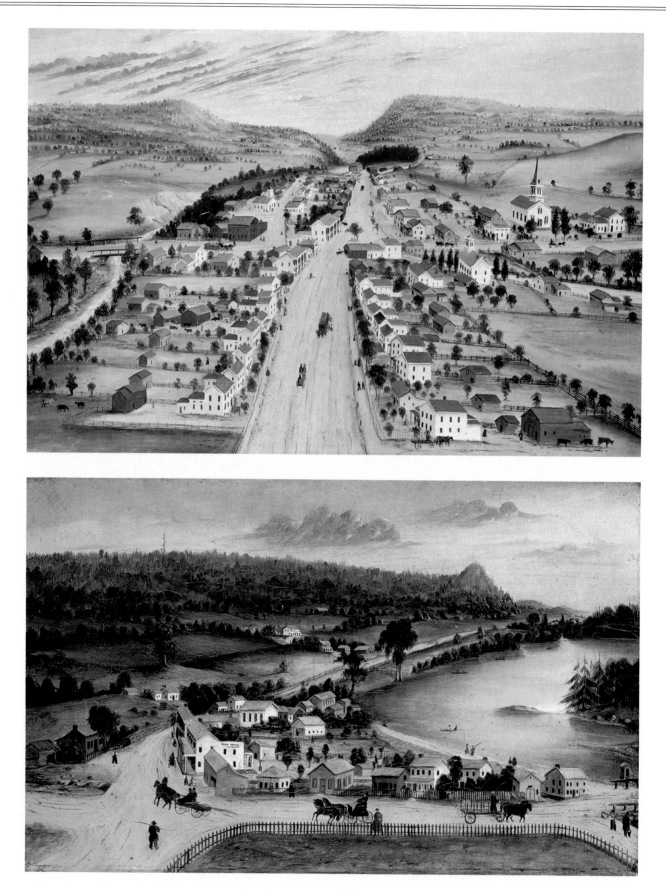

Joseph Hidley

Unlike the itinerants who traveled widely, Joseph Hidley is largely identified with a few small towns in upstate New York, the subjects for his well-known townscape paintings. In 1850, at the age of twenty, Hidley settled in Poestenkill, New York, where he lived until his death from tuberculosis in 1872. He married in 1853, and worked as a professional house painter specializing in decorative work for interiors, but his financial circumstances remained meager at best.

Between commissions, Hidley practiced taxidermy, made shadow boxes, and painted signs, fireboards, and pictures. While his paintings ranged from portraits to copies of European prints, the best were meticulously detailed views of Poestenkill and its surrounding villages. These distinctive works were done from imaginary vantage points that allowed comprehensive views of streets and fields, with buildings angled slightly to display both their fronts and sides. Showing various seasons, and complete with vignettes of residents going about their business, the landscapes are personalized looks at the places Hidley knew well, and thus form a vital record of small-town life.

Poestenkill, New York: Winter, 1868 (oil on wood, 18¾" x 25⅜"). This is the same scene as that opposite top, but in close-up view and transformed by snow. Hidley and his family lived in the yellow house to the left of the steepled Lutheran church.

*Opposite top, **Poestenkill, New York: Summer**, c. 1865-1872 (oil on wood panel, 20" x 29¾").*

*Opposite bottom, **Glass Lake**, c. 1860-1865 (oil on canvas, 13⅜" x 21⅛").*

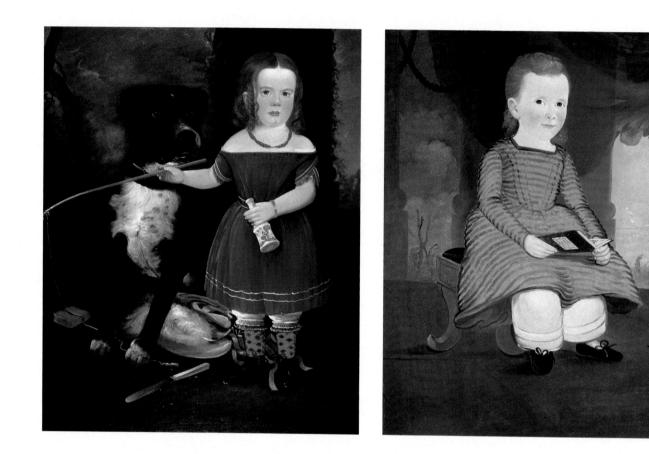

Above left, **Little Child with Big Dog,** *1848 (oil on canvas, 35⅛″ x 29″). Dresses were worn by both girls and boys, but the blue color of the garment suggests that this is a boy. Above right,* **Little Girl from Maine,** *1846 (oil on canvas, 29″ x 25¾″). This canvas was signed and dated by Prior on the back, and its value listed as twenty dollars.*

During his fifty-year painting career from 1823 to 1873, William Matthew Prior exhibited tremendous versatility as an artist. Best known for his small, quickly executed portraits, he was also capable of highly developed works in a more accomplished academic style.

Born in Bath, Maine, in 1806, Prior may have received some initial training in the shop of the painter Charles Codman of Portland, Maine. But by the age of eighteen, Prior had begun traveling between Bath and Portland in search of his own commissions. A self-portrait dated 1825 indicates that he was already a proficient painter; yet Prior's first newspaper advertisements, which appeared in 1827, mention only his skills as

an ornamental painter. Not until 1828 did the artist advertise himself as a portraitist: "Those who wish for a likeness at a reasonable price are invited to call soon," Prior declared in the *Maine Inquirer,* adding, "Side views and profiles of children at reduced prices." Prior proposed a sliding price scale based on his clients' ability to pay—a practice that was characteristic of him throughout his career.

In 1828, Prior married Rosamond Hamblin, who came from a family of painters, and during the rest of his life he worked closely with his brothers-in-law, particularly Sturdevant Hamblin. Their works are often so similar that many paintings are simply attributed to the "Prior-

William Matthew Prior

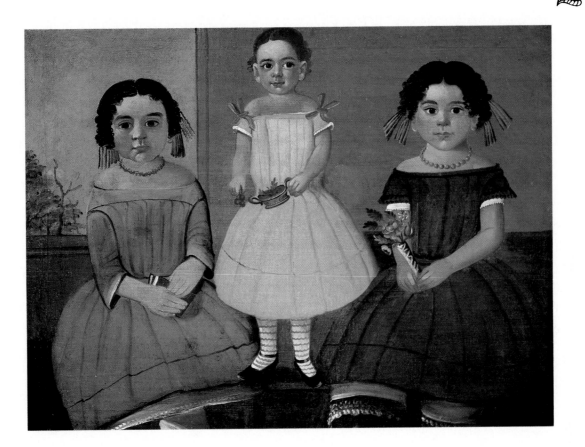

Hamblin school." The Hamblin brothers-in-law accompanied the Priors when the couple moved from Maine to Boston around 1840. Although he traveled occasionally as far south as Baltimore for commissions, Prior spent most of his remaining career in Boston, where he had a studio that he called the Painting Garret.

Prior's best portraits—which were sometimes posed in front of a backdrop or showed children full-length with their pets and toys—sold for between ten and twenty-five dollars. But like other artists of the period who had to compete with the availability of inexpensive daguerreotypes, Prior also offered flat, quick likenesses. "Portraits painted in this style! Done in about an hour's sitting. Price $2.92 including Frame, Glass & c.," reads the label on the back of one of these simplified portraits executed without shading.

As the popularity of photography continued to increase in the 1850s, Prior turned to painting romantic landscape scenes. And by the 1860s, he again offered the public something new: reverse paintings on glass of public figures such as George and Martha Washington and Abraham Lincoln, which he sold for three or four dollars. A businesslike artist until the end of his life, Prior banked his success on his ability to give the public what they wanted at a price they could afford.

Three Sisters of the Coplan Family, 1854 (oil on canvas, 26³/₄" x 36¹/₄"). Prior, who had strong abolitionist leanings, is one of the few 19th-century artists to have painted a large number of portraits of black children and adults.

James and John Bard

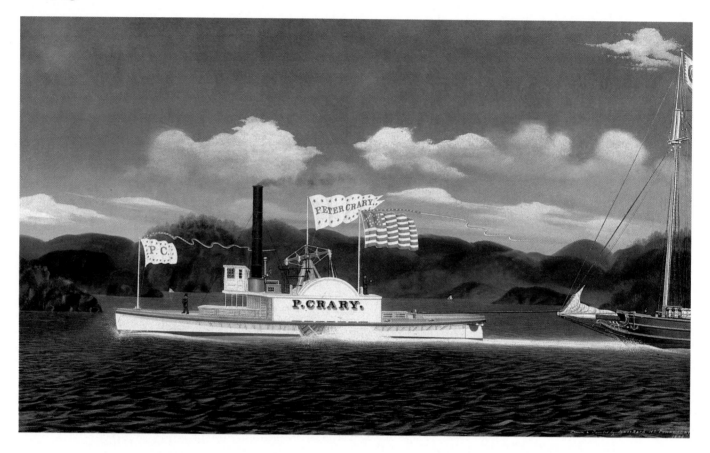

The Hudson River Towboat
P. Crary, *James Bard, 1858*
(oil on canvas, 29" x 50").
Depicted in its original role
as a towboat, the P. Crary
was later used to transfer
immigrants from Ellis Island
to Manhattan. This painting
is sometimes called "a Bard
and a half" since it is one
of few to show more than
one large boat.

In the 19th century, New York City was not only an important port for Hudson River and transatlantic vessels, but it was also a major shipbuilding center. James and John Bard, twins born in Manhattan in 1815, became entranced with boats early in their lives, and the ships of New York Harbor and the Hudson River were the subjects of hundreds—perhaps thousands—of their drawings and paintings.

Wholly self-taught, the brothers collaborated in their work for many years. When John died in 1856, James continued on his own to draw and paint both steam and sailing vessels until his death in 1897, and most of the Bard paintings known today are by him. Some of the early paintings are signed "J. and J. Bard," but when

James Bard worked alone he often added his address on Perry Street in lower Manhattan, as well as his name, as a means of advertisement. Most of his paintings would, after all, be sold to captains or proprietors of vessels, and be seen by other shipowners.

Bard paintings are, essentially, portraits of ships: no docks or secondary large boats ever block the view of the vessel or its name. Although a few of the Bard brothers' early paintings display vessels from the right, all of James Bard's boats are shown from the left, and most appear to be moving at full tilt. Since James had trouble painting perspective, he always depicted his boats broadside rather than at difficult angles. His paintings are also distinguished by the

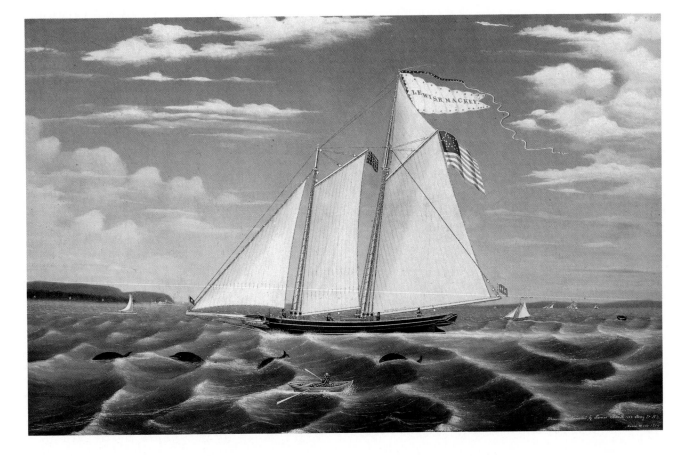

particularly frothy water at the prow of the vessel and in its wake.

All the Bard pictures began with meticulous drawings. James Bard, especially, is known to have measured each detail of a vessel—from the railings and windows to the hull itself. He also took careful notes on the color of the boat before making a scale drawing, doing the actual coloring in his studio from these notations. It has been said that a shipbuilder could conceivably construct a vessel from a Bard drawing since the measurements were so exact. Once a drawing was finished, James would show it to the shipowner for his comments and approval. If he received a commission for the painting, the drawing would then be copied in oils on can-

vas. Many other Bard drawings were simply colored in with watercolor or crayon.

While James Bard was relatively skilled in his ability to paint the sky and sea, many of the peripheral details in his works are quite primitive. Shorelines and houses were typically added in an almost perfunctory manner. The throngs of people who might normally be gathered on the deck of a riverboat were never included in these paintings; those who do appear usually look out of place on a ship, formally dressed as if for a funeral with high silk hats and long black coats. However, true to form, the tiny sailboats and tugboats that dart about in the background of Bard paintings are always perfectly rendered in every detail.

The Schooner Lewis R. Mackey, *James Bard, 1854 (oil on canvas, 33½" x 52"). Schooners commonly hauled cargo up and down the Hudson during the 19th century: this one transported bricks for the Brewster Brickyards in Haverstraw, New York. The school of dolphins and the rowboat are unusual additions.*

Emma Cady

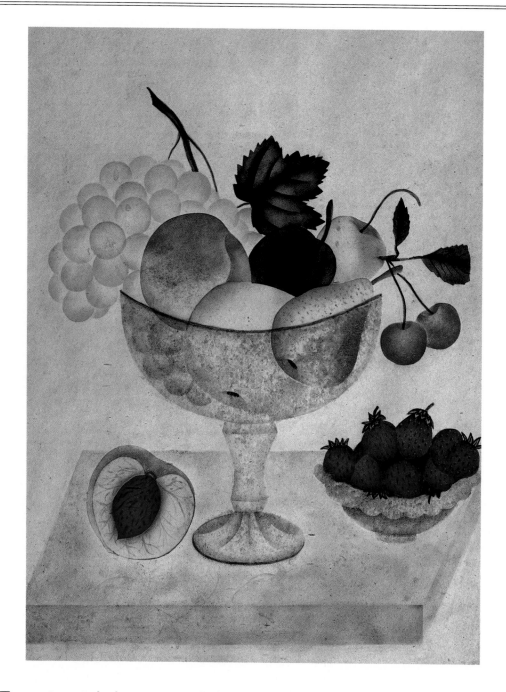

Still Life with Bowl of Fruit, Bowl of Strawberries, and Peach Half, *c. 1890 (watercolor and mica flakes on paper, 14" x 10"). Cady's unusual use of mica on the compote and bowl enhances the illusion that her stenciled fruits are actually sitting inside the dishes.*

Emma Jane Cady, born in East Chatham, New York, in 1854, is one of few female folk artists remembered by name. Little is known of her life; she lived in East Chatham until her parents' death, never married, and after 1911 moved to Michigan, where she died in 1933.

Cady is known for her ethereally beautiful theorem paintings. She probably learned the theorem technique, which involved the use of stencils, in school, but continued to practice the art later in life; much of her work dates to the 1890s.

Cady's still-life compositions are particularly skillful, marked by an inventive use of mica flakes to simulate the shiny surface of glass dishes, and by crisply outlined, realistically shaded fruits. Indeed, the artist's sense of color and her ability to suggest perspective place her among the most highly regarded of folk painters.

WOMEN FOLK ARTISTS

Although women have shared a place in the American folk-art tradition, their numbers are far fewer than those of men. Since becoming an artist was largely a matter of making a living rather than an artistic calling, painting remained mostly a man's domain throughout the 1800s. There were, however, some notable exceptions.

One of America's first professional artists, Henrietta Johnston, for example, began working as a portraitist to ease her financial troubles. Johnston, who died in 1729 in Charleston, South Carolina, was married to a Charleston minister, and made pastel portraits of the planters and merchants in and around that southern city. After her husband's death, she was able to continue, supporting her family with her portrait work.

In most instances, however, the demands of raising children and running a household curtailed the artistic careers of women. Sarah Perkins, born in Connecticut in 1771, was the daughter of a successful doctor and worked at her painting while living at her parents' home. Known for her pastel portraits, it is believed that Perkins may also have been responsible for sixteen unsigned oil portraits—generally referred to as the work of the "Beardsley Limner"—that are considered among the most important in Connecticut history. Yet, however promising her talent, Perkins appears to have stopped painting by about 1795, when she assumed care of her youngest siblings and, soon after, began raising children of her own.

By late in the 18th century, female seminaries, or private schools, had opened in towns along the East Coast. In addition to academic subjects, the girls were taught needlework and theorem painting. While many of the young women limited their painting to their student years, some of them continued afterward. The Connecticut watercolorist Eunice Pinney is noted for the paintings she did in her middle age. And in the 1830s, Deborah Goldsmith followed up her schooling with a career as an itinerant portrait artist in New York State. But like others before her, Goldsmith's career ended with marriage—just as she was getting started, at the age of twenty-four.

Erastus Salisbury Field

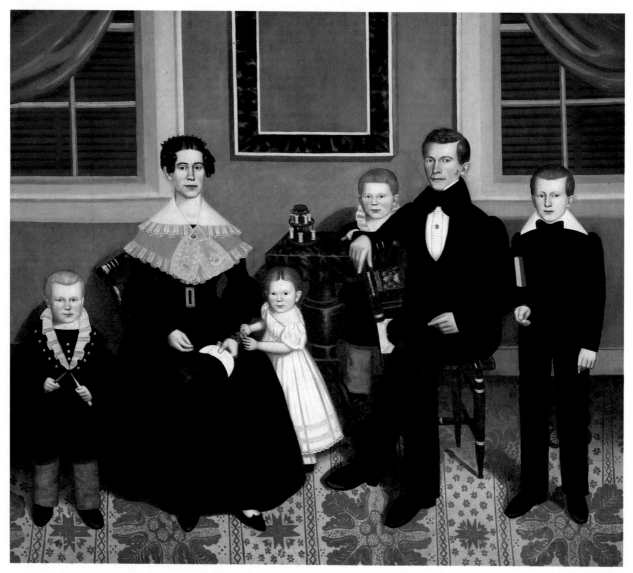

Joseph B. Moore and Family, *1839 (oil on canvas, 82¾″ x 93¼″). Field caught the dignity of a middle-class family in this nearly life-size portrait.*

Erastus Salisbury Field, who lived from 1805 to 1900, started painting years before photography was introduced in this country, continued long after the camera had diminished the demand for oil portraits, and left behind one of the most fascinating bodies of work of any 19th-century American artist.

Field's youthful pastime of sketching his family's activities was encouraged by his parents while he was growing up in the village of Leverett, Massachusetts. By the time he reached his late teens, his desire to become a painter was strong enough that he made the momentous decision to leave Leverett, in the fall of 1824, and

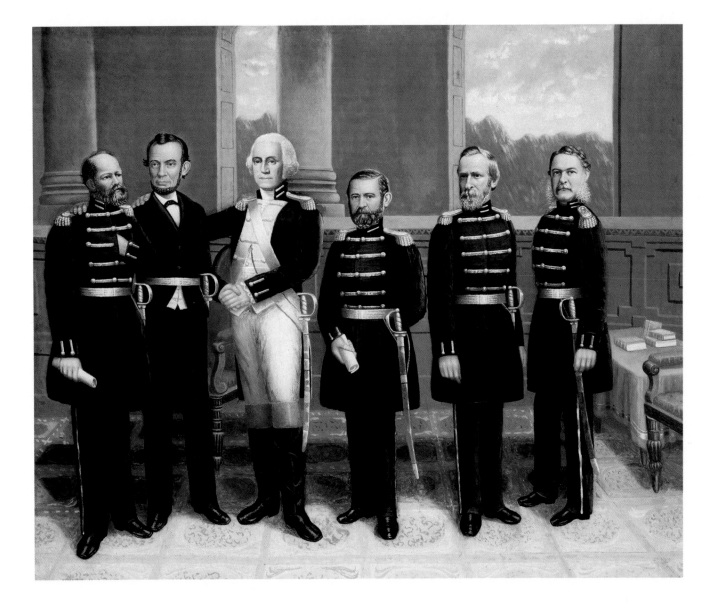

study with Samuel F. B. Morse in New York City. Although Morse would later become better known for inventing the telegraph, he began his career as a painter and, in the mid-1820s, enjoyed some success as both an artist and an art teacher. When Morse's wife died in 1825, he decided to give up teaching, and, subsequently,

Field returned home, his apprenticeship over.

By the following year, Field had begun painting on his own, and, for the next fifteen years, would know the life of an itinerant as he traveled through Massachusetts and Connecticut in search of portrait commissions. Field's portraits, for the most part, are handsome likenesses set

Continued

Lincoln with Washington and his Generals, *1881 (oil on canvas, 32″ x 39½″). This Field painting links various American presidents and military heroes.*

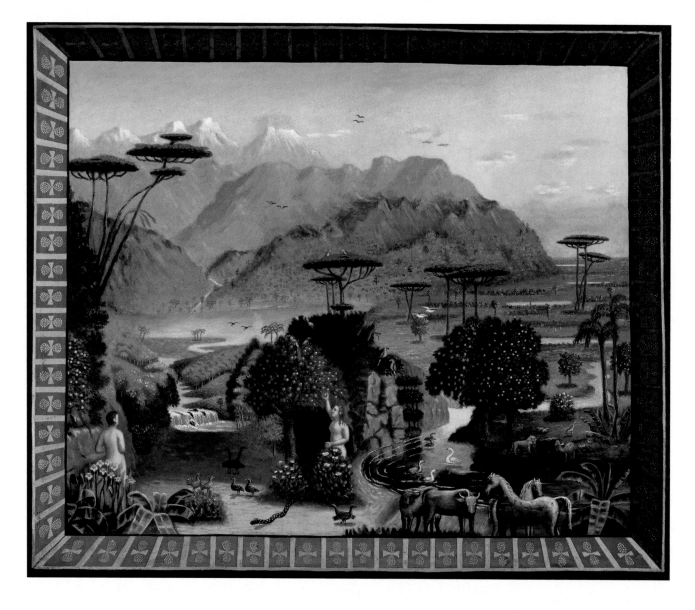

The Garden of Eden, c. 1860 *(oil on canvas, 25" x 41½"). From 1860 on, Field painted mainly religious and historical subjects, and this painting was one of the earliest. Imagery from several English prints inspired the composition.*

against backgrounds that show off the sitters' detailed clothing, lace collars, and elaborate hair styles. The faces are full of character, delicately shaded, and sometimes even exhibit the glimmer of a smile—an expression that is rare in folk portraiture. Children, whom the artist often painted full-length, are typically posed with their toys, and most subjects are depicted standing on boldly patterned rugs or floor cloths.

Field's portraits and other paintings sold for between two and five dollars, and during the early years of his career, the artist was able to earn enough to support his wife Phebe, whom he

married in 1831, and their daughter Henrietta.

Between 1841 and 1848, he was back in New York, experimenting with literary subjects such as *The Embarkation of Ulysses,* a scene that he copied from an English engraving. He also learned photography while living there. In fact, America's fascination with the daguerreotype —which, curiously, was also introduced into this country in 1839 by Samuel Morse—would change the nature of Field's career in painting. When the artist returned to Massachusetts in 1848, and throughout the 1850s, he used photographs as the basis for his portraits. To cut

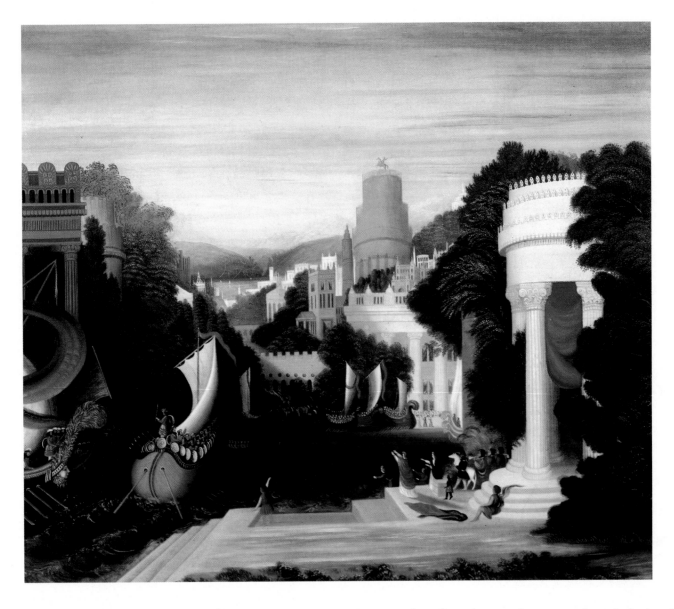

down on the time required for poses, Field simply photographed his subjects and then enlarged the images, reproducing them in colored oils on canvas. Although they were carefully done, the resulting portraits lacked the depth of character seen in earlier likenesses painted by the artist.

In 1859, Field's wife Phebe died and he returned to live in the village of Plumtrees, near Sunderland, Massachusetts, where he had spent happy years as a young man. He purchased some land there and built a studio, which he filled with his paintings. By the 1860s, Field's work had shifted from portraiture to wondrous land-scape scenes that were based on historical or biblical themes. In his studio, he would entertain neighborhood children with descriptions of these fantastic works of art. Among the earliest paintings of this period were the two exotic versions he did of *The Garden of Eden.*

Even as he became gently eccentric in his eighties, Field remained active as a painter, continuing to produce works that had grandiose themes. And although he never traveled farther than New York City, in 1885 the artist completed an imaginative eighty-foot-long panorama of a trip around the world.

The Embarkation of Ulysses, c. 1844-1848 (oil on canvas, 33″ x 38¾″). This painting, which shows the mythological hero Ulysses with his armada in a city of ancient Greece, typifies Field's early exploration of literary subjects.

Art of
the Professional

the remarkable work of carvers,

smiths, painters, potters,

and scriveners

The folk art in this chapter is by professional artisans who worked primarily in the 1800s. These men turned out products as varied as ship carvings, carousel and shop figures, trade signs, weather vanes, painted fire buckets, decorated pottery, decoys, and even illuminated manuscripts. While some were self-taught and others were trained through apprenticeship, all depended on skilled hands to earn a living, and their work represents an age of craftsmanship that was largely eclipsed by the Industrial Revolution.

None of the pieces included here was conceived solely as "art" when it was made, but instead fulfilled a specific purpose: a weather vane indicated wind direction, a trade sign advertised a merchant's wares, a stoneware crock stored food. As folk art, however, these pieces are elevated above mere function because they express the talent and spirit of their makers, who—in the course of a day's work—produced something extraordinary.

A detail of a Pennsylvania-German fraktur, or illuminated text (page 90), displays
the artistry of the professional scrivener.

Ship Carvings

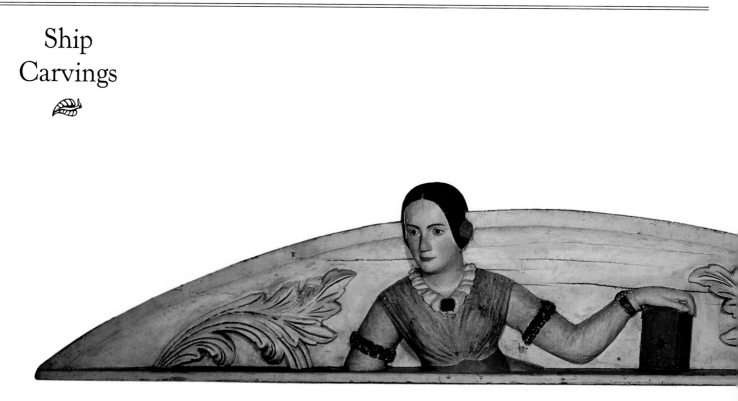

The polychrome pine sternboard above, made in 1845 in Newport, Rhode Island, was commissioned for the schooner Eunice H. Adams. While the ship was named after the wife of a Nantucket shipowner, the portrait on the sternboard was actually modeled after her sister.

From the 1600s until the steamship began to eclipse the sailing ship in the mid-1800s, ship carvers' workshops thrived in ports along the Atlantic seaboard. Here, under a system of apprenticeship, skilled craftsmen produced the splendid ornaments that once graced America's whaling, naval, and merchant vessels. Intended to symbolize the name of a ship or her guardian spirit, and to serve as good luck talismans, these remarkable carvings were an early and significant part of the American folk sculpture tradition.

The most common type of ship carving was the figurehead, which was accorded a prominent place under a ship's bowsprit. Based on English prototypes, the early American figureheads were generally human busts, or "lyons" and other "beasts." The full-length figurehead, an indigenous American form, did not emerge until after the Revolution; it reached its full flowering in the 1840s as it became—with hair and drapery "flowing" in the wind—a natural extension of the sleek clipper ship's curving prow.

While male figures appeared, women were the preferred subject for human figureheads. Portrayals of Lady Liberty were common, as were renderings of Indian princesses. Often a carving was a portrait of a shipowner's wife or daughter, who might pose live for the craftsman. Chiseled from soft white pine, the figures were made in pieces. It is thought that the arms may have been removed to prevent damage in rough seas and put back before the ship entered its next harbor.

Just as figureheads piloted their vessels to safe port, sternboards brought up the rear of the ship. These broad, carved plaques might feature an eagle, an allegorical figure, or a portrait, and be enhanced with scrolls, acanthus leaves, or molding. Painted and gilded, they could be as elaborate as the figureheads.

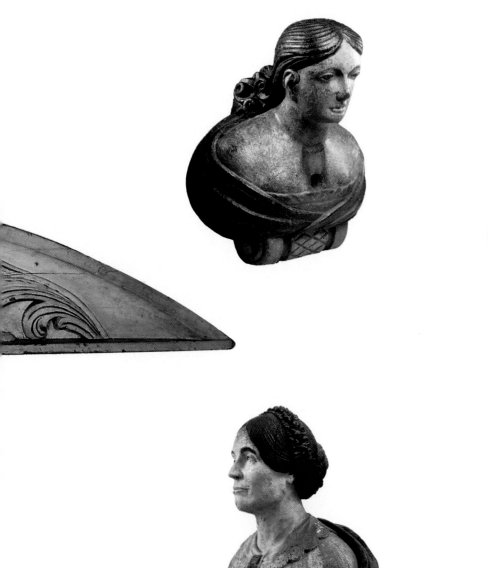

Many figureheads, like the 19th-century bust and the half-length carving above left, were painted in lifelike colors. Figures designed for sleek, white clipper ships, however, were often finished in white and detailed with gilt, as was the full-length lady above right, made around 1850 in Maine.

Shop figures were roughed out from solid pieces of pine—frequently cut from spars bought in shipyards—then refined by chisel. These late-19th-century tobacconists' figures include a Victorian lady, near right, who advertises Squirrel brand cigars, a military figure from the New York City shop of Samuel A. Robb, center, and a nattily dressed dandy, far right, based on a minstrel show character.

Wooden Shop Figures

An enterprising 19th-century merchant who could afford the purchase price—which could run up to several hundred dollars—might invest in a shop figure to promote his wares. While some shop figures were countertop models, the most convincing of these silent hawkers stood just outside the door, and were often mounted on wheels so that they could be rolled in and out. Such full-length figures date to the 1700s, but had their heyday in the mid- to late 1800s; they began to disappear after the turn of the century as electrified signs made them increasingly obsolete.

The products of woodworking shops, these large sculptures were often made by ship carvers who turned their hand to other types of carving as their own trade declined. Different figures signaled different wares—a jaunty sailor was likely to stand in front of a ship's chandlery, for example, while a Chinaman might appear by the door of a tea emporium.

The most common type of shop figure, however, identified the tobacconist's. These figures, initially inspired by the American Indian—who had introduced the exotic weed to European explorers—originated in 17th-century England. In America, however, Indian figures were not made in quantity until the mid-1800s. They generally depicted stereotypical chiefs and squaws—with plumed headdresses, tomahawks, or bows and arrows—but as the use of the Indian figure became widespread, carvers turned to more novel subjects, like the clown character Punch or Uncle Sam, appropriately shown with a bundle of cigars, a snuffbox, or a pipe.

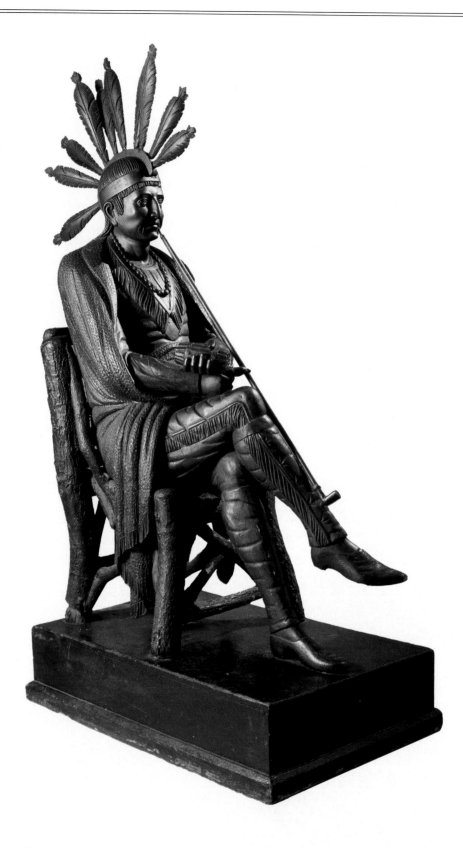

The tobacconist's Indian above, attributed to the French-Canadian-born carver Louis Jobin,

exhibits a rare sense of power; that the Indian is seated is also unusual.

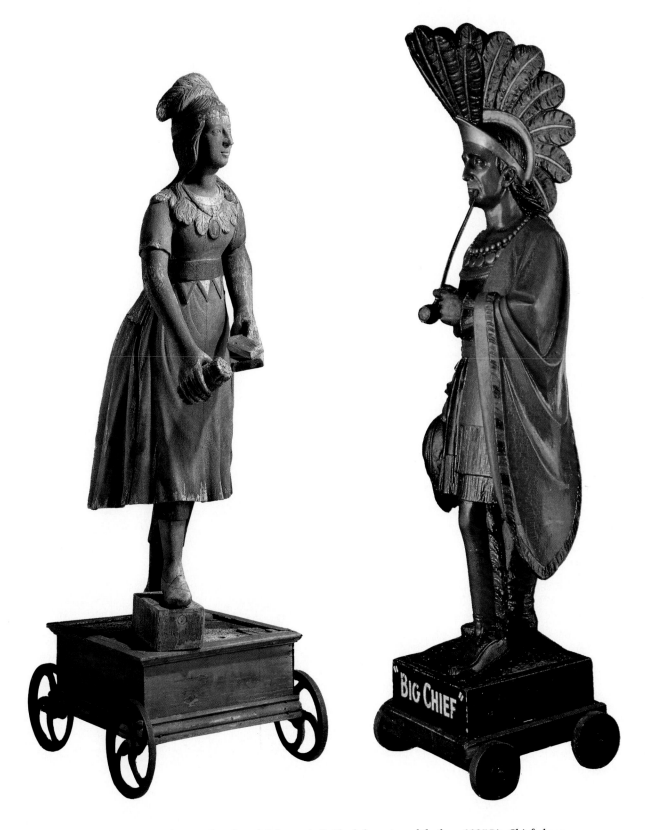

The c. 1860 Indian maiden above left has an individual character, while the c. 1885 Big Chief above right, by Louis Jobin, shows a stereotypical design common to later Indian figures.

KEEPING SHOP

The trade signs and shop figures that merchants customarily placed outside their stores enticed customers to spend their money on an' ever-increasing range of goods during the 1800s. When the century opened, the American mercantile system was a specialized one. Since there was no wholesaling, merchants both in cities and in small towns generally made their own wares, and thus concentrated on a single product. The hatmaker crafted and sold hats, for example, while the apothecary purveyed the drugs and remedies he mixed. One exception to the specialized shop, however, was the rural trading post, where farmers bartered their excess produce for necessities ranging from bullets to molasses.

By the mid-1800s, the development of factories and mills, as well as improved transportation systems, enabled manufacturers to distribute products on a national scale. City shops became retail outlets for manufactured goods, and the trading post developed into the bustling emporium known as the country store, which now stocked food delicacies, toilet soap, Paris ribbon, and Brussels lace, as well as more ordinary basics. The keeper of the country store often served as banker and postmaster, and his place of business also might double as a meeting lodge and social club, where townsfolk could gather to discuss politics or play checkers at the ubiquitous cracker barrel.

Cabinetmaker Duncan Phyfe's shop and home, New York City, 1820

An apothecary shop in Salem, Massachusetts, c. 1850

Leonard Bond's New York City hat store, c. 1828

Trade Symbols

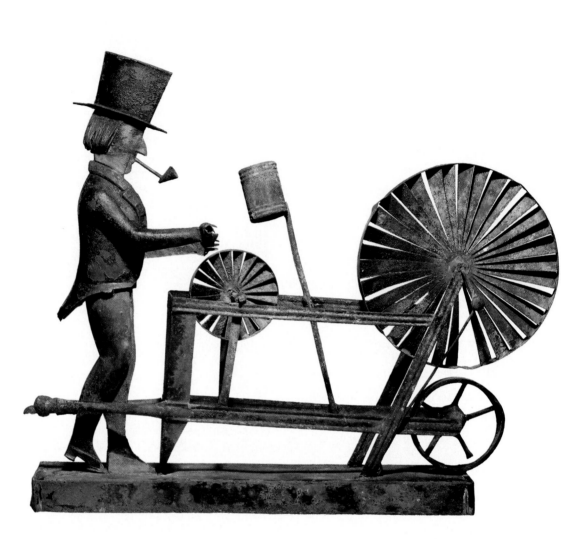

Made in the early 1800s, the painted tin trade symbol at right depicts a tinsmith working at a grinding wheel, and was probably crafted by a tinker for his own use. Realistic details include the figure's clothing, as well as a small can that would have held the water a smith used for grinding.

Shop figures were not the only form of advertising that was used in early America: no sooner did businesses become established in this country than did trade symbols begin to appear over doorways and windows. These large, three-dimensional sculptures, the outgrowth of a European tradition believed to have originated with the ancient Romans, were initially intended to catch the attention of a predominantly illiterate public by offering visual, rather than verbal, messages. Bold and self-explanatory, an oversize cutler's knife or a giant locksmith's key could be "read" instantly by any potential customer—even one passing by quickly on horseback or in a carriage.

Most trade symbols were commissioned by business owners from handcraftsmen. Those carved from wood were generally made by the same workshops that produced ship carvings and shop figures. Metal trade symbols were produced by smiths working in tin, iron, and copper, and beginning in the mid-19th century, metal trade symbols were manufactured in factories that specialized in ornamental cast iron and zinc. Tradesmen wanting to advertise their particular talents also crafted signs for themselves; it was only natural, for instance, for a farrier to hammer out an enormous horseshoe that he could hang outside his own forge.

Their exaggerated forms and the simple logic

Continued

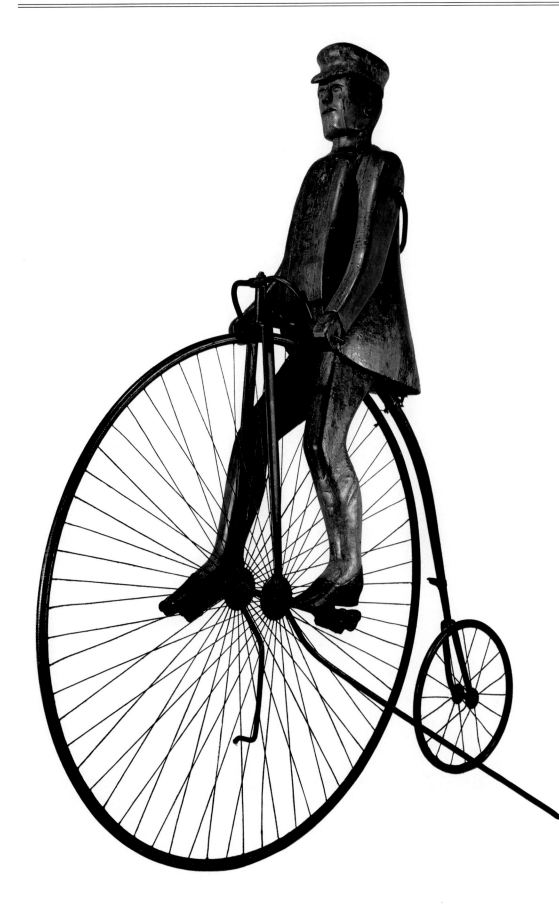

Amidée Thibault, a native of Quebec who learned wood-carving by helping his uncle make church pews, crafted the trade symbol at left around 1895; it hung over the bicycle and carriage repair shop he owned in St. Albans, Vermont. The pieces of the wooden figure were laminated to provide extra strength against the winds blowing off Lake Champlain; the bicycle is an actual Columbia high-wheeler.

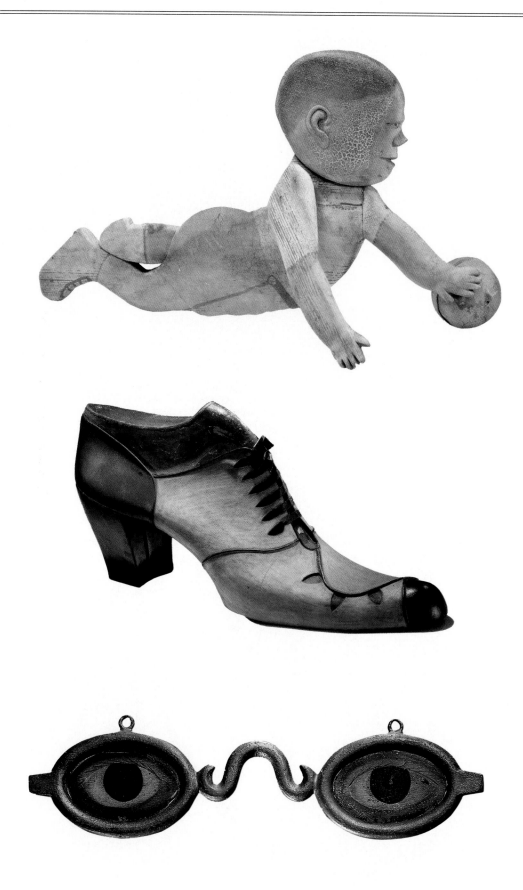

Originally intended to help the illiterate, trade symbols continued to be common long after reading became widespread in the 1800s. A mid-20th-century piece, the wooden baby sign, top, is from a Millbrook, New York, orphanage. The leather-and-wood shoe, middle, was made around 1940 by the employees of the Foot Culture Orthopedic Shoe Store in New York City. And the zinc eyeglasses, bottom, date from the turn of the century.

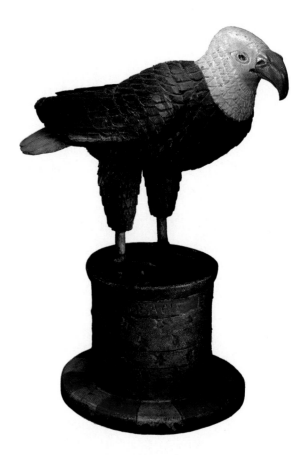

of their straightforward symbolism endow these overblown sculptures with a peculiar appeal. The references were intentionally obvious: scissors indicated the services of a tailor, a pocket watch a jeweler, a shoe a shoemaker, a gun a gunsmith. An oversize tooth was the chilling, yet immediately recognizable sign of a dentist, while a mortar and pestle identified an apothecary. Sometimes the design came from a long-established symbol, like the striped barber's pole. New forms might also develop with the arrival of an industry; the image of the sheep, for example, became a standard symbol for the numerous woolen textile mills that began operation in 19th-century New England.

While many trade symbols were simple sculptural forms, some were quite elaborate, featuring a variety of mechanical contrivances and moving parts. A tin teapot displayed above the doorway

of a teashop, for example, might be plumbed with steam pipes so that puffs of steam would waft from its spout in cold weather. In an equally novel approach, the bespectacled eyes that frequently appeared over opticians' shops were often illuminated with gas lamps in the late 1800s, and then later, as technology developed, with electric lights.

As the form of a trade symbol was generally sufficient to convey information, lettering was seldom added. At the most, a sign might include the name of the proprietor. But while this could be advantageous for a business owner in a busy city—where there might be more than one hatter or one butcher in the same neighborhood—it was hardly necessary in a rural community. In small towns, competition among shopkeepers seldom existed, and proprietors were generally already known by name.

In addition to advertising retail wares, trade symbols might publicize a professional or community service. The mid-19th-century wooden tooth, above left, from Plattsburgh, New York, was a dentist's sign, while the bald eagle perched on Uncle Sam's top hat, above right, was mounted outside a boarding-house for war veterans in Pittsburgh.

Painted Signboards

The 19th-century New England tavern sign above features a lion on one side of the wooden panel and an eagle on the other. While lion motifs were common in colonial times, they lost their royal crowns in the late 1700s after the Revolution, when eagles became a popular symbol of American independence.

An effective alternative to a shop figure or a trade symbol was the painted signboard. Like trade symbols, signboards delivered their messages with characteristic directness, clearly illustrating a product or service. They, too, relied on imagery and symbolism rather than writing to convey information, and carried few words other than the proprietor's name or a brief reference to the enterprise involved.

Signboards were often the work of ornamental painters who learned their trade through apprenticeship to established artists. A number worked as itinerants, sometimes making their signboards for barter, perhaps in exchange for a meal or a night's lodging.

These sign painters were versatile professionals whose talents often extended to many services,

including decorating furniture, and painting carriages and even portraits. According to an advertisement in the 1827 *Portsmouth Directory,* for example, one New Hampshire painter, John S. Blunt, was capable of "The Following Branches, Viz: Portrait and Miniature Painting, Military Standard do. Sign Painting, Plain and Ornamented, Landscape and Marine Painting, Masonic and Fancy do. Ships Ornaments Gilded and Painted, Oil and Burnish Gilding, Bronzing, &c &c."

Among the most common types of "plain and ornamented" signboards produced by men like Blunt were those for taverns, which played important roles as public meetinghouses, stagecoach depots, and rest stops. As early as 1645, decrees issued in Salem, Massachusetts, and in the Rhode Island colony ordered innkeepers

Continued

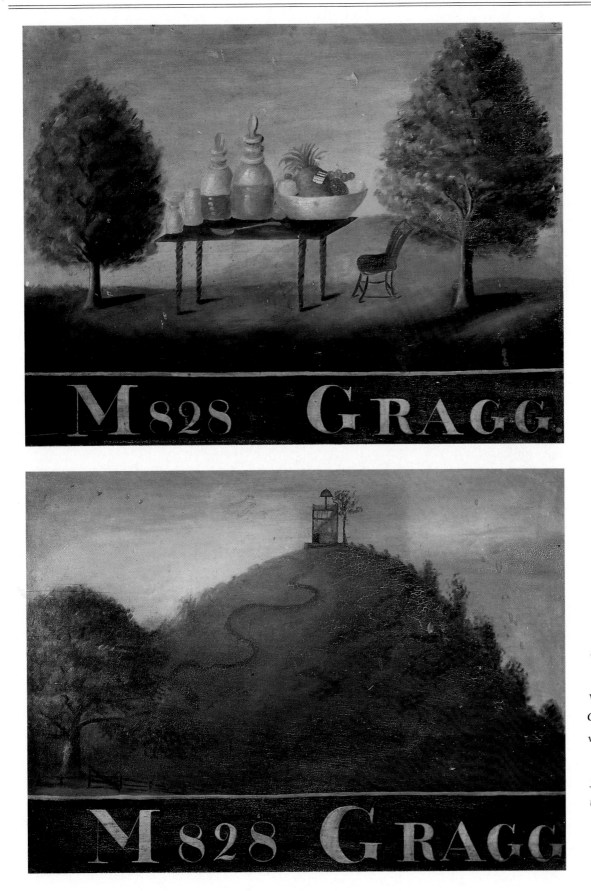

The signboard at left hung
outside the Blue Hill Hotel,
in Milton, Massachusetts,
which was opened by Moses
Gragg in 1828. The oversize
victuals pictured on one side
gave promise of the good
food and drink available at
the inn. On the other side is
a view of nearby Blue Hill,
a well-known landmark
and scenic lookout.

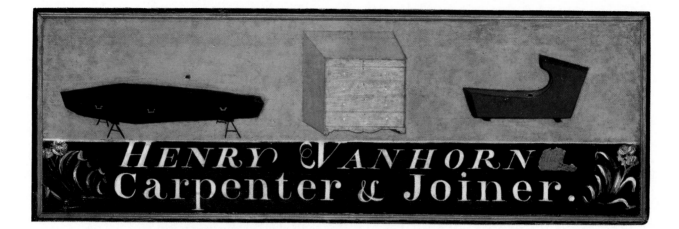

Possibly painted by Edward Hicks, the Pennsylvania sign at top was made for woodworker Henry Van Horn around 1796, and advertises his ability to craft furniture for the living and the dead alike. The 1718 sign at bottom hung outside the Waterman shoe shop in Providence, Rhode Island.

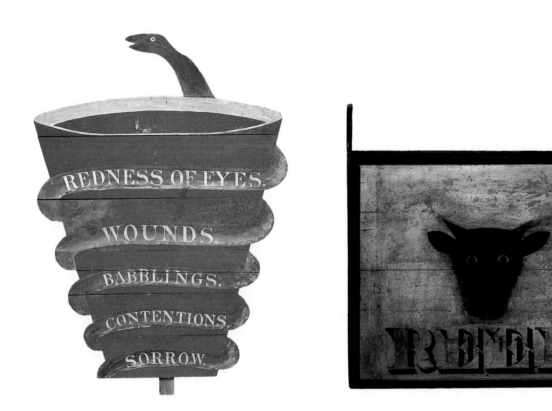

to display signs in a prominent manner to give notice of room, board, and entertainment "to strangers." One early traveler by the name of David Schoef noted that it was easy to spot a tavern from a distance because the signboard "hung from a sort of gallows arrangement which stands out over the road and exhibits the sign of the house." Like most flat signboards, tavern signs were usually hung at a right angle to the road or sidewalk, and it was therefore necessary to decorate both sides; as a result, these boards will often display two different designs.

In the colonial era, the "sign of the house" might be a heraldic emblem or a royal portrait (symbols favored by the British), but after American independence, these generally disappeared. Such patriotic images as flags, eagles, Lady Liberty, and George Washington then began to proliferate, in addition to painterly landscapes and portraits, and the lion—now minus the royal crown. Popular too were scenes of travelers arriving at an inn, diners seated at a table, or depictions of food and drink, which promised comfort and conviviality to wayfarers.

Signboards, however, were by no means limited to taverns. Many painted signs advertised retail shops and tradesmen's establishments, and were logically decorated with pictures related to the business involved—a horse to symbolize a livery stable, perhaps, or a hand to represent a glover. There were toll signs listing charges for ferry and bridge crossings, and even private house signs providing the name and address of the owner. Signboards were also used to publicize the messages of community organizations or to broadcast political sentiments during a campaign. Some signboards even expressed the personal interests or associations of their owner, evidenced by the many examples bearing Masonic symbols.

The signboard above left was made in the 1890s for the meeting lodge of a New Hampshire temperance society; the message on the snake-entwined beaker makes the hazards of drinking alcohol quite clear. The mid-19th-century Vermont butcher shop's advertisement above right had a more commercial purpose.

TRADE BANNERS

During the 19th century, the decorative painter sometimes turned his talents to creating bold, colorful parade banners commissioned by a variety of business, civic, and military organizations, including the trade associations that represented skilled workers and handcraftsmen. Considered among the most beautiful known examples of trade banners, those shown here were made for an 1841 labor parade, and are the work of the ornamental painter William Capen, Jr. Capen began his career as a chairmaker, but in 1827 announced that he had relinquished one branch of his business ("Chair Making"), and intended "to devote his whole attention to Painting, in its various branches." He eventually became one of the most successful sign and banner painters in Portland, Maine.

Capen painted fifteen of seventeen banners used in the parade, which was sponsored by the Maine Charitable Mechanic Association, a local labor society established in Portland

The artist William Capen used oil paints to decorate these silk banners, which were carried in an 1841 labor parade sponsored by the Maine Charitable Mechanic Association. The sheaf of wheat on the banner above was the emblem of bakers and confectioners; the banner at right represented boatbuilders.

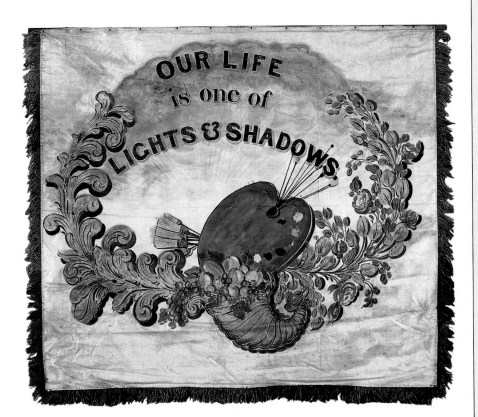

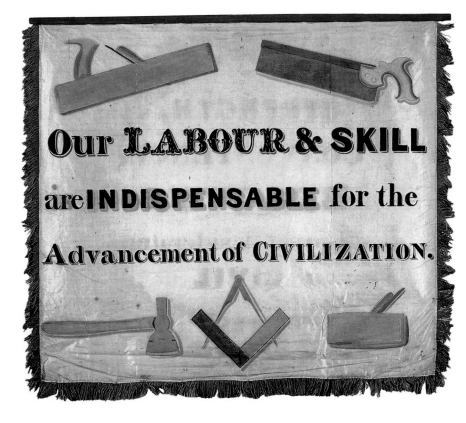

in the early 1800s. At the time, the power of the wealthy "nabobs," or shipowning class, in this seaside town had begun to decline, while that of the "mechanics," or skilled workers, was rising. Formed to protect the interests of the workers and to assist those in need, the association sponsored lectures and exhibits, as well as parades.

Their 1841 parade proved to be the most impressive in the association's history. Applauded by enthusiastic onlookers, marchers proudly carried the banners, which featured the emblems of the various trade groups represented—a sheaf of wheat for the bakers and confectioners, for example, a palette and brushes for the painters and brushmakers—as well as their mottoes. The banners were apparently quite a success; as the local newspaper, the *Eastern Argus,* reported, they "added much to the beauty of the procession, and reflect much credit upon the taste of those who designed them, and also upon their Painters."

Some of William Capen's banners for the Mechanic Association parade featured slogans with double meanings: "Our life is one of lights & shadows" was appropriate for the banner above, which represented painters, brushmakers, and glaziers. Housewrights carried the banner painted with carpenters' tools, left.

Fire Buckets and Parade Hats

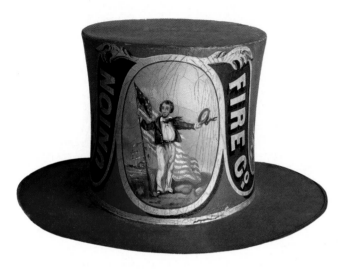

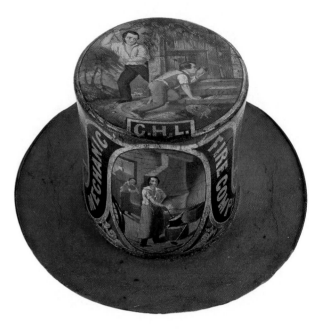

The talents of the professional painter were often called upon to decorate the equipment used by firefighters. In early America, the danger of fire was widespread, and a well-organized firefighting corps was considered essential. A beautifully painted bucket or parade hat reflected an individual's pride in belonging to a volunteer fire company, as well as in the important service he contributed to his community.

Among the earliest specialized pieces of firefighting equipment was the fire bucket, which both househoulders and fire companies were required to own. When an alarm was sounded, people would set their buckets outside the house so that volunteers could pick them up as they ran to the fire. At the scene of the blaze, bucket brigades were then formed to pass the water from the nearest source along to the firefighters or to the tub of a hand-pumped engine. Once the fire was out, the buckets were piled in a central loca-

tion to be reclaimed. Even after steam-powered pumps became common in the mid-1800s, decorated buckets, often used for show in parades and ceremonies, remained a tradition.

The fire buckets were made of leather, generally by cobblers and harness makers, and the decoration was done by professional painters. The simplest ones bear the owner's name or initials, while more elaborate buckets, mainly used by corps members, feature fire company insignia, fire scenes, and portraits of national figures such as Benjamin Franklin, who organized the first volunteer fire company in 1736.

Painted by the same artists who worked on the leather buckets, decorated fire hats, which were made from varnished felt or animal hide, featured similar portraits and scenes. Proudly worn, the distinctive stovepipe hats were never used for firefighting, but were reserved for special occasions such as parades and the friendly musters that were held between fire companies.

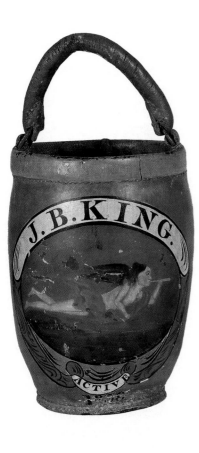

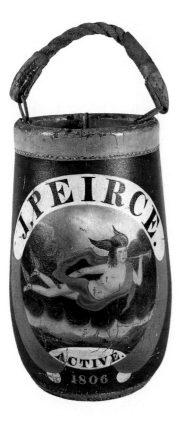

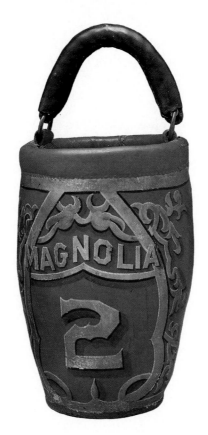

Clockwise from top left: two fire buckets from volunteer firefighting clubs in Salem, Massachusetts; a gilded Magnolia Company fire bucket made in Boston around 1790 for use in parades and ceremonies; and a personalized bucket marked 1806, indicating the founding date of the fire corps that J. Peirce belonged to.

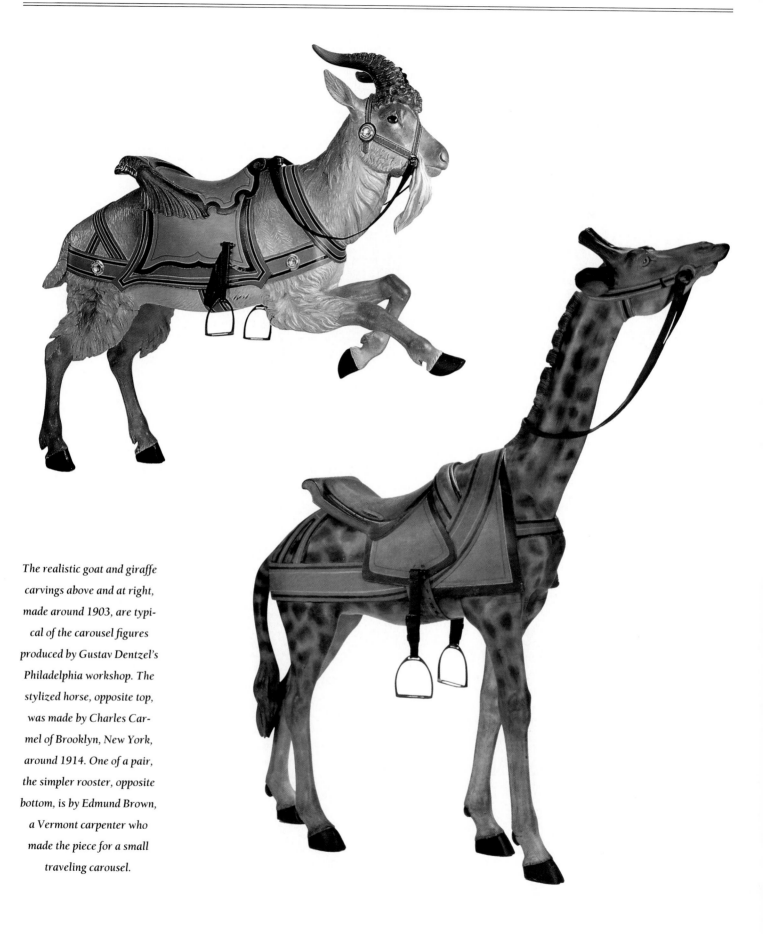

The realistic goat and giraffe carvings above and at right, made around 1903, are typical of the carousel figures produced by Gustav Dentzel's Philadelphia workshop. The stylized horse, opposite top, was made by Charles Carmel of Brooklyn, New York, around 1914. One of a pair, the simpler rooster, opposite bottom, is by Edmund Brown, a Vermont carpenter who made the piece for a small traveling carousel.

Carousel Animals

Carousels were extremely popular attractions in America in the late 1800s and into the 1900s, and about a dozen American workshops specialized in carving ornate wooden animals for these revolving menageries. Before the 1920s, when mechanized factory production began to supplant the shops, the animals were entirely handmade by specialized craftsmen—many of whom emigrated from the European countries where the carousel had developed. Each workshop, headed by a designer or master carver, was characterized by a distinctive style; animals from the Philadelphia shop of the highly regarded German craftsman Gustav Dentzel, for example, are noted for their realism.

Dentzel and his competitors produced all manner of domestic and exotic animals, as well as mythical creatures. But while a rider could mount anything from a timid rabbit to a snarling panther, the horse always remained the most common figure.

Figures designed for the traveling carousels prevalent at carnivals and country fairs were generally small and simple because the carousels had to be disassembled and moved from place to place. Animals created for permanent amusement park carousels were more elaborate, sculpted into dynamic poses that suggested forward motion and intensified the thrill of the ride. The detailed carving was enhanced by brightly colored paint varnished to a high gloss; even on the most sophisticated pieces, the "right" side of the animals—which faced the spectators—was always the more finely decorated side.

The Carousel

For the generations of riders who grew up reaching for the brass ring, no trip to the park, beach, or local carnival was complete without a turn on the carousel. In its heyday, which lasted from the late 1800s to the early 1900s, this popular ride always drew crowds. Neither child nor adult could resist the prancing ponies, gliding swans, and other animals that revolved to the lilt of organ music.

Yet, while the carousel has become an American institution, it did not originate in this country. Its exact history, in fact, is unknown, and the ride may have developed independently in several different regions of the world. One forerunner appears to be a medieval European equestrian tournament, in which gold rings, hung from trees or posts, were speared with a lance. To prepare for this event, horsemen mounted wooden horses that were attached to a central pole; as the pole was rotated, the riders jousted for the rings. By the 1700s, this "practice" carousel had grown into a pleasure ride fitted out with fanciful carved animals and turned by horse-, mule-, or man-power.

The earliest known American carousel was made in New England in 1800 and had crudely carved horses suspended by chains from radiating arms. As the American carousel evolved, the horses gradually grew more lifelike, first by the addition of

horsehair tails and manes, and then with carving. With the introduction in 1865 of steam power—which could pull a heavier load—the horses, and the other animals that began to appear, grew larger and more elaborate.

The art of carving the figures reached its full flowering in the hands

of the skilled immigrant woodworkers who arrived in this country from the mid-1800s onward—many with prior experience in crafting carousels. During the period from the late 1800s to about 1925, the shops they set up produced carvings for more than six thousand carousels.

The method used for making a carousel animal was essentially alike in every shop. Generally, a master carver would devise a pattern for the

animal, which would be roughed out in poplar, pine, or basswood. Each section was carved separately by a different specialist, doweled and glued, then joined to the other parts.

Although the manufacturing process for the figures was the same, three distinctive looks developed. The fanciful but realistic Philadelphia style was pioneered by Gustav Dentzel, an immigrant carousel maker from Germany who arrived in Philadelphia in 1860. The more flamboyant Coney Island type, as seen in stylized animals with flaring nostrils, bulging muscles, and bright paint coloring, was developed by a number of carousel makers—including Charles Looff, from Germany, and the Polish carver Marcus Illions—who worked in the New York City area. Their shops provided carousels for Coney Island and the other amusement parks to which the public flocked on new trolley lines.

The third and simplest design, the Country Fair style, is associated with makers such as Charles Parker of Abilene, Kansas. Parker settled in the Midwest after the 1890s, filling orders for the traveling carnivals that provided entertainment to rural settlements. The Country Fair style developed mainly from necessity: because small country carousels had to be easily dismantled, simple, portable animals proved the most practical.

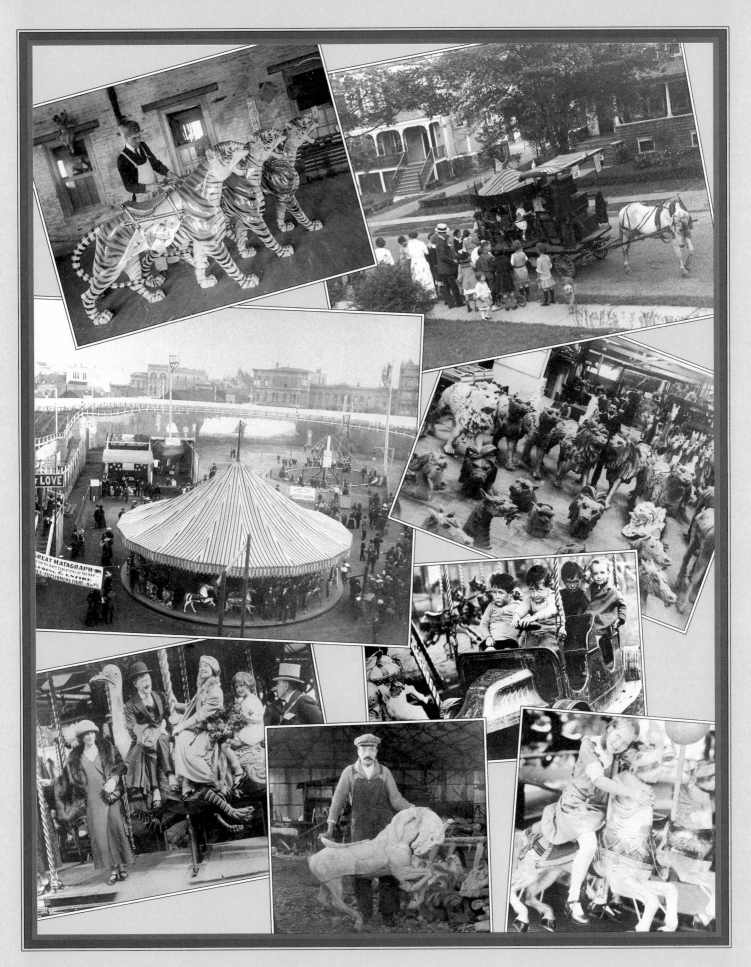

Weather Vanes

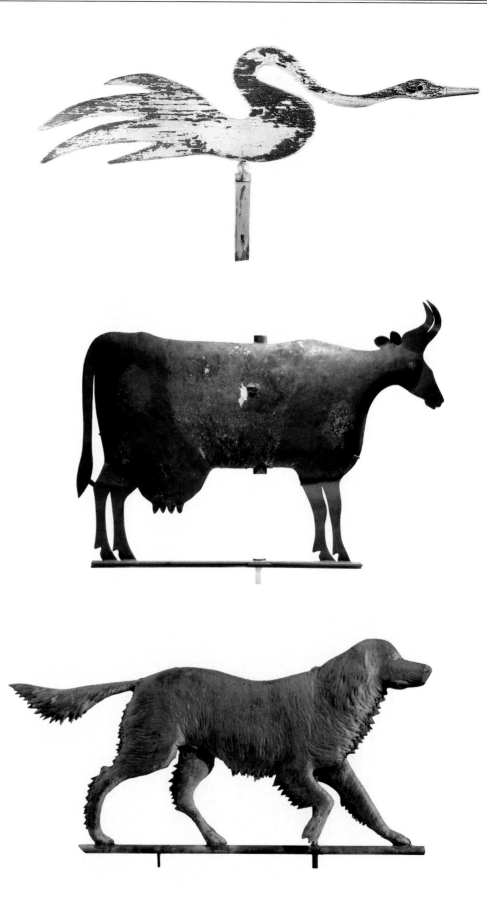

The swan weather vane, top, crafted in the late 1800s by a New Hampshire farmer, is of painted wood, while the early-1900s cow, middle, was hammered from tin. Made from a hand-carved mold, the copper setter, bottom, called McDona's Ranger, was copyrighted in 1882 by L. W. Cushing & Sons of Massachusetts, and originally sold for thirty-five dollars.

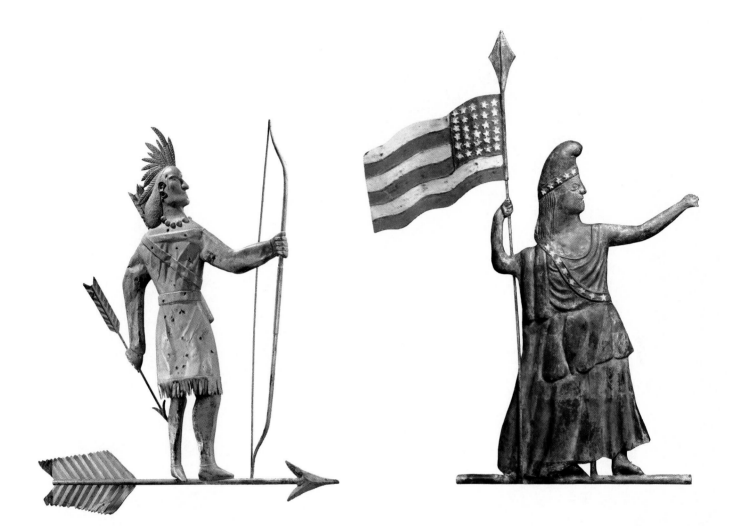

Perhaps no object better expresses the creative spirit of America's folk artists than the weather vane. While everyone from farmer to seafarer looked to these rooftop devices for a daily weather report, vanes were more than meteorological instruments; rendered in countless forms, they became imaginative sculptures in the hands of their makers.

With their bold, clear profiles, weather vanes —usually made of wood or metal—were inherently iconographic in form and often served as trade symbols. A weather vane could also have religious, patriotic, or regional meaning. New England church roofs often boasted vanes shaped like fish, an ancient Christian symbol, while municipal buildings might be topped by a patriotic Lady Liberty or eagle vane. Ship weather vanes proliferated in port towns, and animal weather vanes of every description— especially horses—appeared throughout this agricultural nation.

Many of the craftsmen who made weather vanes, like the 18th-century smith Shem Drowne of Boston, were well-known even in their own time. Nevertheless, relatively few handcrafted vanes produced before the 1850s exist today. Far more prevalent are the hollow metal pieces hammered out in factories after the mid-19th century from hand-carved wooden molds. The best-known firms included J. Howard & Co. and A. L. Jewell & Co., both of Massachusetts, and J. W. Fiske of New York City.

Placed atop the lodge of The Improved Order of Redmen in East Branch, New York, the mid-1800s copper Indian vane, above left, represented Saint Tammany, a legendary chief of the Delaware to whom lodge members pledged their allegiance. The painted copper Goddess of Liberty, above right, was factory-made in the late 1800s.

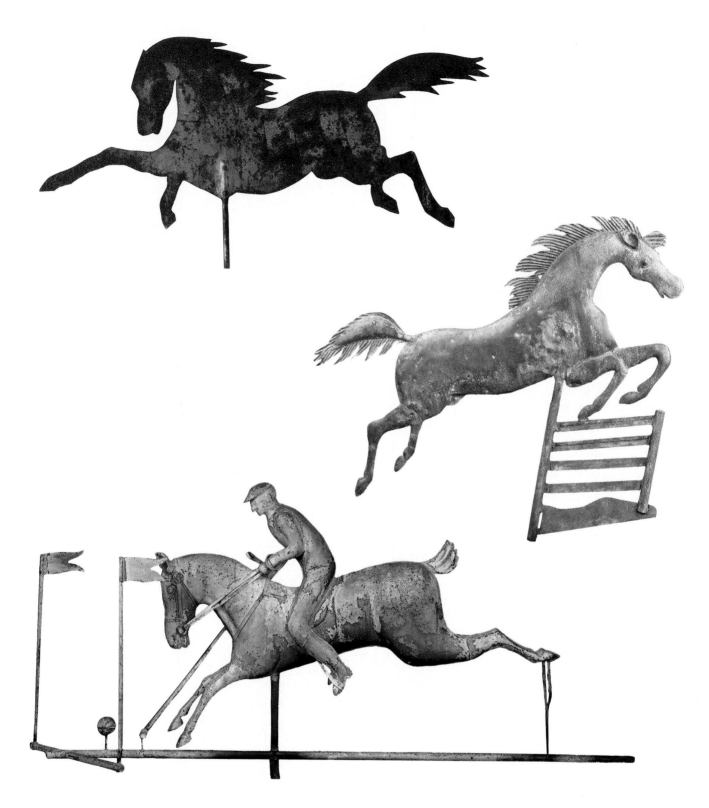

Horse vanes like these copper pieces often display a remarkable sense of movement and life. The c. 1860 horse, top, from A. L. Jewell & Co., gallops through the air, and the more abstract c. 1870 steeple-chase horse, middle, jumps a fence. The c. 1885 polo pony, bottom, may be one of a kind.

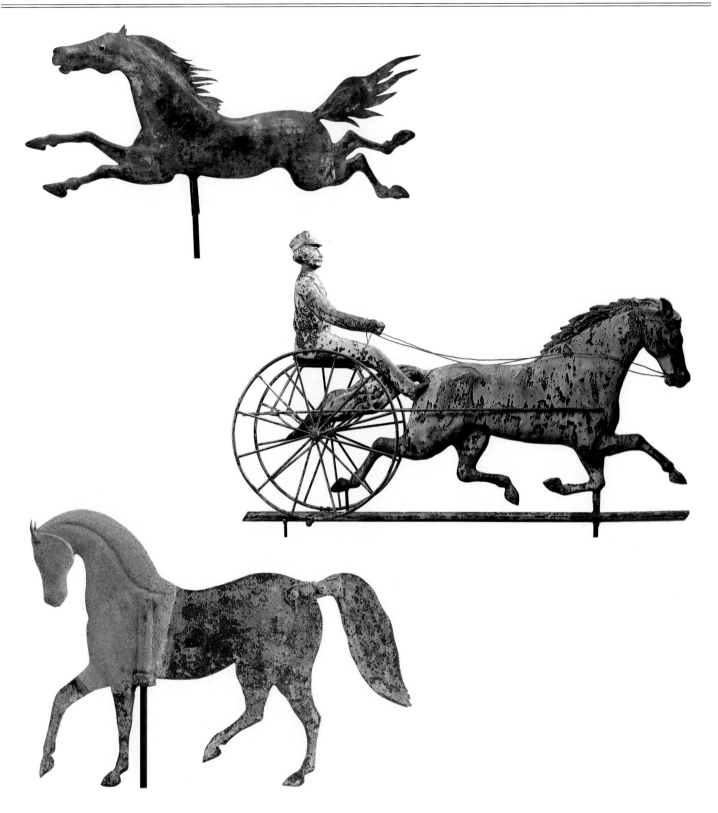

The mid-1800s "flying" horse, top, is from A. L. Jewell & Co., while the c. 1885 sulky and driver, middle, was made by J. Howard & Co. The horse with a zinc front and a sheet-copper body, bottom, is also by Howard; it may have been the prototype for the firm's standard small-size horse.

Wildfowl Decoys

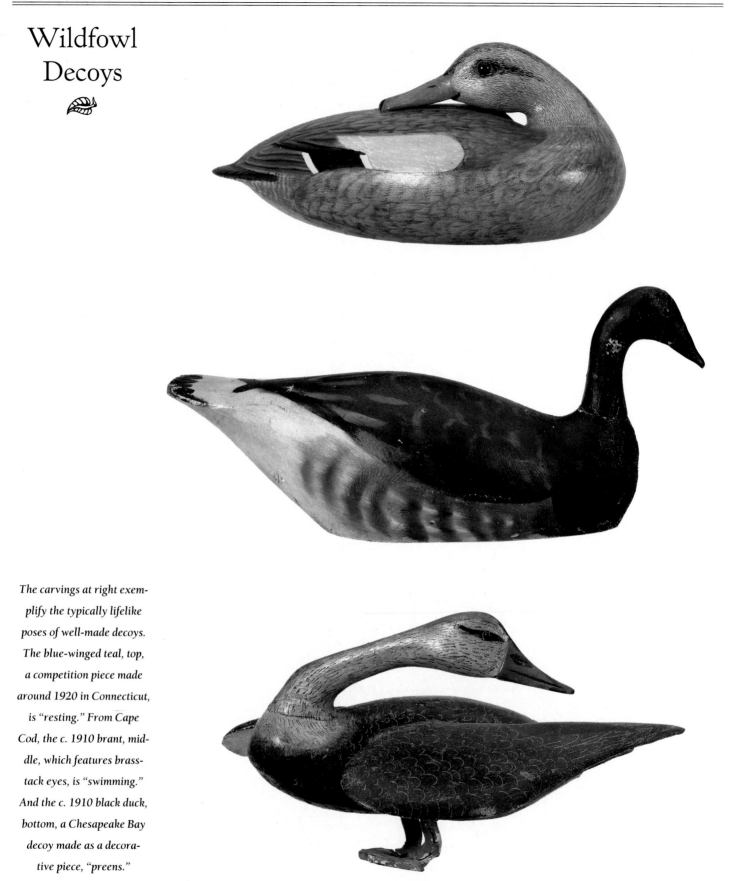

The carvings at right exemplify the typically lifelike poses of well-made decoys. The blue-winged teal, top, a competition piece made around 1920 in Connecticut, is "resting." From Cape Cod, the c. 1910 brant, middle, which features brass-tack eyes, is "swimming." And the c. 1910 black duck, bottom, a Chesapeake Bay decoy made as a decorative piece, "preens."

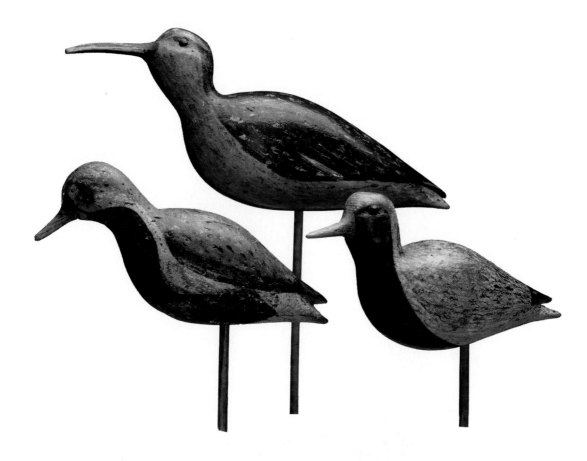

Designed to bring ducks and other water birds into the hunter's range, decoys were first made in this country by Native Americans, who crafted them with grass, feathers, and other readily available materials. Recognizing the value of these ingenious lures, European settlers adapted the decoy in wood; the earliest of the wooden types were probably made in the late 1700s.

As the 19th century progressed, increasing food needs and an apparently endless supply of waterfowl spurred a dramatic growth in bird hunting both as business and as sport. To meet the demand for decoys, craftsmen turned out hundreds of birds, producing many for competitions and decorative use as well as for hunting. By 1900, a thriving cottage industry had developed and it was possible to order decoys by mail from specialized factories. (While the bodies were lathe-turned, the heads and finish work were still done by hand.)

Decoys were made in nearly every major waterfowl-hunting area in the country, and their designs logically reflected regional differences depending on the particular species and the hunting traditions of a given place. Some decoys floated, while others, mounted on thin stakes, were meant to stand in a marsh or at the water's edge. These "stick-ups" attracted small, long-legged shore birds such as plovers and curlews.

A successful decoy was both well-balanced—so it would remain upright—and sturdy enough to withstand years of use. Above all, however, it had to be convincing. Because the carvings were supposed to be seen from a distance, more importance was placed on illusion than on exact detail. Shape was suggested with broad modeling, while simplified paint patterns indicated feathers. The sleek, economic forms that resulted—accentuated by an attenuated neck, perhaps, or a gently curving tail—place decoys among the most elegant of folk sculptures.

The delicately modeled "stick-up" shorebirds above include a long-beaked Hudsonian curlew, center, and two small black-bellied plovers. All were made around 1870 by Nathan Cobb, Jr., a member of a large family of noted wildfowl hunters and decoy carvers from Virginia.

THE FISH DECOYS OF OSCAR PETERSON

Now attracting collectors as colorful folk sculptures, fish decoys like those opposite, made by the highly regarded carver Oscar Peterson, were originally designed to lure an unsuspecting catch into striking distance of an ice fisherman's spear. In a practice used in freshwater ice fishing since prehistoric times, the decoy is attached by a line to a pole known as a jigging stick, then lowered through a hole cut in the ice. A portable shack, or a covering such as a blanket held over the fisherman's head, helps block out daylight, making it possible to see and track the weighted decoy as it is moved through the water.

This dependable fishing method was spread by Native Americans from Alaska throughout Canada and into the Midwest and New England regions, then adopted by European settlers. Most existing examples of fish decoys, made by professional carvers and amateur sportsmen alike, date from the 1920s to the 1950s, and the majority come from the Great Lakes region of Michigan, Minnesota, and Wisconsin.

Peterson himself was a native of Michigan, where he was born in 1887 to Swedish immigrants. In 1895, his family moved from Grayling to Cadillac. An avid outdoorsman, Peterson ran a landscaping business there, and also worked as a hunting and fishing guide. Around 1907, he be-gan carving fish decoys for himself and as gifts. Catering to the northern Michigan tourist trade, he also turned out vases, bowls, plaques, and signs. In addition to trading his works for meals or drinks, he sold them on consignment—at prices

Oscar Peterson, shown with an impressive "catch," is known for the thousands of ice fishing decoys he carved.

ranging from fifty cents to $1.75—in restaurants, bars, gas stations, and bait shops. Pieces were also shipped by mail across the country.

A prolific craftsman, Peterson made countless carvings, including an estimated ten to fifteen thousand fish decoys, before his death in 1951. His decoys are distinguished not only by their sheer number, but also by their realism; unlike other makers who created more abstract "suggestions" of fish, Peterson usually carved identifiable species. The majority of his decoys were brook trout, but he made perch, suckers, rainbow trout, walleyes, pike, and even frogs (which were also effective in attracting fish).

Working with just a few hand tools, including chisel, file, and penknife, Peterson carved the basic forms—which range in length from 2½ inches to 14 inches—from well-seasoned walnut, pine, oak, maple, or birch, following the grain of the wood to create a streamlined, flat-bellied fish. He paid particular attention to the shape of the head, which differentiated the species he carved; a long snout and pronounced underbite, for instance, signified a pike, while a trout's head was more rounded. Some of Peterson's fish, those known as "natural side" decoys, were simply stained and varnished. Others were painted, often in great detail, with the colors and markings of a particular species. Additional distinguishing features of his decoys include the carved gill lines, which were almost always highlighted in red paint, black upper lips and dorsal fins, and eyes made of upholstery, carpet, or thumb tacks, or, more rarely, glass.

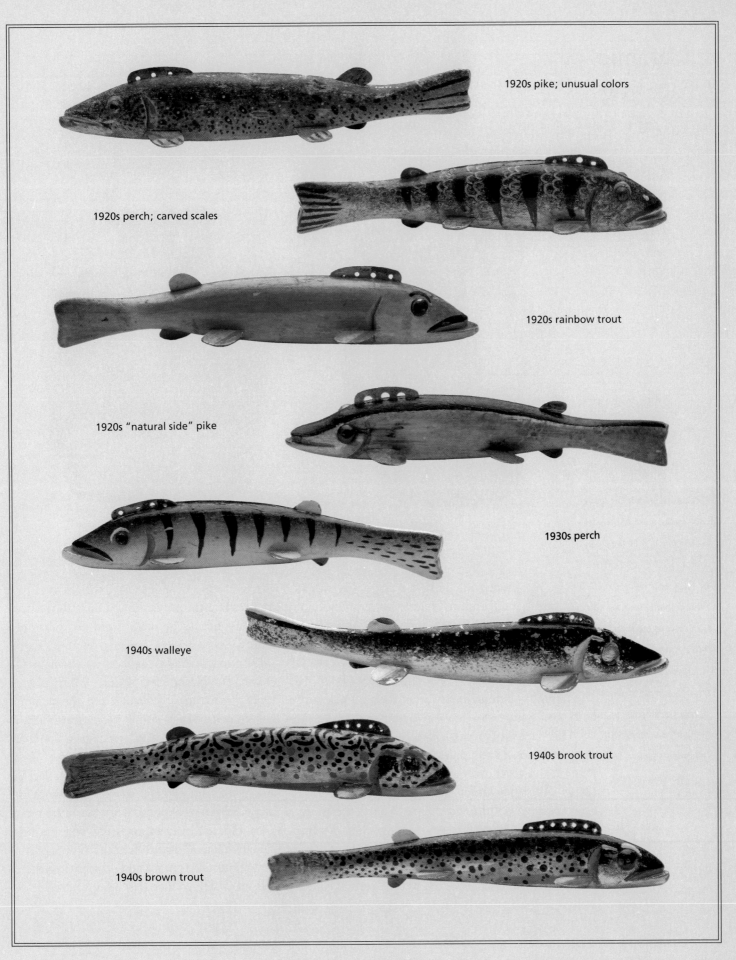

1920s pike; unusual colors

1920s perch; carved scales

1920s rainbow trout

1920s "natural side" pike

1930s perch

1940s walleye

1940s brook trout

1940s brown trout

Ceramic
Face Jugs

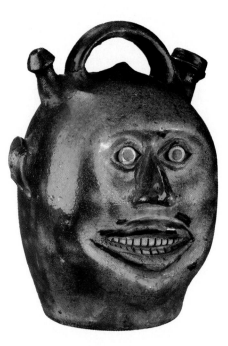

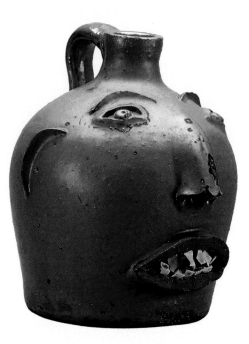

Unusually prominent teeth are often the most distinguishing feature of face jugs. The grinning lead-glazed earthenware jug, near right, a c. 1870 Philadelphia piece, reveals even rows of teeth gleaming with a coating of white clay. The jagged incisors of the less fortunate countenance on the southern redware jug, far right, are made with fragments from a broken porcelain dish.

Among the most startling works of folk art produced on the potter's wheel are face jugs, also known as effigy or grotesque jugs. Designed with exaggerated human features, these odd ceramic vessels, first made in the early 1800s, were found throughout the country, although they are associated primarily with South Carolina and Georgia. Some of the jugs may have originated as "end-of-the-day" novelties for the potter's own amusement; others, however, were apparently commissioned.

After the earthenware or stoneware body of the jug was thrown on the wheel, the potter modeled the features by hand, perhaps adding ears, hair, and a moustache. While the jugs were glazed—black, olive green, brown, or cobalt blue—the eyes and teeth were usually accented with a coating of china clay, which fired to a bright white for an especially unsettling effect. Teeth might also be made from bits of broken pottery.

The artistic origins of face jugs remain unknown. Double pouring spouts, which suggest devils' horns, may have inspired the demonic look on certain faces. Other pieces feature comical, drunken expressions—perhaps a comment on the effects of the liquor that some of the jugs might have held. Still others may reflect the heritage of their makers. Slaves from Africa and the Caribbean were put to work in southern potteries, especially during the Civil War, and jugs made by them appear to find their roots in African sculptural traditions and possibly in customs associated with voodoo.

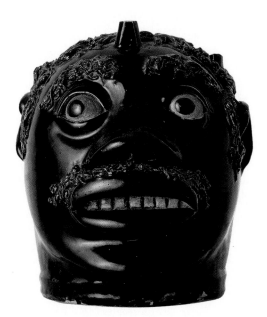
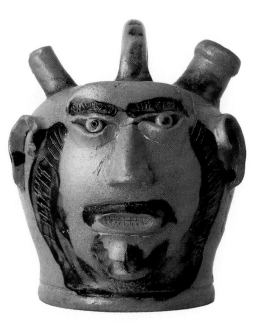
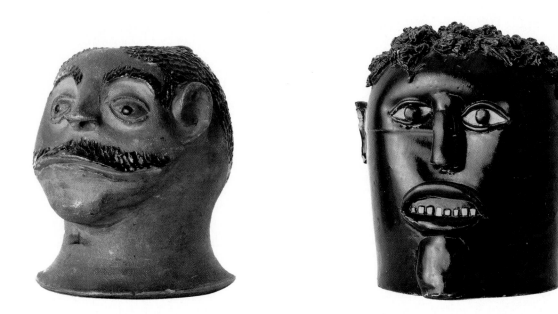

Clockwise from top left: a c. 1870 Ohio jug by John Dollings with applied "cole slaw" hair; a demonic salt-glazed stoneware piece with a center handle and two spouts; a late-1800s Ohio jug thought to have been a presentation piece; and a late-1800s redware jug from Ohio or Pennsylvania.

Decorated Stoneware

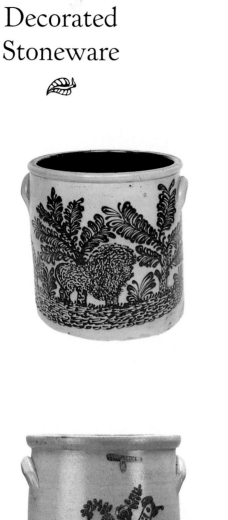
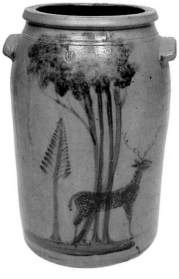
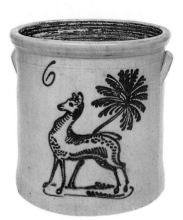
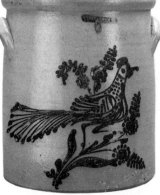
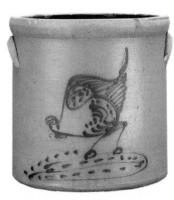
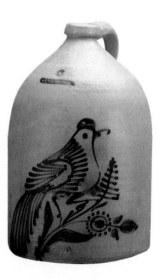

As evidenced by the 19th-century crockery above, animals, both familiar and exotic, were favorite subjects for stoneware decoration.

Salt-glazed stoneware was one of the most common types of pottery used in early America. Because the salt glaze was non-toxic, unlike the lead glazes used on most other ceramics, stoneware was ideal for storing food. Both small potteries and large factories throughout the Northeast and Midwest turned out countless jars, jugs, and other utilitarian crockery, primarily from the late 1700s to the late 1800s.

This ubiquitous pottery offered the artist an endless opportunity for demonstrating his skill, and as a result, stoneware is among the most liberally decorated types of American pottery. Depending on the ability of the decorator—who might be the potter himself or an itinerant ceramic painter—a design could be as simple as a single motif or as complex as a detailed rendering of an entire village.

While early pictorial designs in this country were based on those found on imported European

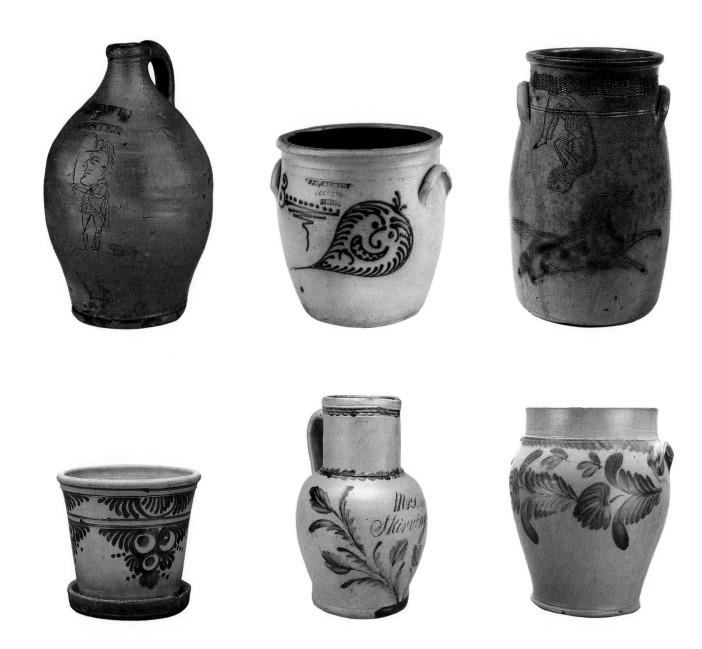

wares, Americans soon developed their own vocabulary of themes. Eagle, flag, and shield motifs reveal strong patriotic sentiments, and the many bird, flower, and animal designs used were drawn from nature. Human figures, exotic beasts, buildings, and ships also found their way onto everything from mustard pots to butter crocks.

Depending on when it was made, stoneware was generally decorated using one of two techniques. Before the 1850s, incised designs, often highlighted with cobalt blue glaze, were typical. But as demand for storage containers increased along with the population around the middle of the century, potters turned to surface glazing, a faster method, which involved applying slip to the body with a brush or trailing it on with a quill-spouted slip cup. The images were most often rendered in cobalt blue, but also in a dark brown called Albany slip after the city in New York where much of the clay was dug.

The stoneware pieces above display the two basic techniques of decoration: incising, often accentuated with cobalt blue glaze, and surface glazing in brown Albany slip or in blue.

Clockwise from top left: an 1805 plate by Johannes Neesz of Tylersport, Pennsylvania; a 1786 piece with a traditional double bird motif; a lively 1786 design of fiddler and dancers; and a c. 1790 plate on which the female figure declares, "Thou hast been a dear man to me since first I ever looked at thee."

Sgraffito Pottery

Made primarily from the late 1700s through the mid-1800s, redware pottery with sgraffito, or scratched, decoration is evidence of the high degree of skill attained by Pennsylvania-German potters. Sgraffito was a common pottery decoration in Europe, and these tradition-conscious immigrants continued the technique largely unchanged in America. Although the settlers were working with coarse local red clays and a limited range of glaze colors—just yellow, green, and black— they were nonetheless able to create masterful ceramic designs.

Sgraffito decoration was done by applying a thin layer of cream-colored slip to the redware body, then incising a design into the coating to reveal the contrasting clay beneath; colored glazes were often added to complement the scratched motifs. The stylized tulips, hearts, birds, urns, animals, and human figures that characterize the exuberant, fluid pottery designs reflected decorative traditions brought from Europe. Some pieces, however, also bear images of Revolutionary War soldiers, George Washington, or the American eagle. Combined with the familiar Germanic motifs, and often a terse bit of German folk wisdom—"Rather would I single live than the wife the breeches give," for example—such pieces display the blend of influences from homelands both old and new that is the mark of many distinctive folk pieces.

Time-consuming and expensive to produce, sgraffito wares were generally ornamental rather than utilitarian. While mugs, vases, jugs, and flowerpots were decorated using the technique, the most common forms are plates and platters, which were often given as presentation pieces and deemed highly desirable by their owners.

The sgraffito plates above, early-19th-century pieces from southeastern Pennsylvania, are both decorated with stylized arrangements of three tulips. Urns or vases containing three spreading flowers are thought to represent the Incarnation.

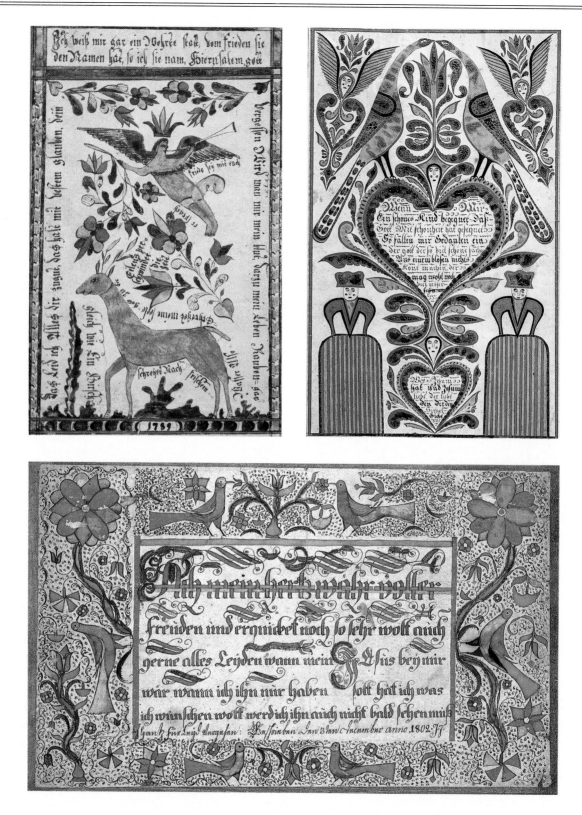

Ink-and-watercolor devotional fraktur, clockwise from top left: a 1789 piece by Johan Adam Eyer
inscribed, "As a deer pants for water, so cries my soul, oh Lord, for Thee"; a c. 1835 heart and bird
design attributed to Martin Gottshall; and an 1802 work from southeastern Pennsylvania.

Illuminated Fraktur

The distinctive artistry of the Pennsylvania Germans is nowhere more apparent than in the ornate hand-lettered and illustrated family records, devotional pieces, and other works on paper known as fraktur. Made mainly between the mid-1700s and mid-1800s, fraktur was typically the work of clergymen, itinerant scriveners, and schoolmasters. In an effort to augment their meager salaries, male teachers commonly prepared letters for individuals who did not know how to write, and they were also frequently called upon to scribe important documents.

The pen-and-brush decoration on such illuminated works derives from two European sources:

the decorative motifs and embellished initial capital letters were inspired by medieval illuminated manuscripts, while the calligraphy resembles *Fraktur,* a typeface of broken, or "fractured," letters developed in 16th-century Germany. But while fraktur was born of German tradition, it was in America that this remarkable form of folk art was preserved and refined.

Indeed, fraktur included virtually all documents and texts important to the Pennsylvania-German culture. The German custom dictating that vital statistics be registered, for example, gave rise to marriage certificates, along with *Geburts-und-Taufscheine*—the birth and baptismal certificates that are the most common ex-

Continued

Ink and watercolor were used to create the labyrinthian Irrgarten, *or maze, left, around 1838. The finely rendered decorative motifs and intricate script—which combines verses from two Germans hymns that were published in colonial America—indicate that it is the work of an experienced scrivener.*

America's first First Family was a favorite subject for fraktur artists. The 1842 piece above left, attributed to Durs Rudy, Jr., honors General George Washington as the nation's commander in chief. Both George and Martha are depicted in the purely decorative work above right, date around 1780.

amples of fraktur. Such records were inscribed with names, the date of an event, and religious verses, all often enclosed in a heart cartouche surrounded by such traditional motifs as birds, hearts, tulips, and stars.

Religion was a dominant force in the lives of the Pennsylvania Germans, and many other fraktur works also reflect its influence. Fraktur decoration featuring doves and crosses distinguished the pages of Bibles and prayer books. *Haus-Segen*, or house blessings, included an illuminated psalm or prayer. Religious precepts, too, could be imparted more palatably with fraktur: the maze-like *Irrgarten* featured hymn verses in minute script intertwined along its "paths." Patriotic symbolism for the adopted homeland of America was also evident in fraktur. A number of works honor George Washington and other na-

tional heroes revered as guarantors of freedom—particularly freedom of expression, which had been denied the Germans in Europe.

Most fraktur was entirely hand-decorated, even though an itinerant artist might prepare part of the design in advance, filling in blanks later to suit a buyer's needs. Many fraktur artists signed their work and remain well-known today. Among the most outstanding is the schoolmaster Johan Adam Eyer of Bucks County, Pennsylvania, who made spectacular fraktur pieces for family and friends. Equally gifted was his contemporary, Heinrich Otto, of Lancaster County. Ironically, the fraktur-motif woodblocks that Otto devised as a shortcut printing method foretold the fate of fraktur; by the late 1800s, improved printing technology had all but replaced the handwork.

Made in 1832, the fraktur puzzle book, or "turn-up," above features Bible stories designed for young

readers, who would flip the half pages up or down in sequence while following a rhyming text.

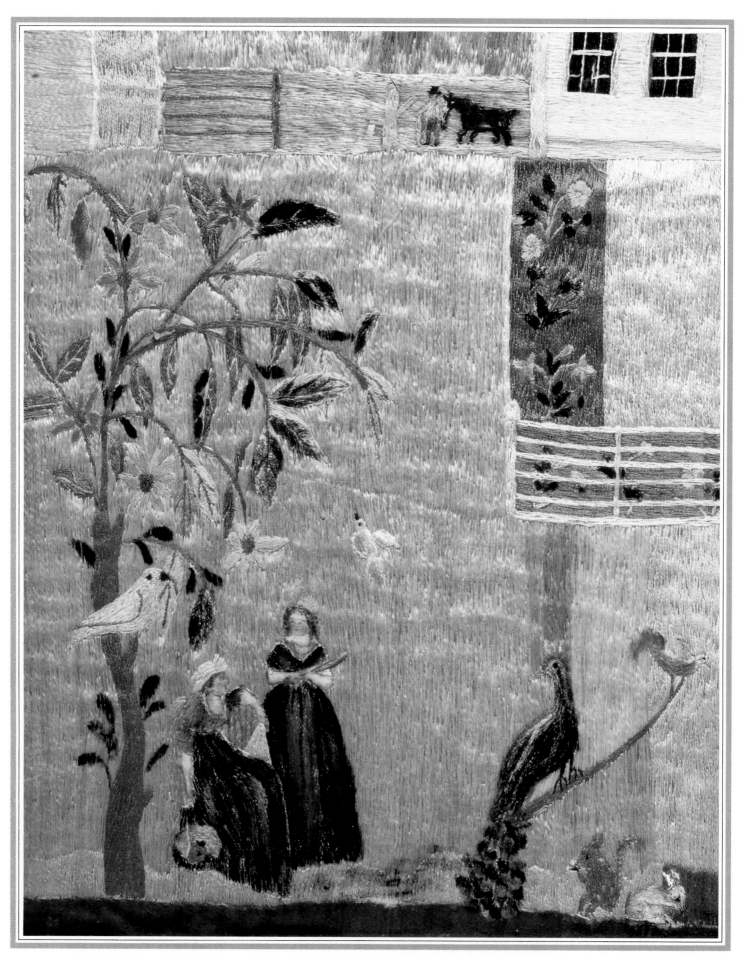

Classroom Exercises

art training in America's
early academies

By the early 1800s, training in artistic skills was an integral part of the curricula at the private academies, or seminaries, that had opened along the East Coast. In many ways, academies were finishing schools where privileged children could learn to become proper ladies and gentlemen. Although girls did study subjects such as geography and literature, the emphasis of their education was on "feminine accomplishments," including fine needlework, watercolor painting, and music. Boys typically followed a stricter course of academics; however, the exuberant calligraphic drawings that they produced as part of their studies in penmanship suggest that they too met artistic challenge in school.

Virtually all of the works included in this chapter began as classroom exercises designed to teach the skillful use of needle, pen, and brush. For the most part, proficiency was emphasized over originality; students generally used published illustrations as the basis for their work, and learned by rote copying. Yet, even the most oft-used illustration was open to creative interpretation, and many pieces of artistic merit were produced.

This detail of an 18th-century needlework picture done in silk thread (page 99) shows
the handiwork typical of pieces made in young ladies' academies.

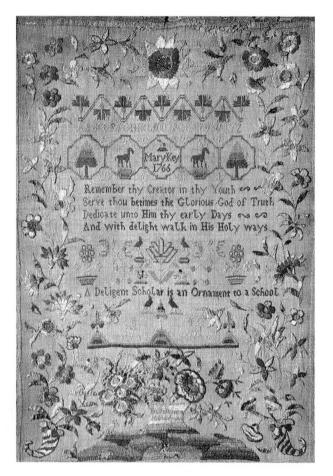

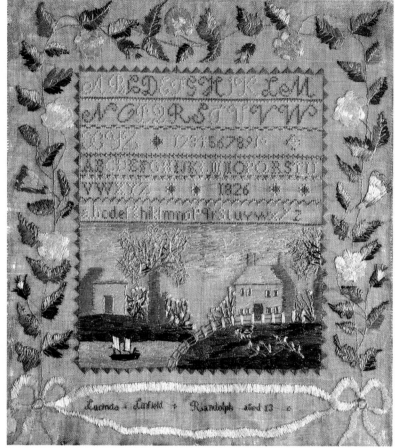

Tiny cross-stitching in Mary Key's 1766 sampler, above left, conveys a message that perhaps all 18th-century schoolgirls learned. By 1826, when the more loosely stitched sampler above right was worked, ornamental needlework had begun to wane in importance.

In the late 18th and early 19th centuries, learning needlework skills was an essential part of a young lady's education. But while plain sewing was learned at home as a practical necessity, stitching fine embroidery was another matter. This leisure pastime, once reserved for the wealthy, had acquired a distinctive social significance for middle-class young women by the late 1700s. And unless a mother was herself a skillful embroiderer with plenty of time for teaching, she would send her daughter to a private school to master this important social art.

A very young student might have learned her elementary lessons at a "dame's school," where she was taught to make a sampler—from the Latin word *exemplar,* meaning "to learn from" —which generally consisted of the alphabet and numbers. Children of both sexes used such simple samplers to practice their ABCs while perfecting basic decorative stitches; only girls, however, went on to make the more elaborate pieces, such as those above.

Worked in fancier stitches and often incorporating verses and needlework pictures, these impressive creations were the products of students in private secondary schools. Unlike the simpler versions, they were made to be framed and shown off in the home and, in a sense, were

Schoolgirl Needlework

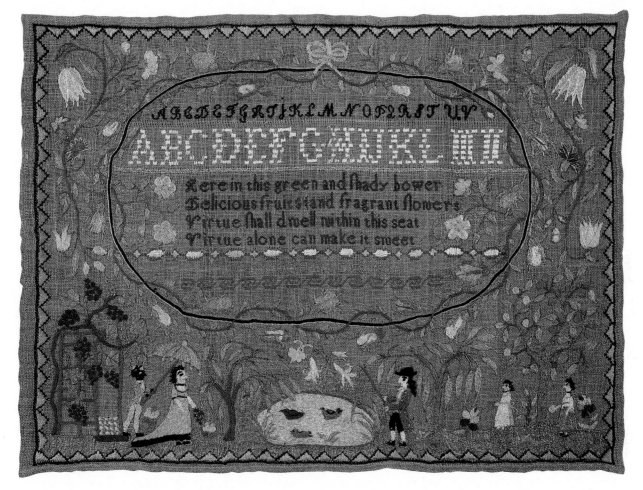

status symbols: proof that parents had the means to send their daughters to school, and that their daughters had the necessary talents to become suitable wives for socially prominent men. The words of one Philadelphia mother express those concerns: "Tell me how you improve in your work," she wrote to her daughter, who was at school in New Jersey. "Needle work is a most important branch of a female education, & tell me how you have improved in holding your head & sholders [sic], in making a curtsy, . . . These things contribute so much to a good appearance that they are of great consequence."

By the early 19th century, dozens of secondary schools specializing in needlework had opened. Often housed in large private homes, they were usually headed by women, who advertised their curricula in newspapers. In 1814, the Misses Saunders and Peirce promoted their Massachusetts school in the *Salem Gazette,* promising "Embroidery of every description in silk, cheneilles [sic], crewels, and cottons." Most schools closed after a few years—when their proprietors married—but some continued for decades; among the longest lasting were Miss Balch's school in Providence, Rhode Island, Sarah Pierce's school in Litchfield, Connecticut, and the Moravian Seminary in Bethlehem, Pennsylvania.

Continued

On her 1801 sampler above, Mary Coffin illustrated the "green and shady bower" of her stitched verse with a pictorial embroidery. The arbor, fruit tree, and procession of figures were probably copied from an English print; interpreted by a child's hand, they have a delightful, naive quality.

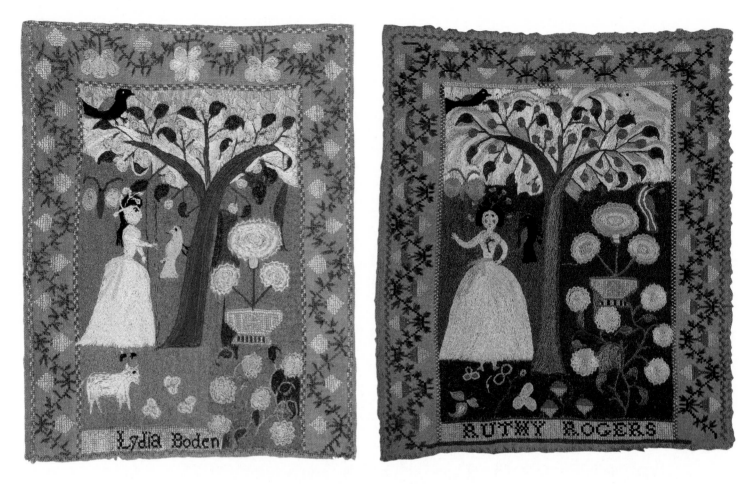

Lydia Boden and Ruthy Rogers were both students at the Marblehead School of Needlework in Massachusetts when they stitched the pictures above in the late 1700s. Although the girls began with the same design, their personal approaches to stitching and color yielded these individual pictures.

Such academies produced not only samplers but also elaborate pictorial embroideries like those above and opposite. Generally worked on over the course of two semesters, pictorial embroideries were made by advanced students and were usually stitched in silk, chenille, or metallic thread on silk backgrounds. The compositions —often landscapes complete with buildings and people—might be adapted from pattern books and engravings, or be designed by the teachers themselves. Indeed, compositional similarity among many pictorial embroideries indicates that they were made under the tutelage of a single instructor. But while students may have started with the same design, they usually personalized it by choosing their own colors and perhaps showing family members and pets in their scenes.

Learning a large repertoire of stitches also allowed the girls to create a variety of pictorial effects. Borders—which often included flowering or berried vines, or ribbons with bows— were typically made with outline, cross, and satin stitches. Clever needleworkers carefully integrated their stitches for optimum effect, using chain stitching for shading, perhaps, or French knots for texture (ideal for the woolly coats of sheep). Some ambitious works even combined stitchery with painting; sky and clouds, for example, might be added with watercolors.

Both samplers and pictorial embroideries remained a mainstay of school curricula until the 1820s, when attitudes toward education for females began to change. As parents came to expect their daughters to have a sound understanding of history, geography, and literature, the emphasis shifted away from ornamental needlework. After 1830, girls still stitched samplers in schools, but these were simple pieces, meant only to teach the skills of plain sewing.

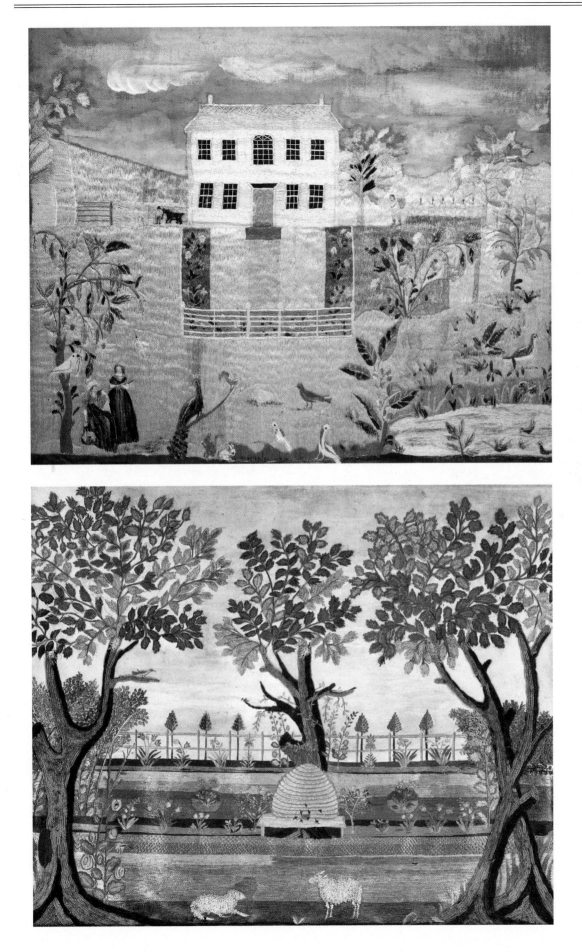

Phebe Carleton of Andover, Massachusetts, included a view of her family home in the satin-stitched pictorial embroidery above, made in the 1790s. The young lady who created the unusual garden scene at left, in the early 1800s, made imaginative use of her needle, working the sheep in French knots and using tiny cross-stitches to suggest bees buzzing around the hive. Both pictures were done in silk on silk; the skies were rendered in watercolor.

Mourning Pictures

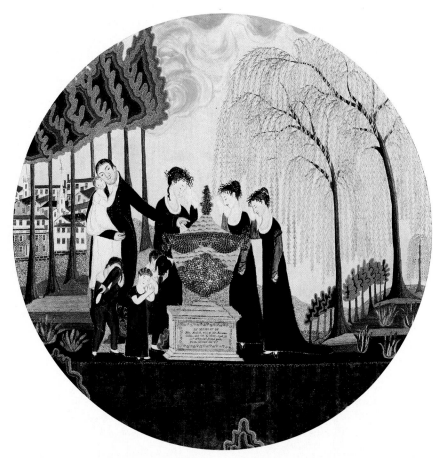

The countless memorial pictures produced in the early 1800s are an intriguing expression of a national fascination with mourning that had been set off by the death of George Washington. When the president died in 1799, America faced the loss of its greatest hero. Soon, images honoring him—and the ideals of classical democracy that he embodied—appeared in parlors across the country.

As mourning art caught on, schoolgirl versions, usually commemorating a departed family member, soon appeared. The earliest works were embroidered, but after 1815, watercolors—on silk, paper, or velvet—began to replace the needlework pieces. The imaginary landscapes depicted nearly always included an urn on a plinth. Two types of trees also appeared: the willow, which has the power to regenerate after it is cut; and the evergreen, a symbol of everlasting life. Always present was a distraught female fashionably outfitted in a Grecian-style dress, or a more sedate family of mourners, sometimes with hankies in hand.

Despite their melancholy subject matter, however, such pieces were not morbid. Their symbolic imagery, often drawn from Greek and Roman mythology, suited the contemporary taste for classical design, raising the pictures to the height of sophistication.

Mrs. Ebenezer Collins was honored in the embroidered 1807 memorial above, done in silk and metallic chenille thread. The Hurlburt watercolor memorial, right, dates to around 1810.

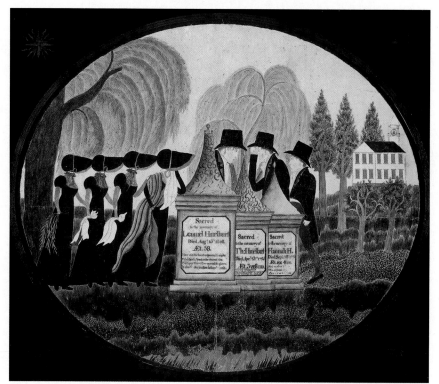

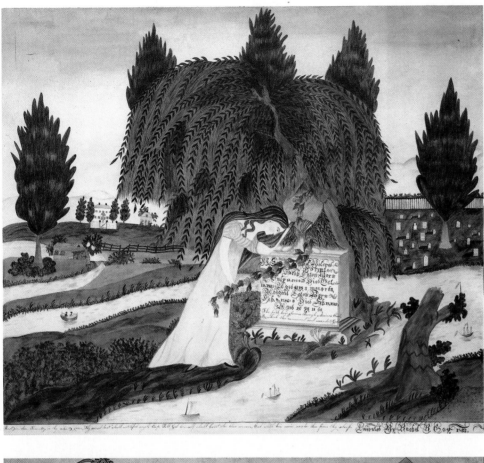

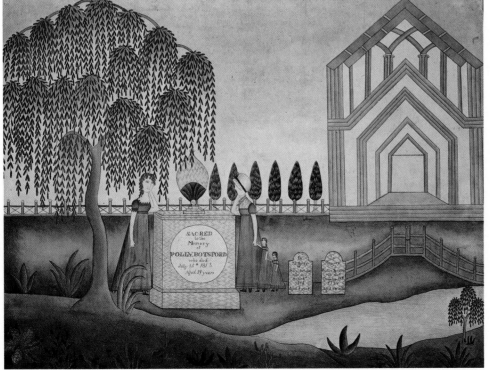

In Rachel Gay's 1833 water-color memorial, above, a single mourner adds her tears to the river of life—while towering over the ships that sail by at her feet. Scale was also of little concern to the painter of the eerily lovely memorial for Polly Botsford and her children, left, done around 1815. Depicted as miniature adults, the little girls are dwarfed by their elders. The abstract rendering of the church in the background is highly unusual.

Classroom Views

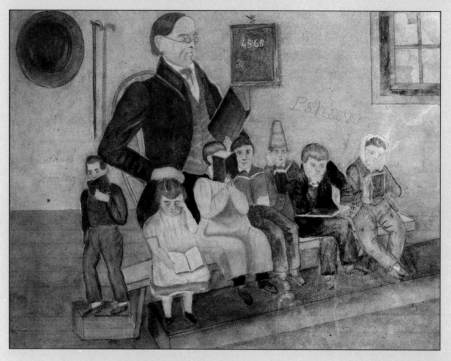

Unhappy scholars appear in this c. 1852 picture by Jonathan Jennings.

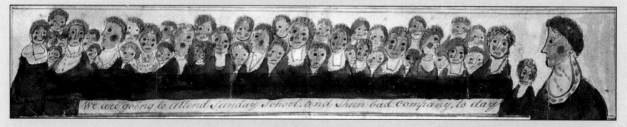

We are going to attend Sunday School and shun bad company, to day

A c. 1810 watercolor depicts rosy-cheeked pupils in Sunday school, where youths were taught their ABCs along with religious principles.

Country schoolchildren provided folk artists with lively subjects to capture in paint. In turn, the paintings have left us with a clear, if sometimes comical, impression of early American education in its various forms.

Although schools had existed since the 17th century, it was not until the end of the 1700s that formal education became widespread. Private academies were one alternative, but as tuition at this time cost about $12.00 a year and room and board might run $1.50 per week, not everyone could afford them.

In the 1800s, less privileged students went to one of the free district schools—or one-room schoolhouses —that were common. Here, in small, cramped classrooms, children of all age groups sat on long, backless benches to recite their lessons. Attendance was not mandatory: boys frequently were called away by farm work, and girls generally stayed at home in the winter.

Various sects, such as the Mennonites, Quakers, and Moravians in Pennsylvania, opened their own schools to ensure the quality of their children's academic and religious training. Some, offering needlework along with history and geography, were considered to be on a level with the best private academies.

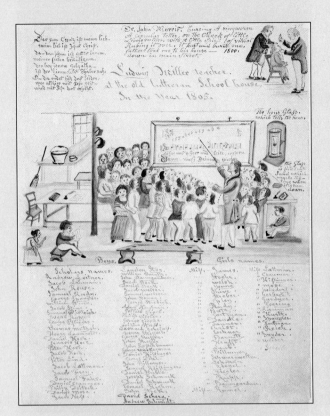

An 1805 picture by Lewis Miller shows a music lesson in a Lutheran schoolhouse in Pennsylvania.

A schoolmaster reads to his two charges from the Ten Commandments in this c. 1815 watercolor.

A detail from a c. 1810 watercolor on silk shows students studying geography at a seminary for young ladies.

Still lifes were favorite subjects for schoolgirl theorems. The compact arrangement of fruit in the painting above is typical, while the 1830s composition at right, signed by the artist, shows far more imagination. In addition to stenciled elements, it features many hand-painted details, including the knife, fork, and watermelon seeds.

Cynthia L. Sears. Sharon

Theorem Painting

By the 1820s, most academies had incorporated stencil painting into their curricula. In exercises designed to teach the "theorematical system of painting," students used stencils to create compositions in pastel or paint. Framed and displayed, the works—on silk, velvet, or paper—were considered as respectable as freehand paintings, and a craft once associated with decorating walls and woodwork was now elevated to "art."

Theorem painting peaked as a fad around 1840. One factor behind its popularity may have been that it could be done successfully by virtually anyone. Using oiled tissue paper, students usually traced their patterns from books or drawings, and constructed their pictures—often still lifes—according to specific instructions. Once an artist found a successful formula, she was apt to stay with it, employing the same stencils in new pictures. Nevertheless, some girls followed their imaginations, cutting their own stencils from pasteboard, and using hand-mixed paints to color and shade the fruits and flowers in handsome and unusual compositions.

Velvet was a popular fabric for theorem paintings because its napped surface helped soften the division between each stenciled element. The painter of the theorem on velvet above carefully drew in the pattern of the basket weave with pen and ink.

Decorated Tables

While stenciling was often used for making pictures, it was not uncommon for schoolgirls to apply the technique in decorating household objects; painted workstands and dressing tables were particularly fashionable "art works" in New England schools from about 1810 to 1830.

Parents normally provided the basic tables, which were made of an unfinished, light-colored wood that would show off the decorating skills of their daughters to advantage. Bird's-eye maple was the most popular material, and if a table was made of a plainer wood, such as birch, painted bird's-eye graining was sometimes added. The tables themselves ranged from simple country pieces—which were inexpensive and appropriate for youthful handwork—to finely crafted one-drawer stands that were obviously intended to be displayed proudly in the home. In some instances, matching trinket boxes were made to place on top of the tables.

For the table decoration, stenciling was typically combined with freehand painting and perhaps pen-and-ink drawing. Stenciled fruit baskets or painted landscapes were favored for the tops. The landscapes were usually European scenes inspired by popular engravings of the day, but occasionally they showed local views. These central designs were sometimes flanked by stanzas of romantic poetry, handwritten in India ink. Motifs for the table skirt and drawer fronts included seashells, floral garlands, and even horizontal views of towns, and the table legs might be entwined with painted vines, garlands, or tasseled cords.

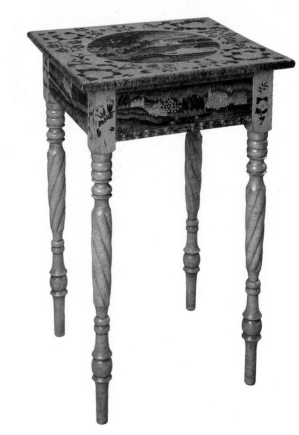

This tiger maple workstand was probably painted between 1810 and 1825 by a schoolgirl. The top shows a view of the state house in Concord, New Hampshire.

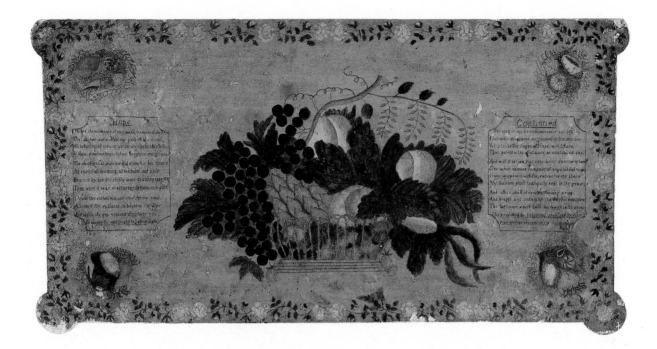

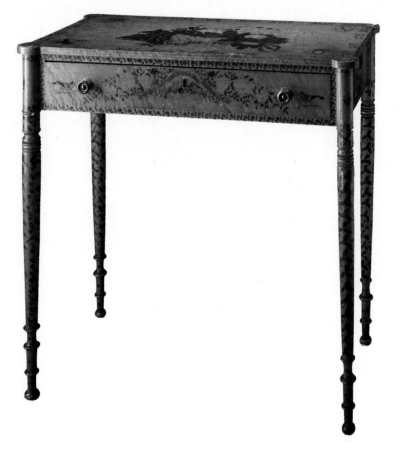

Decorated by Elizabeth Paine Lombard in 1816, this dressing table features verses, entitled "Hope," by the English poet Alexander Pope; the still life is a typical theorem painting.

Painted
Scenes

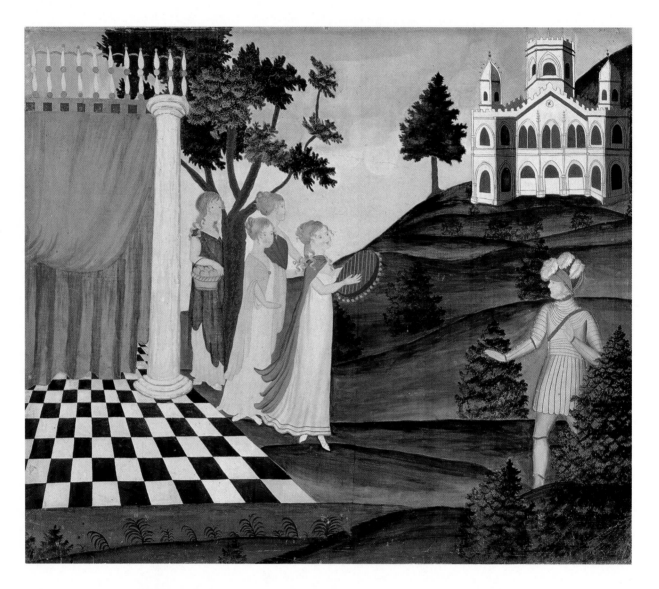

Several schoolgirl versions of the Bible story of Jephthah's Return are known. The example above, detailed with gold paper cutouts, was painted by Betsy Lathrop around 1812.

By the 1830s, freehand watercolor painting had all but replaced needlework as the most common of the schoolgirl arts. Painting on silk or paper was certainly easier on the eyes than painstaking stitching, and took less time. The turnabout in disciplines also reflected changing attitudes toward women's education, which suggested that needlework and stenciling need not be a female's only skills.

Painting was considered an "extra" at schools, and carried an additional charge beyond tuition. At one Vermont academy in the early 1840s, drawing and painting were offered for one dollar per year, a price that included "the use of patterns;" patterns were prints and illustrations that generally served as the basis for students' work.

The subjects that schoolgirls favored for their paintings were often inspired by biblical stories,

Hail, bright Aurora, fair Goddess of the Morn!
Around thy splendid Car, the smiling Hours submissive wait attendance, ascend—and
reillume the face of Nature with thy refulgent beams, & from the Arch of Heaven banish night.

mythology, or literary and historical themes, which were all extremely popular in the then burgeoning age of romanticism. Calypso and Ulysses, Moses in the bullrushes, and the prodigal son were typical, as were patriotic scenes that included images of George Washington, Napoleon, or the Goddess of Liberty.

Similar watercolors that evidently stemmed from the same print source usually display variations in detail, which were added by their imaginative painters. The scenes themselves also show a fair degree of artistic license: the Old Testament scene of Jephthah's Return, opposite, for example, features an English church in the background. And in the distinctive painting of Aurora, above, the Roman "Goddess of the Morn" is shown driving her horse-drawn chariot over a coastal village in New England.

A printed verse glued to the watercolor above identifies its airborne subject as Aurora. Five known related versions of this scene indicate that a print served as the source.

THE ROLE OF PRINTS IN SCHOOLGIRL ART

MOUNT VERNON in VIRGINIA
The Seat of the late Lieut General GEORGE WASHINGTON
Commander in CHIEF of the Armies of the United States

A print often copied by schoolgirls was *Mount Vernon in Virginia,* engraved by Francis Jukes in 1799, after a painting by Alexander Robertson.

While girls enrolled in academies to learn artistic skills, the object of their lessons—initially in needlework and later in watercolor—was craftsmanship rather than inventiveness. Purely original compositions are rare in schoolgirl art; instead, most were based on popular prints.

Most often English in origin, the prints that found their way to private academies were often copies of contemporary paintings. Students could consequently rely on the work of recognized artists to guide them through the intricacies of integrating color, shadow, and perspective in a picture while they mastered fine stitches and brushwork.

Typically, the schoolgirls selected works that demonstrated their familiarity with historical subjects, such as scenes of famous landmarks; the engraved view of Mount Vernon, above, for example, inspired many schoolgirl versions, including the three watercolors opposite.

The pictures that schoolgirls produced were rarely exact copies of the prints, however, and often surpassed the originals in liveliness and boldness of design. The degree of variation often depended on the materials being used. For instance, an engraving might be copied in embroidery by one girl. Her embroidery could in turn be copied in paint by another girl, who would take great pains to re-create the delicately stippled effect of the stitching even though she was using watercolors instead of thread.

Thus, from print to needlework image and finally to watercolor, schoolgirl pictures were far removed from the original paintings the prints had copied. The compositions might remain essentially the same through every step, but variations in detail represent the individual interpretations of the young artists.

The schoolgirl who painted the c. 1810 view of Mount Vernon, left, evidently had trouble understanding how light creates shadows: those of the three trees by the house do not match the trees themselves. The departure from reality nevertheless creates a charming effect.

Susan Whitcomb was a student in Vermont when she painted the lively version of Mount Vernon, right, in 1842. The foliage of the tree in the foreground resembles crewel embroidery, which indicates Whitcomb was working from a needlework version of the print.

Eleven-year-old Anna Williams painted her 1811 view of Mount Vernon, left, at Deerfield Academy in Massachusetts. She chose an imaginative palette, adding a deep red for grasses and the fernlike tree branches, and using dark blue for some of the flowers in the foreground.

Leaping deer and prancing horses were among the most popular copybook subjects for learning calligraphy, since their curved bodies were suitable for the rhythmic repetition of pen strokes and flourishes. The elaborate drawing with calligraphic deer, above, dates to around 1860. The c. 1850 drawing of the horse at right is thought to have been done in Pennsylvania.

Calligraphic Drawings

Fine penmanship was considered an indispensable facet of a young man's education by the early 1800s. Elegant handwriting was required of schoolmasters, and it was highly recommended for any professional who expected to succeed in business. By executing elaborate drawings, schoolboys could practice the cursive script and calligraphic flourishes that were the mark of a distinctive hand.

The sources for most calligraphic drawings were penmanship manuals, used in schools and by people who wished to teach themselves at home. Although such manuals often included advice—how to sit "in a proper attitude for writing," for example—they served primarily as copybooks, filled with pages of letters, words, and drawings ingeniously composed of fluid calligraphic pen strokes.

The best calligraphic drawings are those by enterprising students who might incorporate a copybook drawing—often of an animal—into a landscape setting while adding original details. Elaborate works were specially prepared for "Exhibition Day" at academies, when the students showed off their skills for visiting family. Other calligraphic pieces were created by the writing masters themselves as rewards for particularly deserving penmanship students.

Fine penmanship was stressed in a boy's education, but some schoolgirls practiced calligraphy as well. The flourished birds at left were produced by both girls and boys in a handwriting class taught by Miss Lillian Hamm sometime after 1850. The small birds were first done on cards, then pasted onto a larger calligraphic drawing. The drawing was then presented to Miss Hamm as a gift.

Paper Art

Made around 1785, the still-life composition above displays several mediums and techniques. The fruit and bowl were done in watercolor, while the flowers were made from pieces of silk ribbon, calico, and paper cut and glued in place. Finally, the entire outline of the design was decoratively pinpricked.

The artistic skills that students learned in school—still-life composition, watercolor painting, and calligraphy—often extended beyond classroom exercises. Fanciful pictures were made both during school days and in the years after, as decorations for homes and as gifts for loved ones. Often these works were enlivened with techniques such as pinpricking, which added dimension to the surface of a sheet of paper, and cutwork, which involved using scissors to create intricate, lacy patterns.

Pinprick work was a popular novelty among schoolgirls in the 19th century. By pushing a pin through the back of a piece of paper, it was possible to make a raised outline that was espe-cially evident when the picture was held up to light. In some pictures, closely spaced pinpricks were used to create a nubby surface that might suggest fabric, foliage, or an animal's fur.

Cutwork pictures were particularly popular in Pennsylvania. The technique of folding a piece of paper and snipping away tiny pieces with scissors is identical to that of the German folk craft of scherenschnitt. Many 19th-century American cutwork pictures feature such designs as sailing ships, eagles, and flags, as well as the more traditional German folk-art motifs. Requiring great skill in design and execution, cutwork pictures might be painted and detailed with verses, or left plain, with the cutwork the sole decoration.

Frederick Williams was a sailor out of Portsmouth, Virginia, when he created this tour de force in cutwork, calligraphy, pinpricking, and paint; it commemorates the loss of an American ship.

Elements in the cutwork eagle design above, which was made in Pennsylvania around 1820, are painted with watercolor. The cutwork picture at right, which dates to around 1860, is decorated with embossed colored-paper ornaments.

Cutwork pictures served a variety of occasions in Pennsylvania-German communities. Susannah Starck, who lived in Lancaster County, Pennsylvania, made the mid-19th-century piece above, perhaps as a love token. The c. 1830 work at left, unusual because it is cut from gilt foil, is a mourning picture.

117

TOKENS OF LOVE

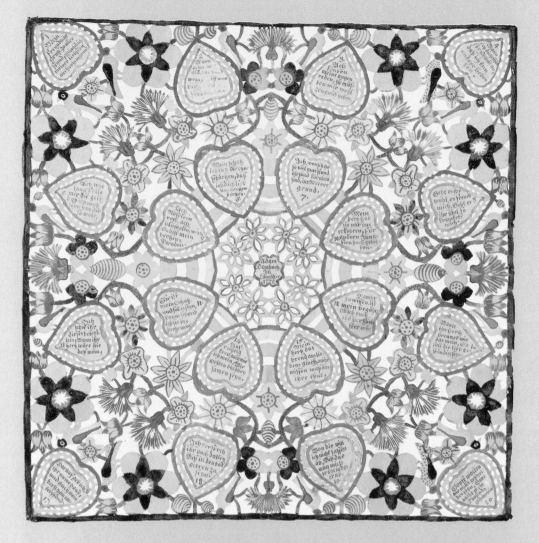

This hand-drawn 1779 cutwork love letter was probably commissioned by Adam Dambach for his sweetheart; they were wed the next year.

The European custom of giving little trinkets and mementos to loved ones was continued in 18th- and 19th-century America by immigrant settlers. Unlike valentines, however, which were traditionally exchanged only on February 14th, these love tokens were presented throughout the year, as a gesture of friendship, a symbol of betrothal, or an expression of esteem, perhaps for a beloved teacher.

While sentimental pieces such as those shown here might be originated by students, love tokens were also often made outside the classroom— by men and women alike. A suitor handy with a penknife, for example, might carve a pretty bobbin for his sweetheart, while a skilled seamstress might stitch a bit of silk with a verse for her gentleman friend.

Among the most common, and intricate, love tokens were those hand-crafted of paper and often elaborately decorated with paint, ink, or cutwork. Paper love tokens were sometimes shaped as hearts, or as hearts and hands, symbolizing the giving of one's hand in marriage. A number of love tokens featured clever wordplays, while others were made as intriguing "purses," which could be folded into decorative patterns and opened to reveal endearing messages from the heart.

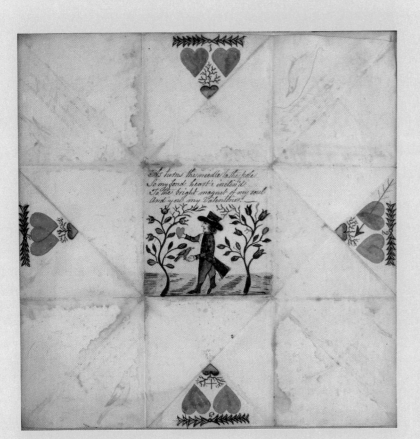

A c. 1790 watercolored puzzle purse unfolds to reveal a picture and verse.

An early-19th-century cutwork love token features knotted locks of hair.

This paper hand with "woven" heart and inked verse dates from the early 1800s.

This folding valentine was made in Virginia in the 1800s by Lewis Miller.

Tinsel paintings are distinguished by their rich colors and a sheen that was thought to resemble mother-of-pearl. Made in the mid-19th century, the tinsel painting above appears to have been done freehand, while the example at right was probably composed with stencils.

Tinsel
Paintings

The highly unusual tinsel painting at left, made in Pennsylvania in the second half of the 19th century, was designed as a decorative border for a daguerreotype portrait.

Fashionable in the 19th century, tinsel paintings were made by doing reverse paintings on glass and backing them with shiny tinfoil. The art of reverse painting on glass had been popular in America since the mid-1700s. In the early 1800s, the technique was used primarily for making the decorative panels on clock cases, and for embellishing looking glasses. It was also taught in many academies, where young girls made glass mats, reverse-painted in black with gold striping, that they used to frame their needlework pictures.

By the 1830s, tinsel painting, or "Oriental work" as it was also known, had become a vogue in schools from New England to Pennsylvania.

Favoring floral and still-life compositions, the girls started their pictures by drawing or stenciling a design on a sheet of glass with pen and ink. Details and shaded portions of flowers, fruit, or a bowl were added with ink or oil paint. The background received a coat of opaque color—usually black or white—while each leaf and flower of the composition was individually delineated with a transparent wash. When a sheet of crinkly foil was affixed to the back of the glass, the metallic surface showed through the transparent areas and the picture sparkled. By the late 19th century, the technique of tinsel painting was featured in women's magazines, and became a popular home craft.

121

Expressions of the People

folk art from the hands of amateurs

The spirit and ingenuity inherent in American folk art is perhaps best represented in the works produced by talented amateurs, who were able to turn out remarkable pieces without benefit of art schooling or professional training. While many individuals led austere lives, there was still room for beauty, and even the most ordinary of homemade household accessories could become works of art in the hands of a gifted seamstress or back porch whittler.

Much of the folk art in this chapter—including quilts, rugs, table covers, pie jaggers, canes, dolls, whirligigs, and boxes—reveals the skill with which "useless" scraps from the sewing basket or woodpile were transformed into objects of pride. Some pieces were purely functional, while others had no purpose but to amuse. In all, however, the efforts of their makers to find a creative outlet and bring a bit of sparkle into daily life are readily apparent, giving these works an irresistible appeal.

A detail from an embroidered and appliquéd 19th-century table rug (page 142) demonstrates a woman's skillful needlework.

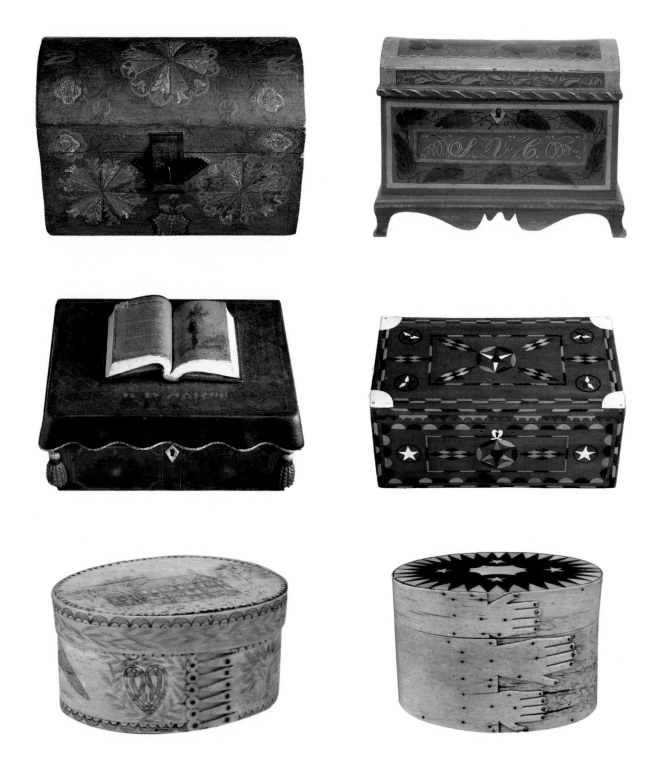

Clockwise from top left: a painted wooden box with an iron latch, marked inside with the date 1800; a dome-lidded trinket box, c. 1830; a New England wooden box inlaid with whale ivory and baleen; two whalebone ditty boxes; and a carved and painted lectern box, c. 1865.

Decorated Boxes

Used to store and safeguard all manner of belongings—from jewelry to candles—boxes were once considered to be among a household's most indispensable accessories. Often made as gifts, they could also be among the most decorative. Exceptional boxes, such as the 18th- and 19th-century examples opposite and above, were not mere containers but individual expressions of creativity and fine craftsmanship.

Many of these boxes are interesting for their form alone. Some, fashioned by skilled woodworkers, were conceived as miniature chests or dome-topped trunks complete with dovetailed joints, scrolled skirts, bracket feet, and even decorative crests—just as a full-size piece of furniture might be. Such boxes often reveal painstaking attention to detail, including intricate wrought-iron hasps, ivory escutcheons, and small but perfectly proportioned drawers fitted with tiny hand-turned knobs.

The material and decoration of folk-art boxes varied greatly. Those fabricated with whalebone or mahogany were often the work of sailors, who fashioned impressive ditty, or storage, boxes from exotic materials encountered on their voyages. Boxes might also be made of leather, papier-mâché, or straw; most typical, however, were those of tin or wood. The latter were frequently embellished with carving or some other kind of surface decoration. Painted boxes, in particular, were extremely popular during the first half of the 19th century, and they were finished using a range of techniques, including stenciling, sponging, and graining. Artists who were handy with a brush might also apply freehand designs that often had personal meaning for the owner of the box.

Wall boxes were often carved with a cut-out design that would show in silhouette when the box was hung up. The 18th-century Connecticut pipe box above left features a heart-and-scroll crest. The scroll on the candlebox above right was a motif typically used by craftsmen in the Connecticut River valley, where this box was made around 1800.

Scrimshaw
Pie Jaggers

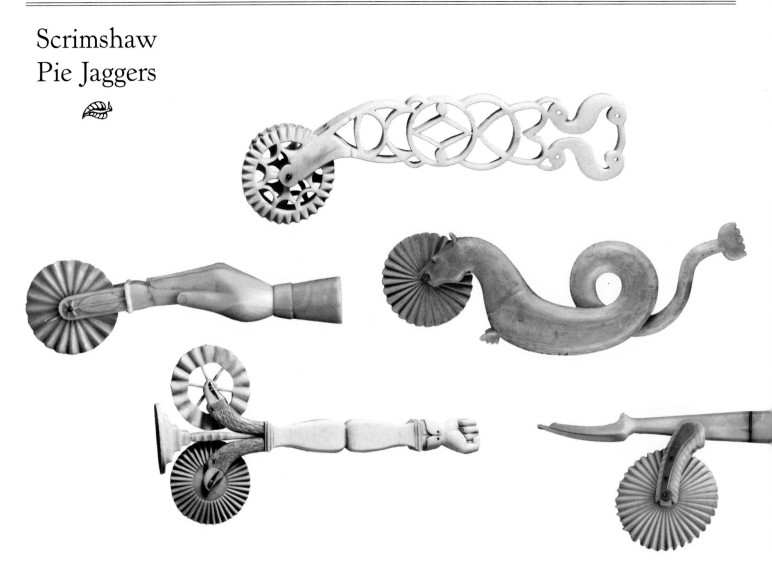

In the hands of the folk artist, even a kitchen utensil such as a pie jagger—an ingenious device that was used to seal, trim, and decorate unbaked pie crusts—could become a piece of sculpture.

The pie jagger was a favorite form for sailors working in scrimshaw, and it is this craft of carving and decorating whalebone and whale ivory that produced the most outstanding examples of such utensils. Scrimshaw developed in the late 18th and 19th centuries, when whaling was vital to the American economy. Hundreds of whaling ships sailed from such ports as Mystic, Connecticut, and New Bedford and Nantucket, Massachusetts, on worldwide voyages that often lasted for years. As sailors chased their quarry, months might pass between sightings, and boredom was unremitting. Noted one whaler in his diary in 1843, "I hope we'll see sperm whales soon. If we don't, I don't know but what I shall go off the handle."

To fill the long, empty hours, sailors took to carving the remnants of the hunt: the large teeth of the sperm whale, known as whale ivory, whalebone (especially from the huge jaw), and baleen, the flexible, hornlike membrane found in the mouths of the many whale species that lack teeth. If a narwhal was encountered along the way, its tusks would be used as well. The industrious sailors worked with whatever tools

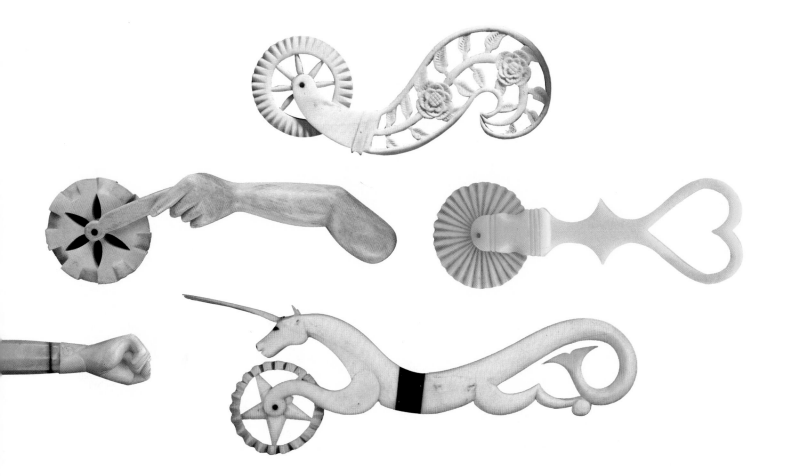

were available aboard ship, including jack-knives, awls, sailmakers' needles, even "sandpaper" made from sharkskin, to create souvenirs of their voyages as well as a range of sentimental trinkets that reminded them of home.

While boredom and Yankee thrift may have influenced the genesis of the craft of scrimshaw, many pieces nevertheless reveal an innate sense of artistry, which was further honed by competition among shipmates to produce the most beautiful designs. The expertise of the craftsmen is perhaps best seen in the delicate pie jaggers, made as homecoming gifts for wives and sweethearts, which are characterized by a masterful union of form, decoration, and function. A han-

dle, for example, might be transformed into a fanciful sea serpent or a lifelike hand, or be elaborately cut out with hearts, flowers, or other motifs so delicately wrought that they have the appearance of lace. The prong of the jagger, used for making holes in a top pie crust, became a slender unicorn horn or the sharp beak of a bird. The wheel might be modeled as a sand dollar, or be lavishly decorated, perhaps with tiny stars pierced or carved into its center and ornamental serrations cut into its edge. As a finishing touch, the jagger was often stained with tea or tobacco juice to produce a desirable amber color, then buffed until the surface was glossy and smooth.

A harmony of form and function is apparent in the scrimshaw pie jaggers above, carved by New England whalers in the mid-1800s. The amber-colored pieces have been stained, while the bone-white examples were left natural.

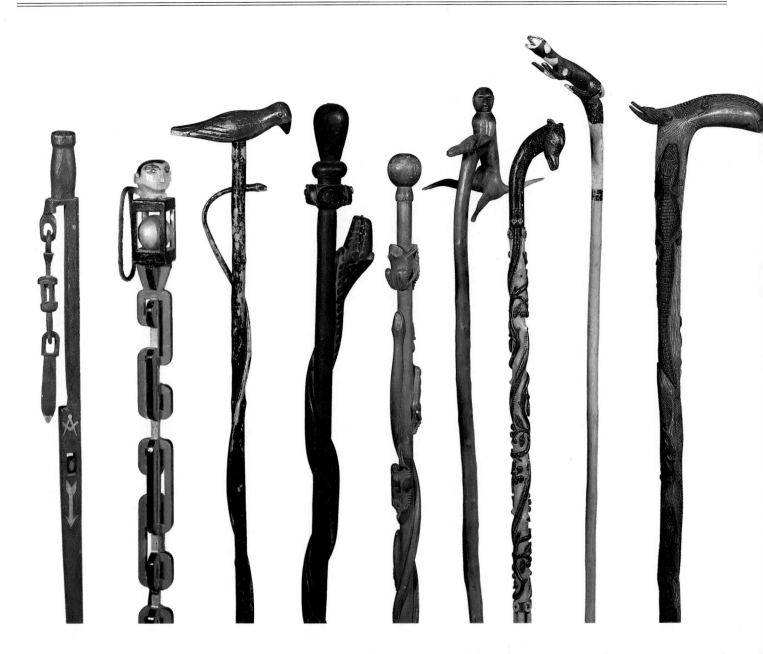

Each of the canes above is a testament to the talent of its maker. Often made by sailors, the intricate chains were "whimsies," meant to show off the carver's ability to turn a single piece of wood into an interlocking design.

Perhaps nowhere is the skill of the amateur whittler more evident than in the ornamental canes made in the 19th and early 20th centuries. These intriguing folk-art sculptures served as far more than walking sticks: displaying a range of motifs and themes limited only by the imaginations of their makers, they became personal statements of pride and prestige.

Some of the most fascinating canes tell a story about their carver or owner, or offer a glimpse into their interests or personalities. A Civil War soldier, for instance, might carve a cane with scenes recalled from the battlefield, while a patriotic citizen wishing to express pride in his country would use a cane with eagles, stars, or a portrait of a hero such as George Washington. Makers who belonged to fraternal organizations such as the Freemasons often worked symbols of their orders into their designs. And a number of canes, perhaps created as endorsements in political campaigns, were carved with the likeness of a favorite candidate.

Canes were frequently made from sturdy hard-

Ornamental Canes

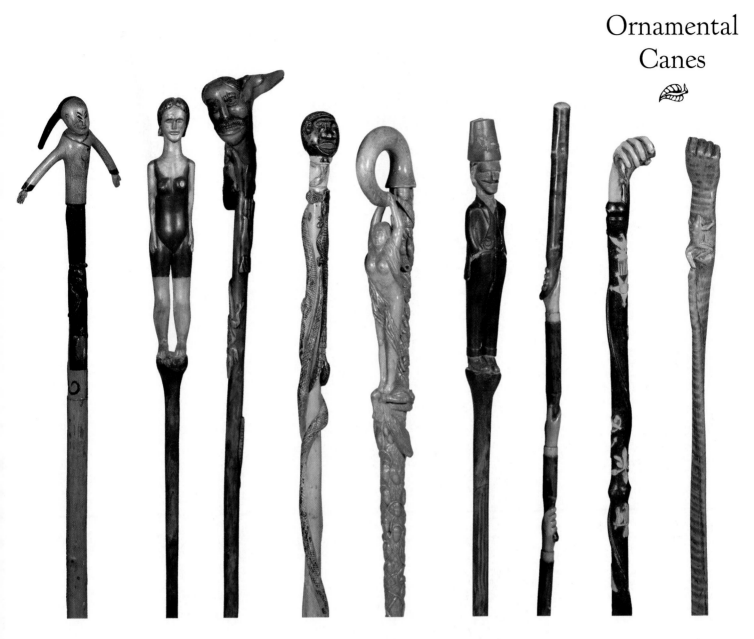

woods, such as hickory or ash, as well as soft pine, which the skilled carver used to show off his talents to full advantage. An entire shaft, carved from a single piece of wood—more often than not a tree branch—might be transformed into a chain or a spiraling snake, with a handle sculpted into a detailed human figure or face. On some canes, knots, burls, and crotches were incorporated as an integral part of the design: two twigs jutting from a central branch might become arms for a human figure, for example, or a root might be transformed into the body of a deer, with tendrils forming a pair of antlers.

While the natural color and grain of the wood sometimes figured into the design of a cane, most pieces were stained or painted. Painted decoration was often used to accentuate a carved design, although it could also take the place of carving. In addition to carved and painted ornamentation, many makers also incorporated a variety of imaginative materials into their canes as inlay—including whole glass marbles and chips of mirror, as well as the more typical ivory, wood, and brass.

The handles on many of the canes above proved to be a natural place for a rounded form, such as a human head or a fist. The shafts, on the other hand, lent themselves to innovative shapes of their own.

The makers of these 19th-century New England whirligigs used a variety of materials to create realistic garments. The Indian, top, is clothed in tin, while the Indian princess, bottom left, wears a leather dress and a metal cross; the uniform of the stern-faced sailor, bottom right, was carefully detailed in paint.

Sculptures
and
Whirligigs

Among the most intriguing examples of folk art are the sculptures and whirligigs that were made not for household or commercial use, but purely for pleasure. Small statues carved in wood can perhaps be described as the folk artist's version of a marble bust or a porcelain figurine. Frequently, pieces such as these reflected the conscious attempt by their maker to specifically create an "art work," but just as often they were the serendipitous handiwork of someone who was simply passing leisure time in an enjoyable pursuit. In either case, the best wood carvings, usually made with no more than a pocket knife, can convey a strong sense of charm and vitality that is particularly evident in pieces such as the striking horseman figures above.

That same spirit is also present in whirligigs, whimsical carvings designed to spin giddily in the wind when they are placed outdoors on a post or fence. When facing the prevailing breeze, such pieces could indicate wind strength, but their main purpose was apparently to amuse; indeed, these pieces created small spectacles as their paddle-shaped "arms" caught the wind and revolved.

Nineteenth-century whirligigs, like the two Indians and the sailor opposite, were primarily made in human forms, and might feature expressive faces and even detailed clothing added in paint or fashioned from durable materials like tin or leather. Whirligig makers also favored figures such as policemen and soldiers, perhaps because the dignity of these authoritative personages was immediately lost when their arms began flailing uncontrollably in the wind.

The carved horseman figures above, both dating from the late 1800s, are remarkable for the animated poses their makers were able to evoke from blocks of wood. The Indian hunter on the left is probably from New England, while the rider at right was found in upstate New York.

FOLK SCULPTOR
JOHN SCHOLL

Dove Chalice, among Scholl's early whittled pieces

A German immigrant who settled in Pennsylvania coal country in the 1850s, John Scholl spent his working life as a farmer and carpenter. It was not until 1907, however, when he was eighty, that Scholl began carving the remarkable whimsical wooden sculptures for which he is known. Before his death at eighty-eight he was to produce at least forty-five such pieces.

The impetus for Scholl's unusual work evidently stems from his early career as a mine carpenter and, later, as a house carpenter. By 1870, he had moved to Germania, a German settlement in the north central region of Pennsylvania. While Scholl began farming there, he continued to use his woodworking skills, building the family farmhouse—decorated with

his own original adaptations of Victorian gingerbread trims—as well as other structures in the town.

Throughout his working years Scholl also found time for whittling, creating little dancing figures and wooden "puzzles." His whittling may have led to his large, complex pieces, which also drew on his work as a carpenter. His freestanding sculptures often incorporated elements of the gingerbread, including fretwork and snowflake designs, that he once used to trim houses.

Scholl's European heritage was also an influence in his sculpture. His mechanical toys are related in feeling to those made in the woodcarving centers of Germany, and the bird and star motifs common in his work are seen in German art.

A small ferris wheel, one of the sculptor's mechanical toys

Mary's Star, one of Scholl's large
sculptures, called "celebrations"

A colorful "celebration," with
architectural scroll brackets

Homemade Dolls

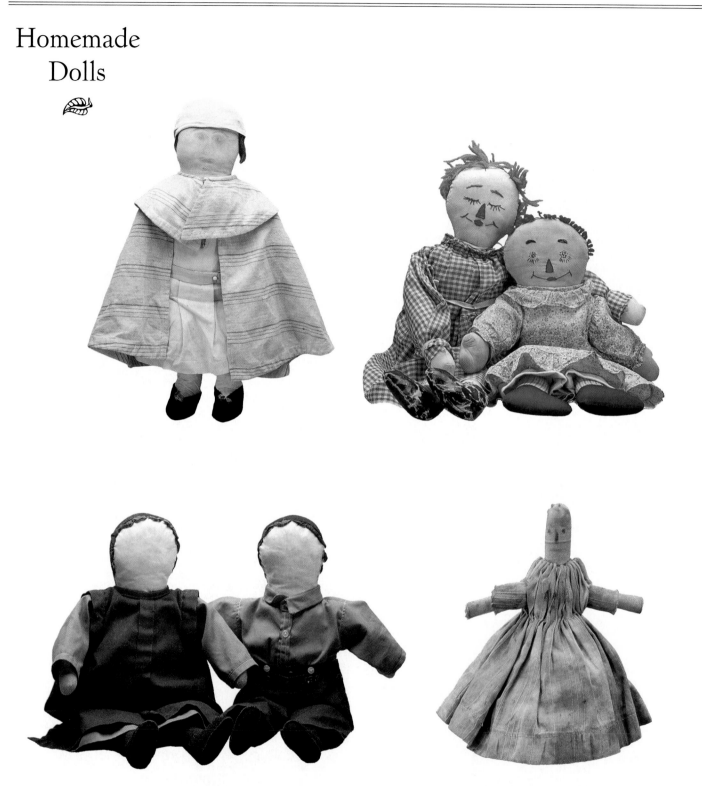

Clockwise from top left: a c. 1910 cloth doll with a flannel cape, velvet shoes, and a wig of human hair; c. 1920 homemade Raggedy Anns, modeled after the 1915 original; an early-19th-century cloth doll of folded linen with a homespun dress; and c. 1920 Amish dolls in traditional, somberly colored costumes.

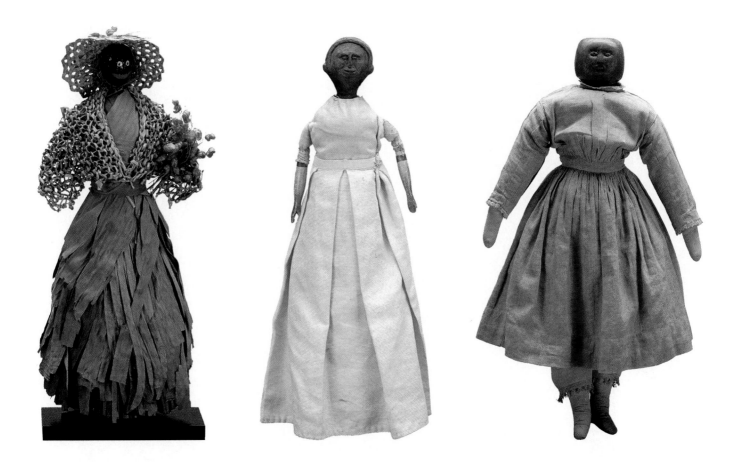

Homemade dolls such as those opposite and above are part of a long tradition in this country. Even after manufactured dolls became available in the 1800s, adults and children alike continued to turn whatever materials were on hand—rags, cornhusks, or bits of wood—into original playthings. "We never had a 'store' doll in our young lives," recalled one pioneer woman, Mary Halls, of her childhood in late-19th-century Utah. "As a substitute, we rolled some cloth . . . and fastened a three-corner piece, if we could find one, around the head."

Cloth dolls like those made by Mary Halls—many played with until they were in tatters—were among the most common. Because sewing was a routine activity in the home, scraps and needle skills were readily available. Dollmakers stitched fabric into bodies that might be stuffed with rags, straw, or sawdust, and sewed together all manner of miniature garments—from drawstring bonnets to lace-up booties.

Wooden dolls, perhaps carved from a stick or an old bedpost, then dressed in clothes, were also common, as were dolls made of "found" objects. A little girl with any imagination could see that a nut or dried apple would make a perfectly suitable head for a doll, and tobacco leaves an acceptable dress.

Make-do features might be penciled or embroidered on, or painted with vegetable and fruit dyes, and hair was made of yarn, thread, animal fur, or human hair. Distinctive cloth dolls, having no facial features and wearing black cloth caps, were made by members of the Amish sect, whose fundamentalist doctrine forbade the depiction of human likenesses.

The dolls above display an imaginative use of materials. The c. 1930 lady, left, is made of straw and leaves, with a walnut head; the 19th-century fabric-bodied doll, center, features a homemade wooden head and manufactured wooden arms; the mid-1800s figure, right, was crafted from a bedpost, and wears her original homespun cotton dress and pantaloons.

Pictorial Quilts

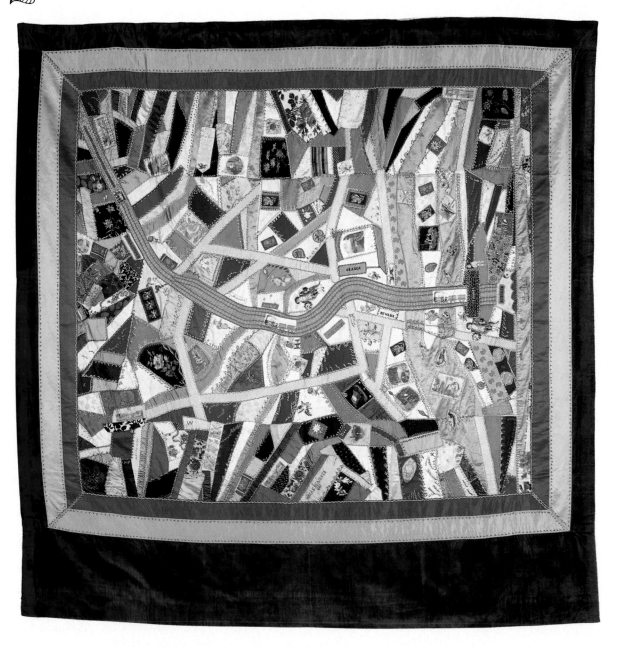

Mrs. A. E. Reasoner, the wife of a railroad superintendent, followed the route of a New Jersey train line in this 1885 crazy quilt.

One of the few practical—and therefore acceptable—outlets for a woman's creative impulses, quilts often served as an important statement of the personal views of their makers in the 19th century. Composed of scraps of fabric stitched into detailed de-signs, pictorial quilts in particular offer a vivid document of the significant events and social concerns of the day.

The exceptional late-19th-century quilts featured here reflect the impact of the developing railroad industry in America. Above, a crazy

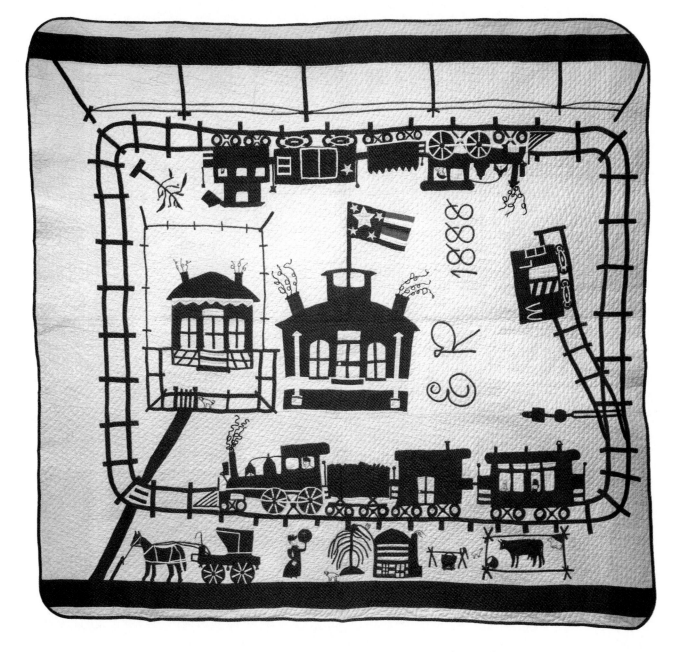

quilt made by the wife of a New Jersey railroad superintendent follows the path of the local line as it snakes through a patchwork of silk and velvet. Not only did the maker include the tracks—complete with trains, ties, and switches—but she also labeled station stops and stitched in local landmarks, including the Hudson River.

The quilt on this page was made by an invalid who lived in Peru, Indiana. The intensity of activity that she conveyed—with two trains chugging down the track, depot chimneys and locomotives billowing squiggles of "smoke,"

Continued

An invalid seamstress in Indiana appliquéd her image of the local Erie Railroad line on the 1888 cotton quilt above.

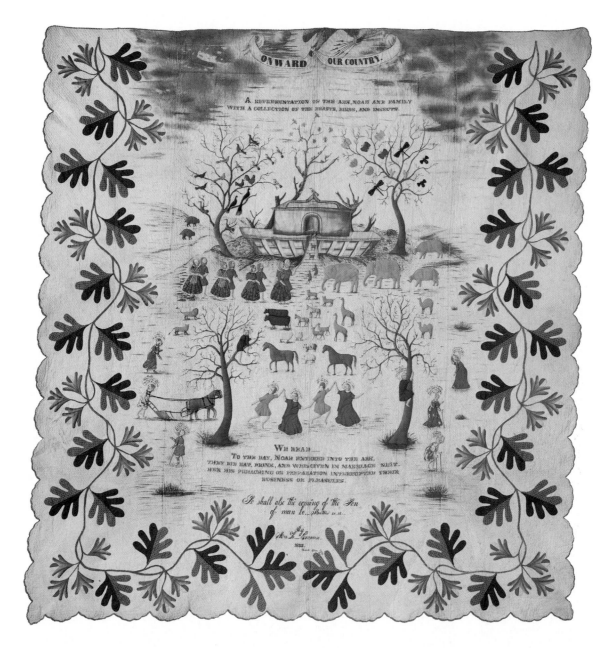

The 1835 quilt above, depicting Noah's ark, was not only sewn, but also painted and inked. Some figures and trees were worked in trapunto, for texture and depth.

and a bustling village—represents, perhaps, a bittersweet comment on the new age of mobility.

While industrial progress provided quiltmakers with a timely theme, Bible stories were an equally rich source of inspiration. The 1835 quilt above, worked in ink, paint, and appliqué, represents one woman's fantastical interpretation of the Bible story of Noah's ark. The theme is lofty, but the maker brought her subject down to earth by literally putting words—marked into cartoon bubbles—in the mouths of the little figures that people her composition. The characters certainly do have opinions of their own: "I'm perfectly disgusted, setch operations—pretending a flood," remarks one indignant individual.

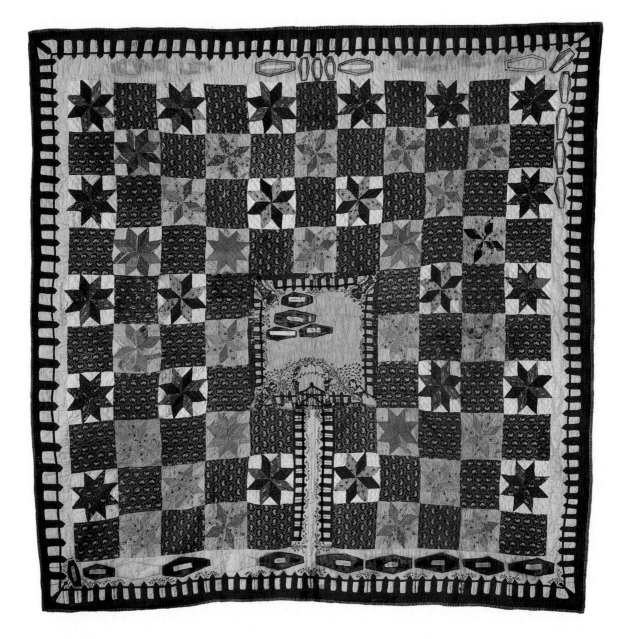

The cotton quilt on this page, made by a Kansas woman in 1829, recalls a time prior to effective medical care, when death was a frequent visitor in the home. To vent her grief at the death of two sons, she worked the image of a cemetery into her quilt and appliquéd small coffins tagged with the names of family members into the border. When a loved one passed away, the appropriate coffin was removed from the border and resewn in the central graveyard.

Because of the chosen medium—fabric and thread—these distinctive quilts have an almost naive quality. Yet, the very "compromises" the seamstresses made in regard to perspective and realism, colored with their personal sentiments, make such pieces moving works of art.

Elizabeth Mitchell created the quilt above—of pieced, appliquéd, and embroidered cotton—in 1839, to mark the deaths of family members.

ADAM AND EVE IN FOLK ART

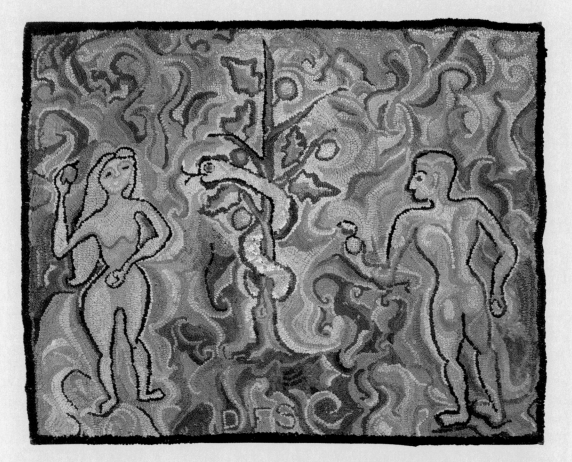

A 1910 hooked rug, made of rayon on a burlap foundation, and signed "D F S" under the tree

Religion has always been one of the most powerful influences on American culture, and one of the best-known biblical stories was that of Adam and Eve. With its inherent drama and universally recognized characters, the tale was a natural subject for folk artists, who often turned to the Bible for inspiration. From the 17th through early 20th centuries, the Garden of Eden and its inhabitants were captured on everything from painted chests to carved gravestones.

Some of the most charming depictions of man's fall were rendered in fabric. Women worked imaginative interpretations of the story into their quilts, samplers, and rugs, often embellishing their scenes with unique visions of Paradise. Images of birds and large butterflies soaring around the Tree of Knowledge, and animals frolicking in the garden, were incorporated into their pieces.

Many whittlers also fashioned woodcarvings of the famous biblical story. An artist working in three dimensions might add a little fence around Adam and Eve to suggest a sense of space. Among the better-known carvers of such Adam and Eve figures are the 19th- and early-20th-century folk artists José Dolores López of New Mexico and Wilhelm Schimmel of Pennsylvania.

Some Pennsylvania-German printers also used Adam and Eve motifs in their work. They published popular broadsides that featured illustrations of the two biblical characters. Printed on paper and frequently hand-colored, the broadsides were generally composed of a stylized version of the temptation of Adam and Eve, along with verse from a ballad or poem, and were often displayed in the home.

A cottonwood carving by New Mexico
artist José Dolores López, c. 1930

THE FALL OF MAN.

Man was by Heaven made to govern all,
But how unfit, demonstrates in his fall,
Created pure, and with strength endu'd
Of grace divine, sufficient to have stood,
But alienate from God he soon became
The child of wrath, pride, misery and shame,

An early-1800s Pennsylvania-German
broadside, *The Fall of Man*

A crewelwork picture on linen by
Mary Sarah Titcomb, c. 1760

A late-1800s painted woodcarving by
Pennsylvania artist Wilhelm Schimmel

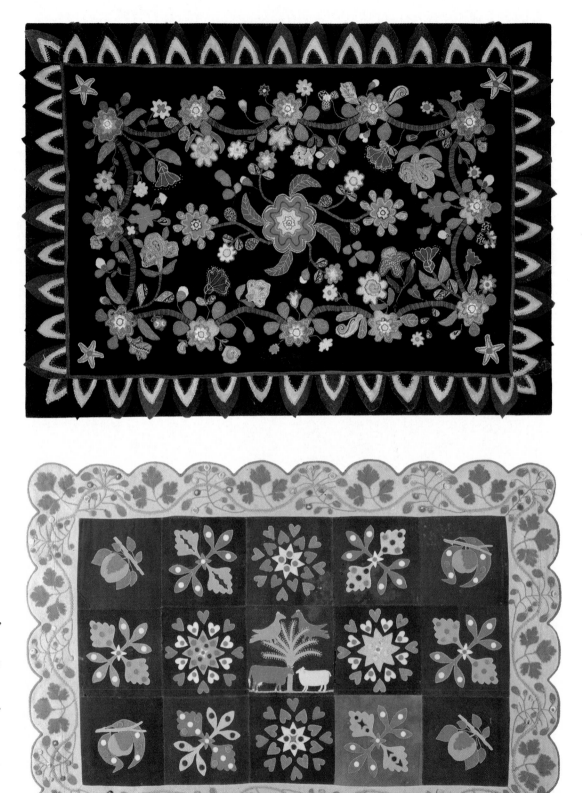

The c. 1830 New England table rug above, made of wool, is intricately detailed, with some of the appliquéd flowers built up in fabric layers. The c. 1845 table rug at right, made with wool appliqué on a woolen ground, features individual picture blocks, and resembles the album quilts of the period.

Table Rugs

The artistic skills of 19th-century needle-workers were often beautifully exhibited in table rugs, which were used as coverings for tables and chests instead of being placed on the floor. In both craft and imagery, these decorative textiles are more closely related to quiltmaking than to rugmaking, and some of the most intricate pieces resemble the album quilts that were especially popular at that time. Indeed, such table rugs were made in the same fashion as the quilts: women worked on small squares of fabric, stitching individual designs into each, then sewed all of the blocks together to create a larger, overall composition.

Table covers might also be crafted from continuous lengths of cloth, usually wool, decorated with appliquéd or embroidered patterns. As a finishing touch, many seamstresses framed their handiwork with a separate border, which could be as elaborate and carefully worked as the rug it surrounded.

The two woolen table rugs opposite were made in the early 1800s and display the flower and animal motifs that were so popular in that period. The late-19th-century appliquéd example above, however, represents an imaginative departure from the mainstream. In this piece, the Pennsylvania maker chose to fashion a mock tabletop of wool; set with fabric dishes and cutlery, and featuring a large platter of tufted fruits and vegetables, it is a masterpiece of whimsical trompe l'oeil.

The table rug above, made around 1870 in Pennsylvania, has a trompe l'oeil design appliquéd with cotton on wool. Its creator took pains to embroider a detailed floral pattern on the "china," and set out a platter of delectably plump fruits and vegetables.

143

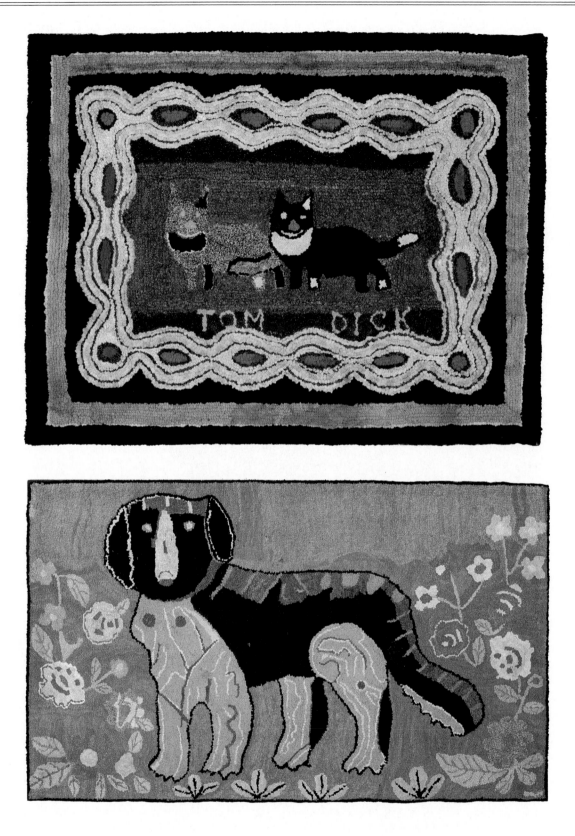

Animals, especially pets, were favorite motifs for hooked rugs. The c. 1915 rug at top features two distinctive cat portraits, and the c. 1895 piece at bottom depicts a St. Bernard.

Floor Rugs

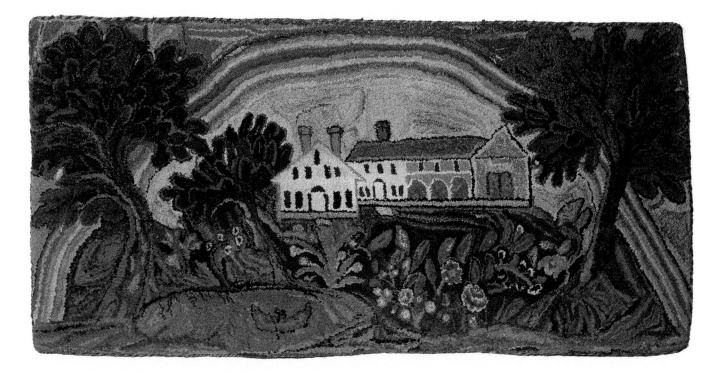

Small 19th-century floor rugs made from rags, remnants, and scraps exemplify the skill with which clever rugmakers worked bits of scrap fabric and yarn into handsome furnishings. Such floor coverings incorporated all manner of original images—from the family pet to the family homestead—and featured novel combinations of color and pattern that were in part dictated by the materials on hand.

Among the rug types made early in the century were the yarn-sewn rug, in which lengths of woolen yarn were sewn in a looped running stitch through a linen backing, and the shirred rug, made by gathering fabric strips and sewing them onto the backing. Such rugs were typically designed with nature panoramas, geometric motifs, animals, or even entire village scenes, and show a wonderful disregard for perspective or other artistic conventions; enormous trees, for

example, are apt to tower above tiny houses, and in many pieces, figures are flattened to two dimensions.

In the mid-1800s, burlap became available, and the loose weave of this durable material inspired the technique of rug hooking, which involved pulling strips of cloth through an open-weave foundation fabric. Since the fabric strips were a bit more difficult to work into tiny detail than yarn, the designs of rugs hooked through burlap tended to become quite simplified; many depict one large image—a house or flower, for instance—that could be rendered easily.

Beginning in the 1860s, rug backings with prestamped designs came on the market. Yet even when using such commercially made patterns, imaginative rugmakers could still vary their colors or improvise on the design to individualize the finished piece.

The hooked rug above— remarkable for its detail— was made around 1860 by Lucy Barnard of Dixfield Common, Maine, who used yarn and cloth on a burlap ground. While the house may have actually existed, the distorted perspective lends the composition a feeling of fantasy.

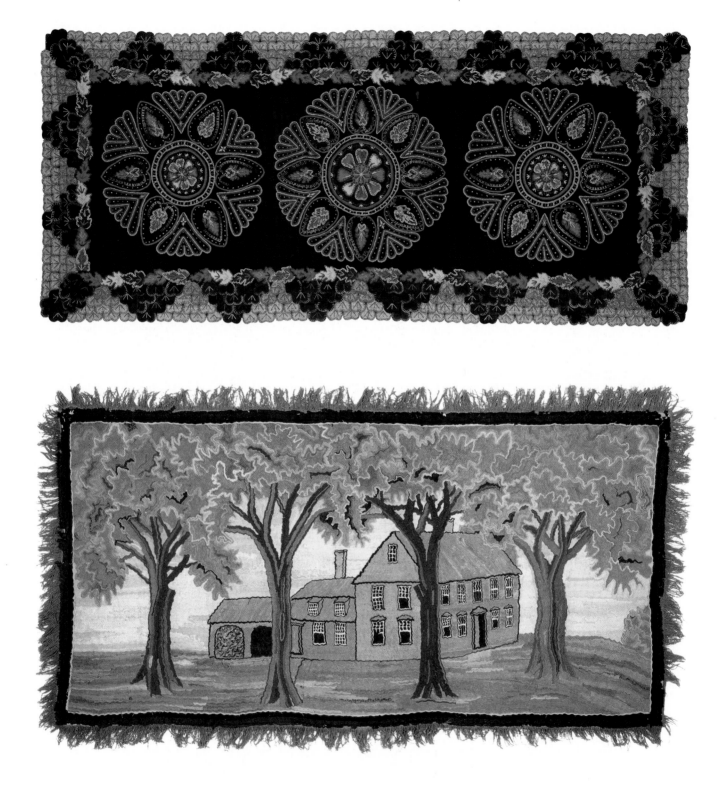

The 19th-century wool hearth rug at top, from Ohio, was stitched using a combination of appliqué and embroidery. Made in 1842 by Arabella Sheldon of Deerfield, Massachusetts, the rug at bottom is one of the earliest signed and dated examples displaying the shirring technique.

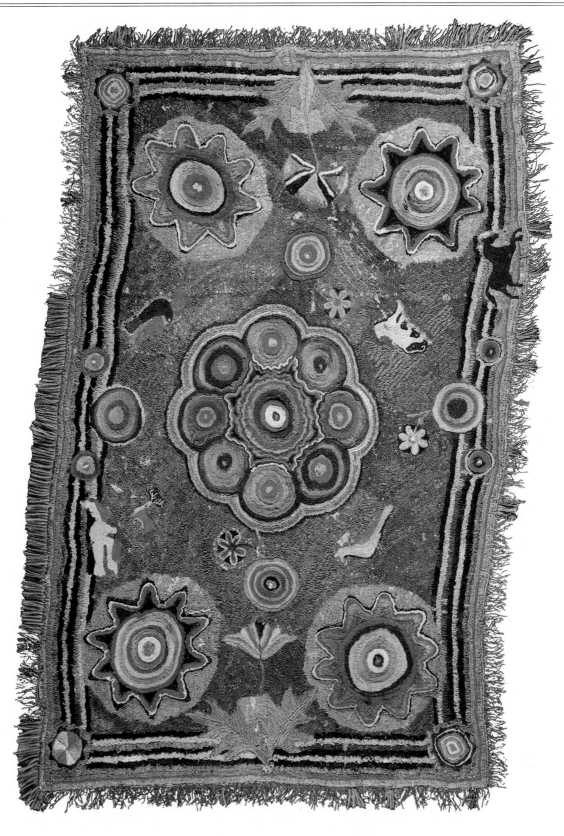

The delightfully disorderly c. 1825 wool rug above—with figures and flowers floating randomly—

was made with yarn-sewing, embroidery, and fabric shirring on a linen ground.

Living with Folk Art

three major collections

What is the particular appeal of folk art? Judging by the distinctive collections featured on the following pages, the answer might be found in an elemental beauty and sense of charm that makes this unpretentious art a pleasure to live with. The houses shown here are not museum environments, but comfortable homes where the collections can be enjoyed, admired, and touched. Folk art dominates every room: walls are covered with paintings and weather vanes, tables showcase whirligigs, decoys, and baskets, and in one house even the ceilings become display spaces—for a collection of hooked rugs.

Not insignificantly, each of the collectors felt an instinctive attraction to such works at an early age, captivated by pieces they saw at the homes of grandparents or family friends. Now, their houses express the pride they take in their own collections, which are intriguing expressions of their artistic tastes as well as important documents of America's early cultural heritage.

A fireboard painted around 1825 by the artist Rufus Porter is a handsome backdrop
for a primitive sailor whirligig and a duck decoy.

A Taste for Collecting

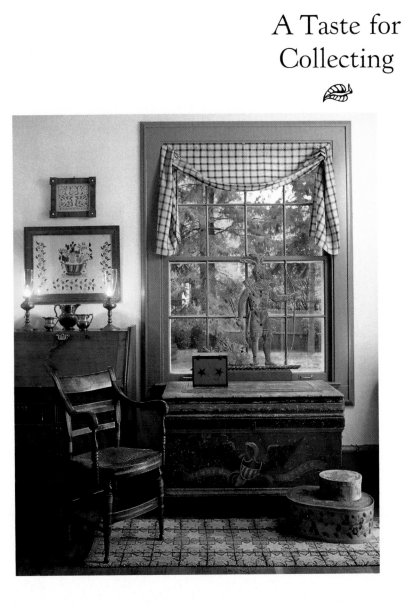

Nearly thirty years ago, the owners of this Minnesota house began collecting the whirligigs, weather vanes, paintings, and other works of folk art that today are displayed in every room of their home. Although there were few useful books on the subject to guide them in their search, they began buying folk art because they felt instinctively that it would withstand the test of time, and they

Continued

The 19th-century copper weather vane in the window above depicts the Wampanoag Indian chief Massasoit. It was made by J. Harris & Son, of Boston, Massachusetts.

Particularly prized among the 19th-century folk-art pieces displayed in the living room, left, is the overmantel, painted on three wood planks.

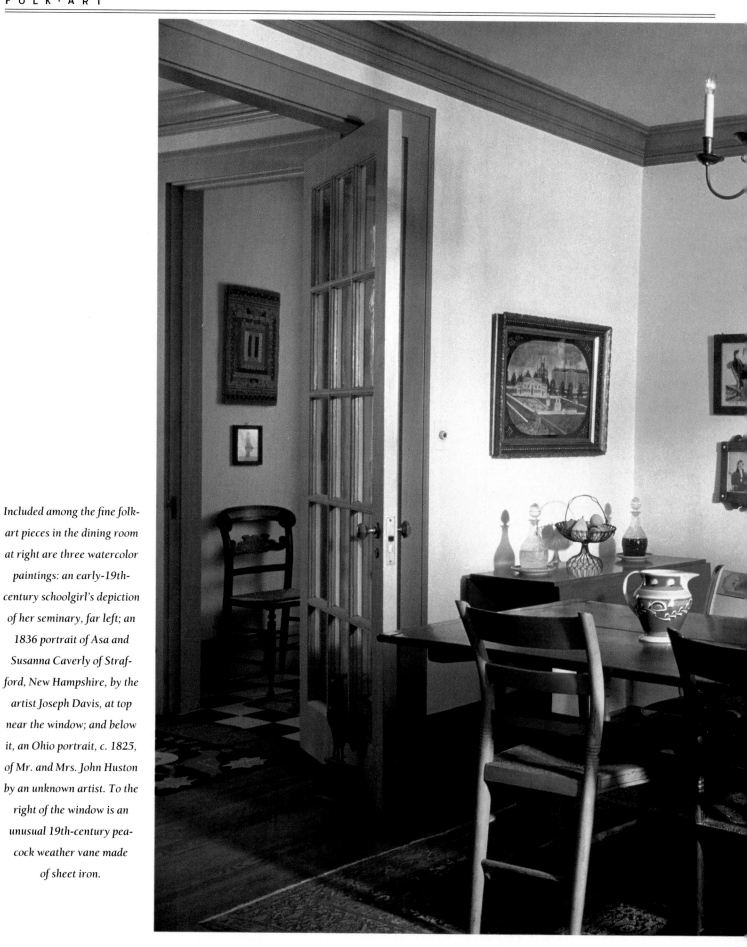

Included among the fine folk-art pieces in the dining room at right are three watercolor paintings: an early-19th-century schoolgirl's depiction of her seminary, far left; an 1836 portrait of Asa and Susanna Caverly of Strafford, New Hampshire, by the artist Joseph Davis, at top near the window; and below it, an Ohio portrait, c. 1825, of Mr. and Mrs. John Huston by an unknown artist. To the right of the window is an unusual 19th-century peacock weather vane made of sheet iron.

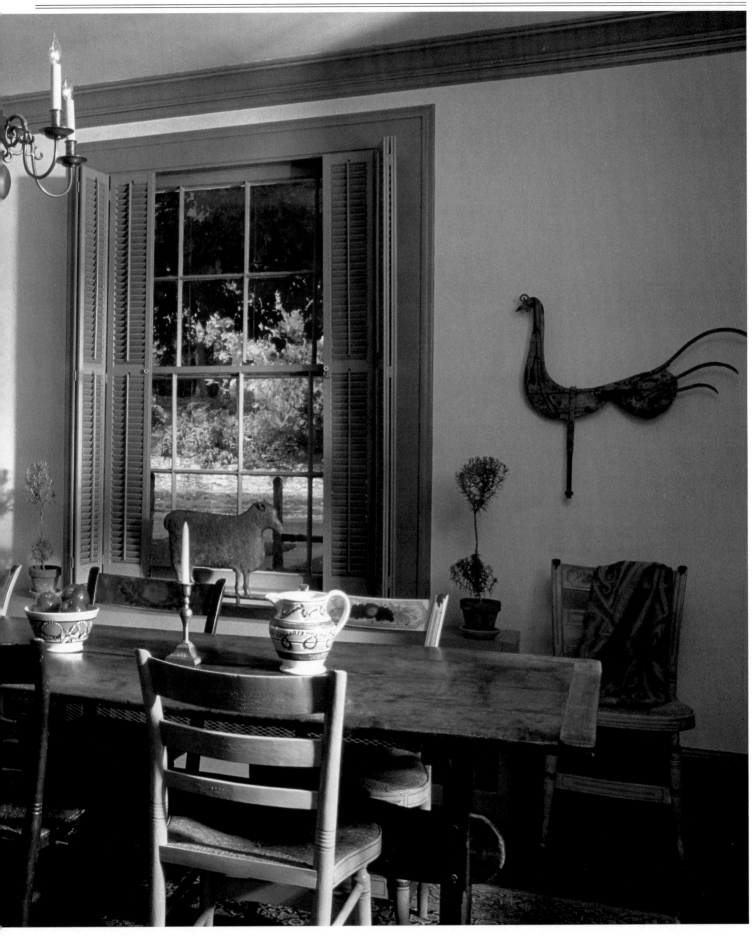

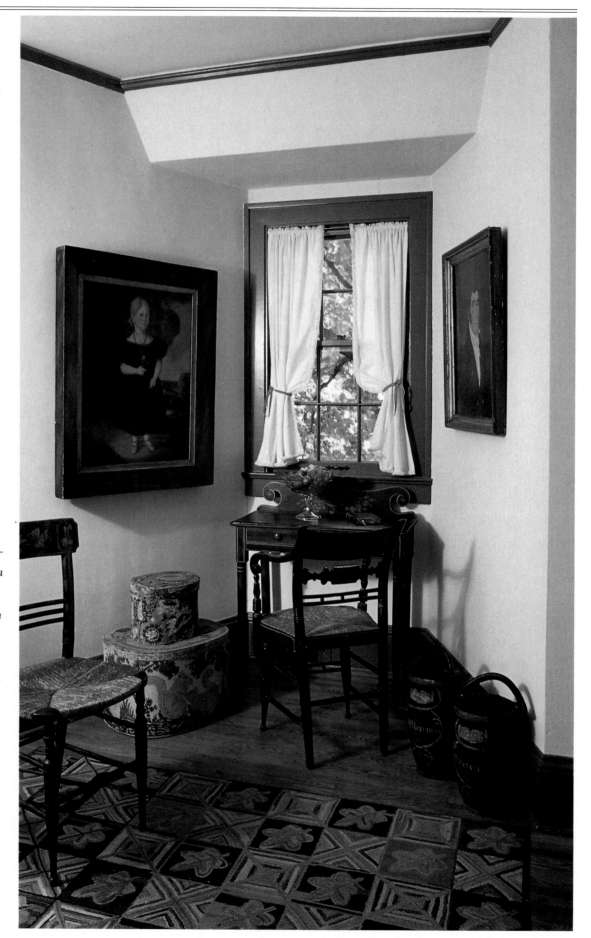

Two 19th-century portraits—
one of a young girl wearing a
necklace made of coral,
traditionally associated with
warding off evil spirits, and
the other of a sea captain—
hang to either side of a sten-
ciled desk from Maine in
an alcove of the master
bedroom, right. On the
floor are a pair of leather
fire buckets from the
1820s, both painted with
the name F. W. Mitchell
and an image of
clasped hands.

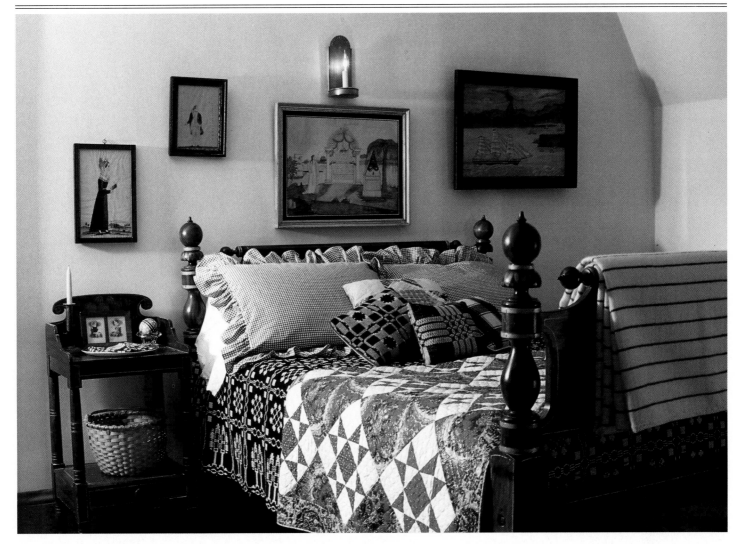

chose pieces that they thought had a classic look.

When the couple first started to collect, they traveled to New York City to search, but were intimidated by dealers who worked "by appointment only." Eventually they gathered their courage, telephoned a dealer, and bought their first good piece—a unique Amish farmer weather vane that now hangs next to the fireplace in their living room. Another early purchase was a carved wooden eagle mounted on the top of a newel post. They found the eagle in New York as well, and because they thought it might get damaged in the baggage compartment of the plane on their flight home, they actually bought a separate seat for it.

Today these collectors continue to buy folk art mainly in Manhattan, through a few dealers they

have come to trust, and at major antiques shows. Although they may have once acquired pieces sight unseen on the basis of advertisements, the couple now prefer to view a work in person so that they are better able to judge its quality before making the purchase. Still, their philosophy of collecting has not changed much over time; from the beginning, they have bought only pieces that they love. As a result, the couple have kept every item of folk art that they have ever purchased, and they freely admit that if they had to make a choice between furnishing their house or adding to their collection, they would always choose the art.

As the couple have gained experience as collectors, they have found that they are particularly drawn to pieces from the early part of the

Continued

Above, folk paintings in the master bedroom include, from left to right, a watercolor portrait of Maria Rex by Jacob Maentel, c. 1827; a c. 1760 watercolor of George III; an 1824 mourning picture recording deaths in the Streeter family; and an oil painting of an Italian volcano done around 1850 by a sailor who visited that country.

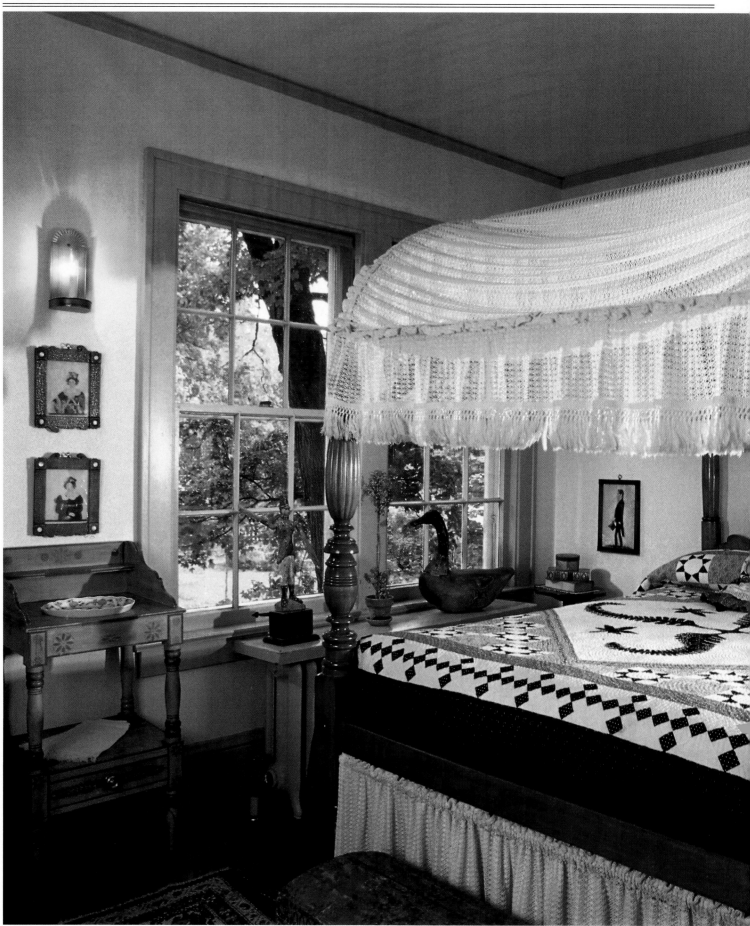

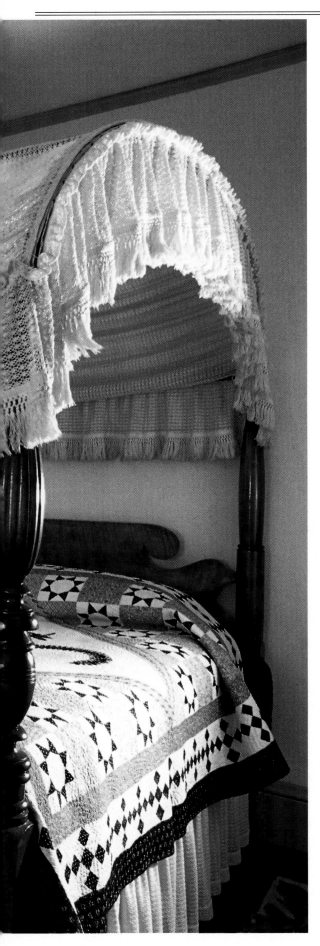

19th century and limit their purchases mainly to that period. Among their favorite acquisitions have been a circa 1815 overmantel that depicts a white clapboard house in Roxbury, Connecticut, and a circa 1825 fireboard painted by the well-known itinerant artist Rufus Porter. More recently, they have purchased a number of watercolors dating to the early 19th century by Jacob Maentel, who is known for his distinctive profile portraits.

These collectors say that living with American folk art from this period has influenced their entire way of life: they have come to prefer the pared-down existence of that earlier time. "This art has a spirit that can't be snuffed out," they explain. "It speaks to you about the way you should live."

A Canada goose decoy and a wood soldier whirligig are displayed next to a curly maple tester bed in the guest bedroom, left.

Two 19th-century milliners' heads draw attention to a wall display, above, that includes a theorem painting on velvet, a portrait of a Pennsylvania gentleman by Jacob Maentel, and a small framed birth record dated 1840.

An Eclectic Eye

T he owner of this collection of 19th- and early-20th-century American weather vanes and other folk sculpture, toys, and patent models likes to relate that the first words he learned to say were, "Can I take it home with me?" His childhood instinct has never left him. Objects gathered over the course of twenty years cover the walls and nearly every tabletop of this New Jersey house converted from a turn-of-the-century barn. Many of the pieces reflect long-standing interests in ships and classic cars: one of his prized possessions is a large weather vane, minutely detailed to replicate a 1931 Cadillac phaeton. Still other sculptures, from a Keystone Kop whirligig to a life-size carved boxer, appeal to him for their humor.

Since the large and varied collection was started, it has grown constantly, and the addition of new pieces has, over the years, become a pleasant addiction. Although this collector would never consider selling any of his folk art, neither can he display everything he owns; many things must be stored away. "When I look through the boxes, it's like visiting old friends," he says.

Yet as much as he enjoys being surrounded by his myriad treasures, he also feels that his possessions should be arranged attractively in a way that does not overwhelm his living space. The purpose in assembling so many

Continued

Among the weather vanes in the living room, right, are a copper, iron, and wire witch and a copper replica of a 1931 Cadillac phaeton.

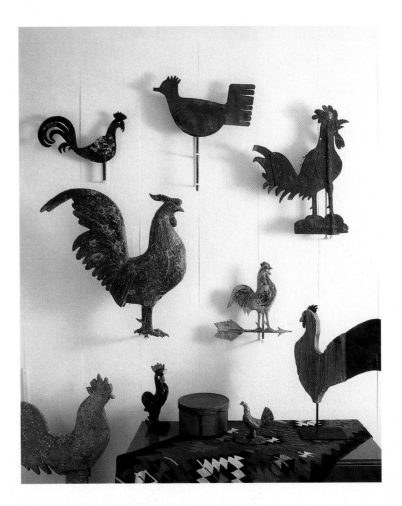

pieces, the collector feels, is, after all, for the sheer pleasure of looking at them.

To that end, he has designed several practical display features throughout his home. The framework of the walls, for instance, was constructed as a grid, rather than with simple upright studs, thus increasing the number of places where supports for heavy pieces such as weather vanes can be attached. The floor-to-ceiling shelves that fill one wall in the dining area can be dismantled either partially, for the display of large pieces, or entirely—in case the collector decides that, instead of toys and sculpture, he would rather show folk-art paintings.

American patent models and toys are among the pieces that fill the dining area shelves at left.

Since their broad tails are perfect shapes for catching the wind, roosters and hens are two of the most familiar forms for weather vanes. The grouping of roosters above includes both hand-made iron and wood examples and factory-made copper vanes.

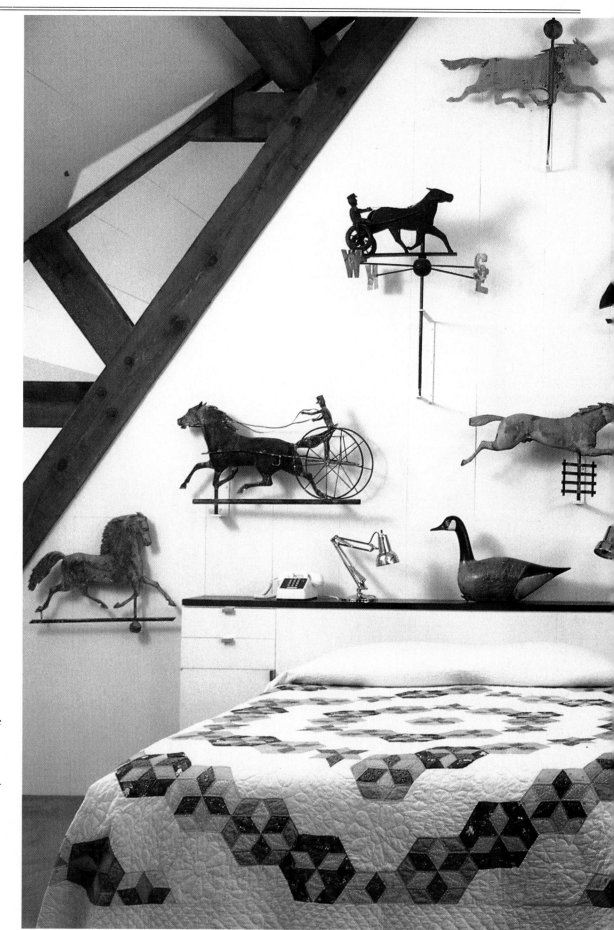

The beams of the house's original barn structure are visible in the bedroom at right, which features a collection of horse weather vanes. Among these is a welded sheet-iron running horse that is more than six feet wide.

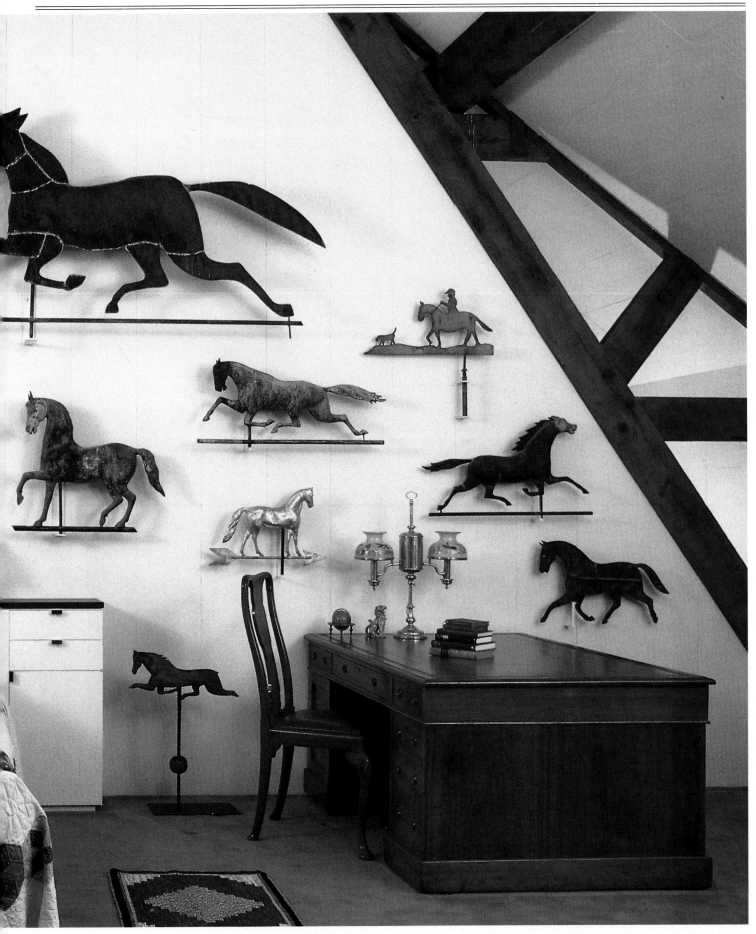

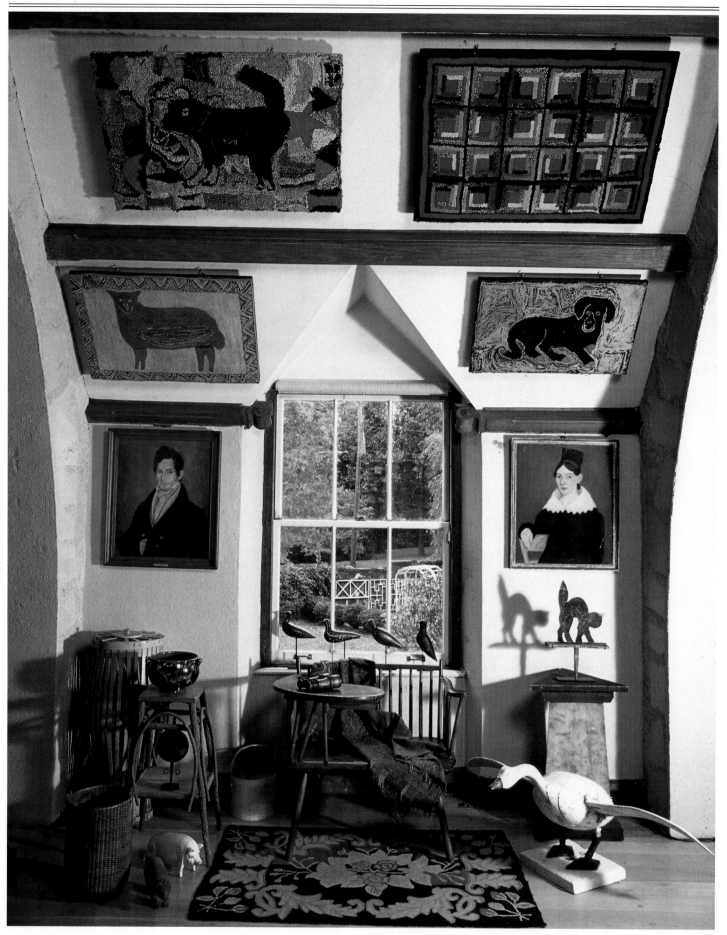

A Love of Americana

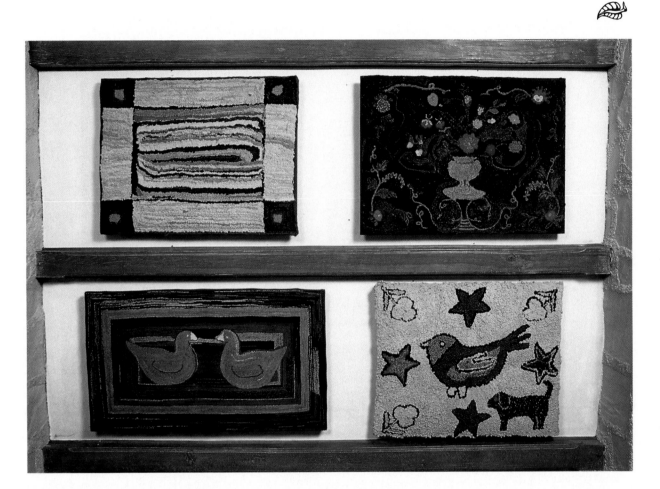

As a teenager growing up in Europe, the collector whose home is shown here used to love visits to her grandmother's house, where exploring the cabinets and shelves filled with treasured pieces was her favorite activity. Since then she has always been fascinated with beautifully crafted objects, and once she moved to this country her interests, logically, turned to American folk art.

The extensive collection that fills her house today favors hooked rugs and fish decoys, but also includes an imaginative mix of primitive portraits, sculpture, baskets, bird decoys, and painted furniture. Both 19th- and 20th-century works are equally at home.

The owner values her collection not only because she finds the objects delightful in themselves, but also because she considers them to be a part of the American cultural experience. "What I love about folk art is that so much of it was created for creativity's sake," she explains. "No one *had* to make a decorated rug or fash-

Continued

The hooked rugs above, which range in date from the 19th to the early 20th centuries, are mounted on wooden stretcher frames for wall display; sheets of acid-free paper between the stretchers and the rugs help protect the fibers.

The arrangement opposite features a pair of portraits by the 19th-century folk artist Micah Williams. The vaulted ceiling creates a dramatic setting for hooked rugs.

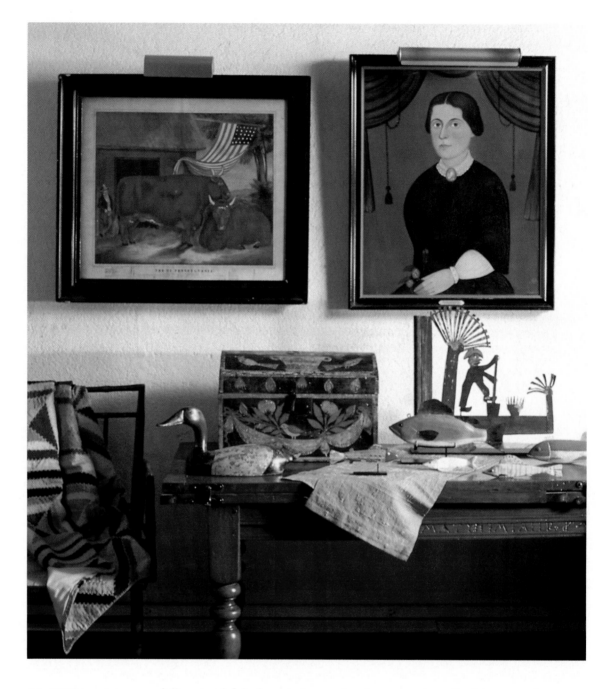

Above, a portrait by William Matthew Prior, a 19th-century itinerant painter, presides over a 1930s tin weather vane and early-20th-century fish decoys.

ion a carefully carved fish decoy when a simple version was all that was really needed."

When considering the addition of a new piece, the collector places less importance on the object's date or materials than on its textural and pictorial qualities. Although she does take advice from knowledgeable dealers on points of particular historical interest, she can

never be talked into purchasing something that would look out of place with the folk art she already owns or that does not appeal to her aesthetically.

Not bound by convention, the homeowner strives for an almost playful effect in the arrangement of her collection, as evidenced by the folk-art vignettes found throughout the house:

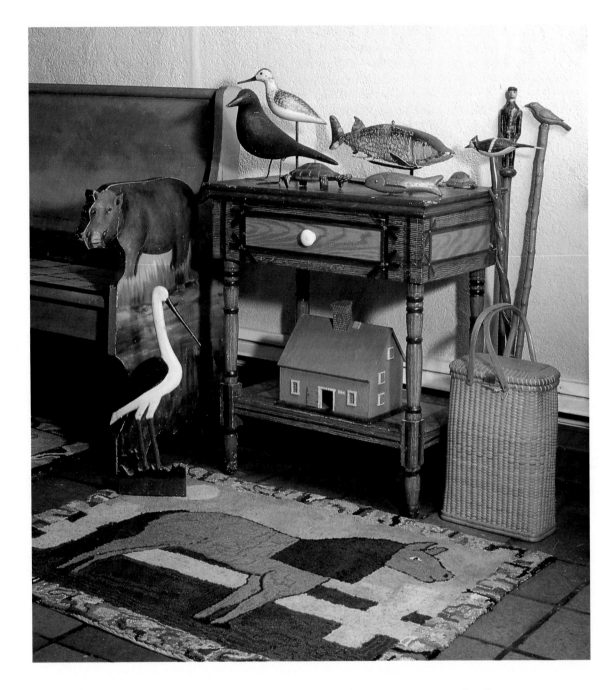

whimsical textiles, carvings, and toys, for example, make surprising contrasts with more somber portraits. And while she enjoys such groupings for their decorative effect, she feels that in many cases it is not necessary to limit her pieces solely to display. For instance, the colorfully painted carousel benches in her dining room function quite conveniently as furniture, and

hooked rugs are often put to use on the floor.

Although this collector's first instinct in decorating her house is to set out everything at once, she does go through an editing procedure, and admits that standing back with a critical eye is important. Indeed, it is that very process of collecting and culling that provides her with a constant source of pleasure.

The menagerie of folk-art pieces above includes a colorful carousel bench with hippo arms. The painted wooden stork cutout is a bookend.

Museum, Collection, and Photography Credits

Cover: photo by Steven Mays. Frontispiece: courtesy of The Henry Francis du Pont Winterthur Museum, Winterthur, DE. Page 8: Abby Aldrich Rockefeller Folk Art Center, Williamsburg, VA. Page 10: Old Colony Historical Society, Taunton, MA. Page 11: The Metropolitan Museum of Art, NYC, gift of Edgar William and Bernice Chrysler Garbisch, 1963 (63.201.1). Page 12: (both) New York State Historical Association, Cooperstown, NY. Page 13: courtesy of David A. Schorsch, Inc., NYC. Pages 14, 15: The Connecticut Historical Society, Hartford, CT. Page 16: (far left) New York State Historical Association, Cooperstown, NY. Pages 16-17: (top row, left to right) collection of the Museum of American Folk Art, NYC, gift of Joseph Martinson Memorial Fund, Frances and Paul Martinson; collection of Marna Anderson/photo by Steven Mays; collection of Marna Anderson/photo by Steven Mays; America Hurrah, NYC; America Hurrah, NYC; (middle row, left to right) Lyman Allyn Art Museum, New London, CT; collection of Marna Anderson/photo by Steven Mays; collection of the Museum of American Folk Art, NYC, gift of Joseph Martinson Memorial Fund, Frances and Paul Martinson; collection of the Museum of American Folk Art, NYC; (bottom row, left to right) collection of Marna Anderson/photo by Steven Mays; collection of the Museum of American Folk Art, NYC, gift of Howard and Jean Lipman in memory of Joyce Hill; collection of the Museum of American Folk Art, NYC; collection of Marna Anderson/photo by Steven Mays; collection of Marna Anderson/photo by Steven Mays. Page 18: Abby Aldrich Rockefeller Folk Art Center, Williamsburg, VA. Page 19: The Metropolitan Museum of Art, NYC, gift of Edgar William and Bernice Chrysler Garbisch, 1962 (62.256.3). Page 20: Philadelphia Museum of Art, Philadelphia, PA, bequest of Lisa Norris Elkins. Page 21: Abby Aldrich Rockefeller Folk Art Center, Williamsburg, VA. Pages 22, 23: Maryland Historical Society, Baltimore, MD. Page 24: courtesy of The Henry Francis du Pont Winterthur Museum, Winterthur, DE. Page 25: (both) private collection/photos by Stephen Donelian. Page 26: collection of the Albany Institute of History and Art, Albany, NY. Page 27: (top) courtesy of The New-York Historical Society, NYC; (bottom) New Bedford Whaling Museum, New Bedford, MA. Page 28: courtesy of The Fogg Art Museum, Harvard University, Cambridge, MA, gift of the Estate of Harriet Anna Niel. Page 29: (top) Abby Aldrich Rockefeller Folk Art Center, Williamsburg, VA; (bottom) private collection/photo by Capital Photo, Fairfield, CT. Page 30: collection of the Museum of American Folk Art, NYC, promised anonymous gift. Page 31: The Chrysler Museum, Norfolk, VA, gift of Edgar William and Bernice Chrysler Garbisch. Page 32: (all) courtesy of David A. Schorsch, Inc., NYC. Page 33: (both) private collection/photo by Richard Cheek. Page 34: (top) The Connecticut Historical Society, Hartford, CT; (middle row, left and center) courtesy of the Essex Institute, Salem, MA; (middle row, right) Pocumtuck Valley Memorial Association, Memorial Hall Museum, Deerfield, MA; (bottom) courtesy of The Henry Francis du Pont Winterthur Museum, Winterthur, DE. Page 35: National Portrait Gallery, London. Pages 36, 37: private collection/photos by Stephen Donelian. Pages 38-39: (all) Abby Aldrich Rockefeller Folk Art Center, Williamsburg, VA. Page 40: (left) New York State Historical Association, Cooperstown, NY; (right) Shelburne Museum, Inc., Shelburne, VT/photo by Ken Burris. Page 41: courtesy of the Museum of Fine Arts, Boston, MA. Page 42: America Hurrah, NYC. Page 43: courtesy of The New-York Historical Society, NYC. Page 44: courtesy of Hirschl & Adler Folk, NYC. Page 46: courtesy of the Museum of Fine Arts, Boston, MA. Page 47: Museum of Fine Arts, Springfield, MA. Page 48: Shelburne Museum, Inc., Shelburne, VT/photo by Fred G. Hill. Page 49: private collection, Rochester, NY. Page 50: Abby Aldrich Rockefeller Folk Art Center, Williamsburg, VA. Page 52: New Bedford Whaling Museum, New Bedford, MA. Page 53: (left top) from *American Primitive* by Roger Ricco and Frank Maresca. Copyright © 1988 by Roger Ricco, Frank Maresca, and Julia Weissman. Reprinted by permission of Alfred A. Knopf, Inc.; (left bottom) courtesy of David A. Schorsch, Inc., NYC; (right) Shelburne Museum, Inc., Shelburne, VT/photo by Ken Burris. Page 54: (left) New York State Historical Association, Cooperstown, NY; (right) Shelburne Museum, Inc., Shelburne, VT/photo by Ken Burris. Page 55: Shelburne Museum, Inc., Shelburne, VT/photo by Ken Burris. Page 56: The Brooklyn Historical Society, Brooklyn, NY. Page 57: (left) America Hurrah, NYC; (right) Shelburne Museum, Inc., Shelburne, VT/photo by Ken Burris. Page 58: (inset photo) The Metropolitan Museum of Art, NYC, Rogers Fund, 1922 (22.281.1). Page 59: (top inset photo) courtesy of the Essex Institute, Salem, MA; (bottom inset photo) The Museum of the City of New York, NYC. Pages 58-59: (all black-and-white photos, except bottom center) collection of Rell G. Francis, Springville, UT/photos by George Edward Anderson; (bottom center) Culver Pictures, NYC. Page 60: America Hurrah, NYC. Page 61: collection of the Museum of American Folk Art, NYC, gift of David L. Davies. Page 62: (top and middle) from *American Primitive* by Roger Ricco and Frank Maresca. Copyright © 1988 by Roger Ricco, Frank Maresca, and Julia Weissman. Reprinted by permission of Alfred A. Knopf, Inc.; (bottom) photo by Bill Holland. Page 63: (both) Shelburne Museum, Inc., Shelburne, VT/photos by Ken Burris. Page 64: (both) Westmoreland Museum of Art, Greensburg, PA. Page 65: (both) Dedham Historical Society, Dedham, MA. Page 66: (top) Abby Aldrich Rockefeller Folk Art Center, Williamsburg, VA; (bottom) courtesy of The Rhode Island Historical Society, Providence, RI (1898.5.1). Page 67: (left) The Sandwich Historical Society, Center

Sandwich, NH; (right) Shelburne Museum, Inc., Shelburne, VT/photo by Ken Burris. **Pages 68-69**: (all) courtesy of the Maine Charitable Mechanic Association, Portland, ME/photos by Richard Cheek. **Page 70**: (both) America Hurrah, NYC. **Page 71**: (top left and right) courtesy of the Essex Institute, Salem, MA; (bottom left) courtesy of David A. Schorsch, Inc., NYC; (bottom right) Christie's, NYC. **Page 72**: (both) Shelburne Museum, Inc., Shelburne, VT/ photos by Ken Burris. **Page 73**: (top) collection of the Museum of American Folk Art, NYC, gift of Laura Harding; (bottom) America Hurrah, NYC. **Page 74**: Zon International Publishing Co., Millwood, NY. **Page 75**: (clockwise from top left) Bettmann Archive, NYC; Culver Pictures, NYC; Zon International Publishing Co., Millwood, NY; Bettmann Archive; Zon International Publishing Co.; Zon International Publishing Co.; Bettmann Archive; Zon International Publishing Co. **Page 76**: (top and middle) from *American Primitive* by Roger Ricco and Frank Maresca. Copyright © 1988 by Roger Ricco, Frank Maresca, and Julia Weissman. Reprinted by permission of Alfred A. Knopf, Inc.; (bottom) Hirschl & Adler Folk, NYC. **Page 77**: (left) collection of the Museum of American Folk Art, NYC; (right) © Schecter Lee/Esto. **Page 78**: (top) collection of George H. Meyer/photo by George Ross; (middle) collection of Marna Anderson/photo by Steven Mays; (bottom) private collection/photo by Peter Brenner. **Page 79**: (top) America Hurrah, NYC; (middle and bottom) collection of Marna Anderson/photos by Steven Mays. **Page 80**: (all) Richard A. Bourne Co., Inc., Hyannis Port, MA. **Page 81**: (all) Shelburne Museum, Inc., Shelburne VT/photo by Ken Burris. **Page 82**: collection of Gary Miller/ photo courtesy of Michigan State University Museum, East Lansing, MI. **Page 83**: (all) collection of Ron Fritz, Fife Lake, MI/ photos by Steven Mays. **Page 84**: (left) Abby Aldrich Rockefeller Folk Art Center, Williamsburg, VA; (right) © Schecter Lee/ Esto. **Page 85**: (all) collection of George

H. Meyer/photos by George Ross. **Page 86**: (top row, all) © Chun Y. Lai/Esto; (bottom row, all) © Schecter Lee/Esto. **Page 87**: (top row, left and center) Abby Aldrich Rockefeller Folk Art Center, Williamsburg, VA; (top row, right) from the collections of Henry Ford Museum & Greenfield Village, Dearborn, MI (20.B.84); (bottom row, left and right) © Schecter Lee/Esto; (bottom row, center) Christie's, NYC. **Page 88**: (top left) private collection; (top right, and bottom left and right) Philadelphia Museum of Art, Philadelphia, PA/gift of John T. Morris. **Page 89**: (both) private collection. **Page 90**: (all) private collection. **Page 91**: Abby Aldrich Rockefeller Folk Art Center, Williamsburg, VA. **Page 92**: (left) Philadelphia Museum of Art, Philadelphia, PA/ Titus C. Geesey Collection; (right) Abby Aldrich Rockefeller Folk Art Center, Williamsburg, VA. **Page 93**: (all) Lehigh County Historical Society, Allentown, PA. **Page 94**: Skinner, Inc., of Boston and Bolton, MA. **Page 96**: (both) Shelburne Museum, Inc., Shelburne, VT/photos by Ken Burris. **Page 97**: private collection/ photo by Stephen Donelian. **Page 98**: (left) courtesy of David A. Schorsch, Inc., NYC; (right) private collection/photo by Stephen Donelian. **Page 99**: (top) Skinner, Inc., of Boston and Bolton, MA; (bottom) Abby Aldrich Rockefeller Folk Art Center, Williamsburg, VA. **Page 100**: (top) collection of the Museum of American Folk Art, NYC, gift of Eva and Morris Feld Folk Art Acquisition Fund; (bottom) private collection/photo by Stephen Donelian. **Page 101**: (top) courtesy of David A. Schorsch, Inc., NYC; (bottom) Abby Aldrich Rockefeller Folk Art Center, Williamsburg, VA. **Page 102**: (top) © 1987 Sotheby's, Inc., NYC; (bottom) courtesy of The Henry Francis du Pont Winterthur Museum, Winterthur, DE. **Page 103**: (top left) courtesy of the Historical Society of York County, York, PA; (top right) Abby Aldrich Rockefeller Folk Art Center, Williamsburg, VA; (bottom) The Saint Louis Art Museum, St. Louis, MO. **Page 104**: (top) collection of the

Museum of American Folk Art, NYC, gift of Mrs. William P. Schweitzer; (bottom) America Hurrah, NYC. **Page 105**: America Hurrah, NYC. **Page 106**: (both) collection of the Museum of American Folk Art, NYC, promised anonymous gift/photos by John Parnell. **Page 107**: (both) Shelburne Museum, Inc., Shelburne, VT/photos by Ken Burris. **Page 108**: Abby Aldrich Rockefeller Folk Art Center, Williamsburg, VA. **Page 109**: Christie's, NYC. **Page 110**: I. N. Phelps Stokes Collection, Miriam & Ira D. Wallach Division of Art, Prints and Photographs, The New York Public Library, Astor, Lenox and Tilden Foundations, NYC. **Page 111**: (top and bottom) Abby Aldrich Rockefeller Folk Art Center, Williamsburg, VA; (middle) Historic Deerfield, Inc., Deerfield, MA. **Page 112**: (both) Abby Aldrich Rockefeller Folk Art Center, Williamsburg, VA. **Page 113**: collection of the Museum of American Folk Art, NYC, gift of Cyril I. Nelson. **Page 114**: Shelburne Museum, Inc., Shelburne, VT/ photo by Ken Burris. **Page 115**: America Hurrah, NYC. **Page 116**: (top) Shelburne Museum, Inc., Shelburne, VT/photo by Ken Burris; (bottom) Abby Aldrich Rockefeller Folk Art Center, Williamsburg, VA. **Page 117**: (top) Christie's, NYC; (bottom) © Schecter Lee/Esto. **Page 118**: courtesy of The Henry Francis du Pont Winterthur Museum, Winterthur, DE. **Page 119**: (top left) © Schecter Lee/Esto; (top right and bottom left) Hallmark Historical Collection, Hallmark Cards, Inc., Kansas City, MO; (bottom right) Abby Aldrich Rockefeller Folk Art Center, Williamsburg, VA. **Page 120**: (top) The Newark Museum, Newark, NJ; (bottom) Abby Aldrich Rockefeller Folk Art Center, Williamsburg, VA. **Page 121**: collection of the Museum of American Folk Art, NYC, gift of Day Krolik. **Page 122**: Susan Parrish, NYC. **Page 124**: (top left, and middle left and right) private collection/photos by Stephen Donelian; (top right) courtesy of David A. Schorsch, Inc., NYC; (bottom left) © Schecter Lee/Esto; (bottom right) New

Bedford Whaling Museum, New Bedford, MA. **Page 125**: (left) © Schecter Lee/Esto; (right) collection of the Museum of American Folk Art, NYC. **Page 126**: (top) Shelburne Museum, Inc., Shelburne, VT/ photo by Ken Burris; (middle left) private collection/photo by Stephen Donelian; (middle right) Peabody Museum of Salem, Salem, MA/photo by Mark Sexton; (bottom left) Shelburne Museum, Inc., Shelburne, VT/photo by Ken Burris. **Pages 126-127**: private collection/photo by Stephen Donelian. **Page 127**: (top) Shelburne Museum, Inc., Shelburne, VT/photo by Ken Burris; (middle left) Peabody Museum of Salem, Salem, MA/photo by Mark Sexton; (middle right) © Schecter Lee/Esto; (bottom) New Bedford Whaling Museum, New Bedford, MA. **Pages 128-129**: (all) courtesy of the Hill Gallery, Birmingham, MI/photos by Charles H. Cloud III. **Page 130**: (top) Shelburne Museum, Inc., Shelburne, VT/ photo by Ken Burris; (bottom left) collec-

tion of Marna Anderson/photo by Steven Mays; (bottom right) courtesy of David A. Schorsch, Inc., NYC. **Page 131**: (both) collection of Steve Miller, NYC. **Page 132**: (left and right top) collection of the Museum of American Folk Art, NYC, gifts of Cordelia Hamilton, Dr. and Mrs. Lester Blum, and Murray Eig and William Engvick; (right bottom) New York State Historical Association, Cooperstown, NY. **Page 133**: (left) New York State Historical Association, Cooperstown, NY; (right) courtesy of the Hill Gallery, Birmingham, MI/photo by Charles H. Cloud III. **Pages 134-135**: (all) © Schecter Lee/Esto. **Page 136**: The Newark Museum, Newark, NJ. **Page 137**: Thos. K. Woodard/American Antiques & Quilts, NYC. **Page 138**: America Hurrah, NYC. **Page 139**: collection of the Museum of the Kentucky Historical Society, Frankfort, KY/photo by Nathan Prichard. **Page 140**: collection of Barbara Johnson. **Page 141**: (top left) collection of The Museum of

Modern Art, NYC; (top right) private collection/photo courtesy of Michigan State University Museum, East Lansing, MI; (bottom left) Wadsworth Atheneum, Hartford, CT, gift of James Junius Goodwin; (bottom right) Philadelphia Museum of Art, Philadelphia, PA, Titus C. Geesey Collection. **Page 142**: (top) Susan Parrish, NYC; (bottom) © Schecter Lee/Esto, courtesy of America Hurrah, NYC. **Page 143**: Schwenkfelder Library, Pennsburg, PA. **Page 144**: (both) America Hurrah, NYC. **Page 145**: The Metropolitan Museum of Art, NYC, Sansbury Mills Fund, 1961 (61.47.3). **Page 146**: (top) © Schecter Lee/Esto; (bottom) Pocumtuck Valley Memorial Association, Memorial Hall Museum, Deerfield, MA. **Page 147**: courtesy of The Henry Francis du Pont Winterthur Museum, Winterthur, DE. **Pages 148-167**: photos by Steven Mays.

Index

Acknowledgments

Our thanks to Julia Arliss, Barbara and Edward Braman, David Davies, Janey Fire of the Museum of American Folk Art, Karla Friedlich of the Museum of American Folk Art, Peter Goodman, Catherine H. Grosfils of Colonial Williamsburg, Inc., Stacy Hollander of the Museum of American Folk Art, Barbara Johnson, Art Kimball, Kate and Joel Kopp of America Hurrah, Frank Maresca of the Ricco/Maresca Gallery, George H. Meyer, Steve Miller of American Folk Art, Pauline H. Mitchell of Shelburne Museum, Inc., Ann-Marie Reilly of the Museum of American Folk Art, Roger Ricco of the Ricco/Maresca Gallery, David A. Schorsch of David A. Schorsch, Inc., Robert Shaw of Shelburne Museum, Inc., and Peter Tillou for their help on this book.

First printing
Published simultaneously in Canada
School and library distribution by Silver Burdett Company,
Morristown, New Jersey

TIME-LIFE is a trademark of Time Incorporated U.S.A.

Production by Giga Communications, Inc.
Printed in U.S.A.

Library of Congress Cataloging-in-Publication Data

Folk Art
p. cm. — (American country)
ISBN 0-8094-6800-X — ISBN 0-8094-6801-8 (lib. bdg.)
1. Folk art—United States.
I. Time-Life Books. II. Series.
NK805.F58 1990 745'.0973—dc20 89-77352
CIP

American Country was created by Rebus, Inc., and published by Time-Life Books.

REBUS, INC.

Publisher: RODNEY FRIEDMAN • Editor: MARYA DALRYMPLE
Executive Editor: RACHEL D. CARLEY • Managing Editor: BRENDA SAVARD • Consulting Editor: CHARLES L. MEE, JR.
Senior Editor: SUSAN B. GOODMAN • Copy Editor: ALEXA RIPLEY BARRE
Writers: JUDITH CRESSY, ROSEMARY G. RENNICKE • Freelance Writer: JOE L. ROSSON
Design Editors: NANCY MERNIT, CATHRYN SCHWING
Test Kitchen Director: GRACE YOUNG • Editor, The Country Letter: BONNIE J. SLOTNICK
Editorial Assistant: LEE CUTRONE • Contributing Editors: ANNE MOFFAT, DEE SHAPIRO,
KATE TOMKIEVICZ • Indexer: MARILYN FLAIG

Art Director: JUDITH HENRY • Associate Art Director: SARA REYNOLDS
Designers: AMY BERNIKER, TIMOTHY JEFFS
Photographer: STEVEN MAYS • Photo Editor: SUE ISRAEL
Photo Assistant: ROB WHITCOMB • Freelance Photographers: STEPHEN DONELIAN, GEORGE ROSS
Freelance Photo Stylist: VALORIE FISHER

Special Consultants for this book: MARNA ANDERSON, ROBERT BISHOP
Series Consultants: BOB CAHN, HELAINE W. FENDELMAN, LINDA C. FRANKLIN, GLORIA GALE,
KATHLEEN EAGEN JOHNSON, JUNE SPRIGG, CLAIRE WHITCOMB

Time-Life Books Inc. is a wholly owned subsidiary of THE TIME INC. BOOK COMPANY.

President and Chief Executive Officer: KELSO F. SUTTON
President, Time Inc. Books Direct: CHRISTOPHER T. LINEN

TIME-LIFE BOOKS INC.

Editor: GEORGE CONSTABLE • Executive Editor: ELLEN PHILLIPS
Director of Design: LOUIS KLEIN • Director of Editorial Resources: PHYLLIS K. WISE
Director of Photography and Research: JOHN CONRAD WEISER

President: JOHN M. FAHEY JR.
Senior Vice Presidents: ROBERT M. DeSENA, PAUL R. STEWART, CURTIS G. VIEBRANZ, JOSEPH J. WARD
Vice Presidents: STEPHEN L. BAIR, BONITA L. BOEZEMAN, MARY P. DONOHOE, STEPHEN L. GOLDSTEIN,
JUANITA T. JAMES, ANDREW P. KAPLAN, TREVOR LUNN, SUSAN J. MARUYAMA, ROBERT H. SMITH
New Product Development: YURI OKUDA, DONIA ANN STEELE
Supervisor of Quality Control: JAMES KING
Publisher: JOSEPH J. WARD

For information about any Time-Life book please call 1-800-621-7026, or write:
Reader Information, Time-Life Customer Service
P.O. Box C-32068, Richmond, Virginia 23261-2068

Time-Life Books Inc. offers a wide range of fine recordings, including a Rock 'n' Roll Era series.
For subscription information, call 1-800-621-7026, or write TIME-LIFE MUSIC,
P.O. Box C-32068, Richmond, Virginia 23261-2068.